Study in Black and White

The Pennsylvania State University Press

UNIVERSITY PARK, PENNSYLVANIA

TANYA SHEEHAN

Study in Black and White } PHOTOGRAPHY, RACE, HUMOR

Unless otherwise noted, the figures are the author's photos.

This publication has been made possible through support from the Terra Foundation for American Art International Publication Program of the College Art Association.

Library of Congress Cataloging-in-Publication Data

Names: Sheehan, Tanya, 1976– author.
Title: Study in black and white : photography, race, humor / Tanya Sheehan.
Description: University Park, Pennsylvania : The Pennsylvania State University Press, [2018] | Includes bibliographical references and index.
Summary: "Explores the connections among race, visual humor, and technologies of photography in the nineteenth and twentieth centuries, with special attention to the reappropriation of racial humor by contemporary artists"—Provided by publisher.
Identifiers: LCCN 2018007930 | ISBN 9780271081106 (cloth : alk. paper)
Subjects: LCSH: Photography, Humorous—History. | Ethnic wit and Humor—History. | Photography—Social aspects—History.
Classification: LCC TR679.5.S54 2018 | DDC 770—dc23
LC record available at https://lccn.loc.gov/2018007930

For A. H. R.

Contents

Illustrations

x

Acknowledgments

When a book develops over the course of a decade, there are many institutions and people to acknowledge. At the top of the list is the Leslie Center for the Humanities at Dartmouth College, where *Study in Black and White* began its life as a research project. It was at the Center's Humanities Institute in the fall of 2007, directed by the late Angela H. Rosenthal, that I began to explore ideas about race in photographic humor. Dedicated to Angela, this book honors her indefatigable spirit and the extraordinary body of scholarship she left to the world.

Residential fellowships continued to nurture the project, providing access to a wealth of primary materials and opportunities for presentation and feedback. I am honored to have been awarded in 2009–10 the Donald C. Gallup Fellowship in American Literature at the Beinecke Rare Book and Manuscript Library, Yale University, and a National Endowment for the Humanities Fellowship at the American Antiquarian Society. For their boundless generosity, curiosity, and expertise in early American visual and material culture, I remain grateful to Gigi Barnhill, Lauren Hewes, Laura Wasowicz, and Nan Wolverton at the AAS. Leading the Center for Historic American Visual Culture seminar at the AAS in the summer of 2017 reminded me just how much of this book stemmed from conversations with these extraordinary women. In 2011–12, I received a Short-Term Research Fellowship at the New York Public Library and a Sheila Biddle Ford Foundation Fellowship from the W. E. B. Du Bois Institute (now part of the Hutchins Center) for African and African American Research, Harvard University. A research associate position at the Hutchins Center, held since 2012, has afforded me valuable access to scholarly resources and a community of colleagues devoted to the critical study of the black image, among them David Bindman, Henry Louis Gates Jr., Vera Ingrid Grant, and Paul Kaplan. Most recently, in 2012–13, my

work benefited greatly from a research fellowship from the Harry Ransom Center, University of Texas at Austin, and a Beatrice, Benjamin, and Richard Bader Fellowship in the Visual Arts of the Theatre from Houghton Library, Harvard University.

Financial support for the book came from my home institutions: Rutgers, The State University of New Jersey (2008–13) and Colby College (2013–). A Research Council Grant from Rutgers supported summer research in Australasia, while at Colby the Humanities Division, Office of the Provost, and William R. Kenan Jr. endowed professorship funded the publication of an illustration-rich book. Additionally, Penn State University Press was awarded in 2018 the Terra Foundation for American Art International Publication Grant to support this project. I deeply appreciate the Terra Foundation's support of my work and all they have done to foster scholarship on American art in a global context.

Chapters in progress were presented at all of the institutions named above and at the University of Delaware, Bryn Mawr College, University of Georgia, Brown University, Rhode Island School of Design, Philadelphia Museum of Art, annual meetings of the American Studies Association, and the College Art Association Conference in the United States; Concordia University and University of Toronto in Canada; the Monash University Prato Centre in Italy; Australian National University and Monash University in Australia; and University of Gothenburg in Sweden. Thanks to my hosts at these venues for their support of my work and to the audiences for their interest, healthy skepticism, and probing questions; those questions took the book in unexpected and productive directions.

An early version of chapter 1 was published as "Comical Conflations: Racial Identity and the Science of Photography," in the July 2011 issue of *Photography and Culture*. The same essay was reprinted in *No Laughing Matter: Visual Humor in Ideas of Race, Nationality, and Ethnicity* (Hanover: University Press of New England, 2015). Edited by Adrian Randolph and David Bindman, this volume emerged from the Humanities Institute of the same title at Dartmouth College. Sections of chapters 3 and 5 were first published as "Looking Pleasant, Feeling White: The Social Politics of the Photographic Smile," in *Feeling Photography*, edited by Elspeth H. Brown and Thy Phu (Durham: Duke University Press, 2014).

To the countless people who watched this project evolve, recommended key sources, offered discerning queries, extended introductions to scholars and artists around the world, or provided image reproductions and rights, I am indebted. At the risk of offending by omission, I want to single out the contributions of Geoffrey Batchen, Elspeth Brown, Adrienne Childs, Helen Ennis, Louis Kaplan, Shana Lopes, Melissa Miles, Heather Shannon, Gwendolyn DuBois Shaw, James Smalls, Shawn Michelle Smith, Andrea Volpe, Deborah Willis, and Mary Yearwood. I must also

express my deepest gratitude to the executive editor at Penn State University Press, Ellie Goodman, for her investment in and expert shepherding of this project.

My final words of acknowledgment are reserved for my partner and fellow art historian, Daniel Harkett, and for our son, Hayden Sheehan Harkett. With remarkable understanding, my family has experienced too-frequent travel, innumerable nights and weekends devoted to the laptop, and the seemingly strange collecting practices this book required. Our home has contained many of the vintage photographs and other vernacular objects discussed in the following pages. I will appreciate always the conversations they stimulated among the three of us, as we watched the first black president of the United States take and leave office, and as my son began developing his consciousness of race in America.

Introduction

Around 1900, the Universal Photo Art Company of Philadelphia published a stereo-card titled *A Study in Black and White* (fig. 1). Looking through the binocular eyepiece of a stereoscope, middle-class Americans, who consumed stereocards in great numbers at the turn of the twentieth century, would have experienced a familiar joke in three dimensions. In the nearly identical photographs on the card are two black babies, dia-pered in white cloth and seated in an expanse of white cotton on a southern plantation. Sitting upright, the slightly older boy grasps the white fluff in his chubby hands as he turns to look at his companion. Arms in motion, eyes closed, and mouth parting, as if midcry, the younger child appears to object to his current circumstances. The white viewers whom the Universal Photo Art Company aimed to entertain were encouraged to disregard the child's distress, the inexplicable absence of the babies' parents, and the oddity of the scene as a whole. To laugh with the photograph was to focus instead on the play of opposites signaled by its title—namely, the blackness of the babies juxtaposed with the whiteness of the cotton. What, for the card's viewers, could have been more opposite than the values *black* and *white* at a time when blackness connoted filth and ugliness, darkness and disorder, evil and sin, disease and death—everything that whiteness was not?[1] Humorous to them, too, would have been the application of a refined aesthetic term (*a study*) to the coupling of African Americans with a com-modity signifying their enslavement and backbreaking labor in the southern states. And yet that juxtaposition would also have been experienced as logical and pleasing, if one believed that blacks were essentially suited to—or born into, as the babies on the stereocard suggest—an inferior social status. What was incongruous in one respect about bringing blackness and whiteness into intimate relation was thus imagined as quite natural and expected in another.

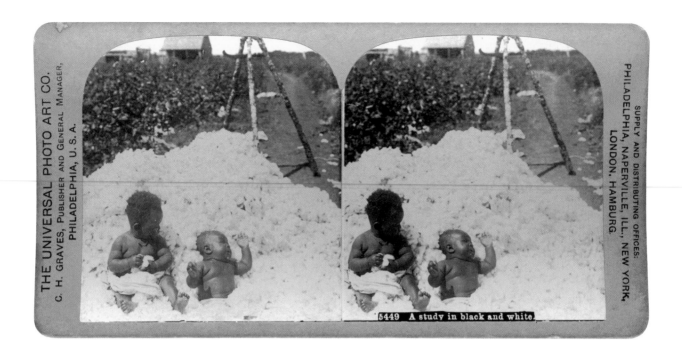

On the stereocard image:
5449 A study in black and white.

1. The Universal Photo Art Company, *A Study in Black and White*, ca. 1900. Albumen prints mounted on stereocard. Private collection.

That photography itself relied on a contrast of black and white added another layer to the card's humor. Since most photographic processes depended on light's stimulation of silver nitrate to darken, or blacken, the white ground of a photosensitive surface, the medium served as a ready metaphor for racial difference and the ground upon which many jokes about race were laid. Its potential to embody contemporary social relations thus informed much more than the production of the stereocard; it generated a robust genre of racial humor that emerged with the earliest public discussions of photography around 1839 and remained popular into the twentieth century. Exploring the connections that this genre forged between photography and race in America, this book asks how and why humorists used the medium to express evolving ideas about blackness and whiteness.

Since the 1970s, interest in early photographic humor among historians and collectors has led to publications cataloguing its many varieties in Europe and the United States. Compilations of jokes about photography—in graphic satire, popular literature, and comic photographs—show how humorists poked fun at the huge number of people who flocked to commercial portrait studios or took up amateur photography. Presenting them as evidence of photography's mass popularity since the mid-nineteenth century, these studies uncovered countless examples of humor that pointed to the unnaturalness of photographic poses, the ridiculous efforts to capture a pleasing

likeness, and the absurd ubiquity of the camera.[2] While collecting together many varieties of photographic humor from public and extensive private collections, the aim of this book far exceeds that of accumulation. The central interest of the following chapters lies in reconnecting racial comedy to historical questions not only about the technology of photography but also about racialized subjectivity, agency, and citizenship—questions that resonate with social concerns in the twenty-first century.

By approaching photographic humor as more than a collectible curiosity or "mere" entertainment, *Study in Black and White* contributes to recent efforts in American studies and art history to take visual humor seriously and treat it as complex social commentary.[3] I share the view, now established in these fields, that the "study of humor becomes yet another way of understanding social history, cultural institutions, and the development of both a sense of national identity and threats to that identity."[4] This is not to say that scholars should take humor's cultural status for granted; rather, we should think carefully about how humor has been constituted within cultures and how its status has changed over time. We must ask, as historian Daniel Wickberg puts it, "how humor was talked about in culture, what values were attached to it, [and] how it was structured and produced."[5] This approach adopts a key aspect of French philosopher Henri Bergson's influential theory of humor, first published in 1900. "To understand laughter," Bergson proposed, "we must put it back into its natural environment, which is society, and above all must we determine the utility of its function, which is a social one." Laughter, in Bergson's view, "must have a social signification."[6]

Studies of racial and ethnic humor have been sympathetic to Bergson's claim that laughter signals an individual's desire to belong to a social group and to relieve social tensions, sometimes by ironically reenacting them. Such studies have also incorporated aspects of the superiority theory of humor, which emerged from the writings of Aristotle and Thomas Hobbes. As Joseph Boskin and Joseph Dorinson note in their often-cited study of ethnic humor, "Hobbes related laughter to power and traced the origins and purposes of laughter to social rivalry." He therefore would have understood the ethnic stereotype as aggressively proclaiming the "eminency in ourselves by comparison with the infirmity of others."[7] Similarly, many of the examples of photographic humor considered in *Study in Black and White* stem from white Americans' wished-for social superiority in the face of black emancipation, waves of immigration, and further efforts to bring "others" into the national body. But as Boskin and Dorinson observe, a joke cannot always be explained simply as a form of aggression—as a self resisting the perceived threat of an other. It can conceal or mask feelings that are unconscious or unsafe to express directly, or it can affirm an ethnic group's identity and express collective pride. In African American humor specifically, there is a long tradition of embracing role reversals, pointing to the absurdity of situations or subjects,

and revealing the gap between appearance and reality.[8] Among the social functions these comic gestures have served since the mid-nineteenth century are "group survival, escape into pride and dignity, self-criticism, and the resolution of conflict."[9]

Examining ideas about race in photographic humor exposes the need for robust and nimble theories to describe their motivations, strategies, and effects. Addressing this need most productively and inventively, in my view, has been the prolific writing since the 1990s on blackface minstrelsy. In analyzing this theatrical performance of black caricature popularized in the 1830s, scholars have demonstrated an ability to see it as accomplishing many things at once: collapsing artifice and authenticity, degrading and envying black bodies, fearing and desiring others, blacking up and becoming white. Led by the scholarship of Eric Lott, they have found ways of accounting for the ambiguities and contradictions in blackface performances, staged by both white and black actors, while attending to their social as well as psychic dimensions.[10] For these reasons, the history and historiography of minstrelsy runs through my consideration of photographic humor's appropriation of black stereotypes and other comic racial performances. I have also incorporated social theories of affect, particularly recent work in the field of happiness studies and literature on race and melancholy.[11] While minstrelsy provides valuable models for understanding how and why comic tropes invest in certain raced subjects feeling and looking joyful, affect theory offers insights into the simultaneous rejection of and clinging to racial others that have motivated minstrel and photographic humor alike.

Study in Black and White has been further shaped by a recent shift in studies of blackface, from a treatment of minstrelsy as a distinctively American form of humor best approached in national terms to a global phenomenon with a variety of cultural meanings.[12] Motivating this shift are two decades of vigorous reflection on what it means to construct geographically, culturally, and conceptually expansive American histories. Associated with historians Donald E. Pease, Thomas Bender, and many others, this work has encouraged the study of objects, peoples, and ideas across the Americas, the Atlantic, and the Pacific world.[13] And so when I speak of the humor that linked *photography* and *race in America*, I recognize these terms as having been constructed transnationally, through the circulation of racial humor within and beyond the borders of the United States and through its participation in local and global networks. The opening chapters of this book therefore ask: How did the American exportation of photographic humor interact with racial discourses in Britain and parts of the British Empire? In what ways did different geographic and social contexts shape the meanings of popular American images and ideas about race?

Readers of *Study in Black and White* will note, however, that many of the materials I have selected for discussion originated in a relatively limited geographical area—specifically,

the northeastern, mid-Atlantic, and midwestern United States. This is because a significant number of the historical producers of photographic humor were located in major cities in these regions, notably Boston, New York, Philadelphia, Chicago, Cincinnati, and Detroit. These same producers allow us to talk about the national character of the genre, for the publishers of comic magazines and books, trade journals, stereocards, and postcards, some of whom also distributed photographic technology and supplies, cultivated large markets. Circulating widely, their humor had the potential to transcend local and regional references and present itself as a national discourse that constituted a shared cultural imagination for the middle-class whites it targeted. We will pay close attention to important exceptions.

In addition to the national and transnational dimensions of photographic humor, this book is concerned with the circulation of comic images and tropes across time and media. The stereocard with which this introduction began is an excellent example of the mass reproduction and dissemination of a particular comic trope, for it belonged to a vast collection of stereocards, postcards, and other staged photographs that placed black children in a sea of cotton and remained popular in the United States for more than a century (fig. 2). Through its caption, figure 1 also participated in comic and sentimental genres that included photography as well as print satire, musical scores, children's literature, commercial trade cards, and much more. In the early twentieth century, for

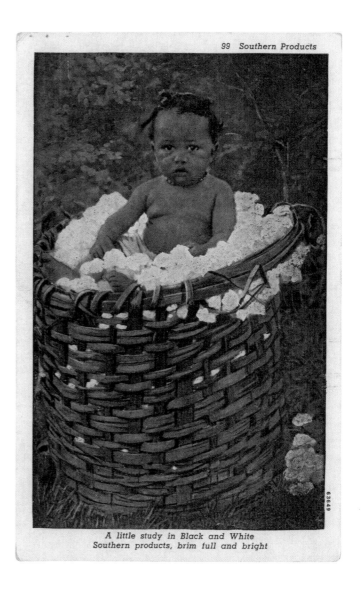

A little study in Black and White
Southern products, brim full and bright

2. Asheville Postcard Co., *A Little Study in Black and White*, ca. 1930. Color linen postcard. Private collection.

example, the phrase "A Study in Black and White" was used to describe everything from photographs of white missionaries posing with the dark-complexioned Pacific peoples they hoped to "civilize" to a popular American song that featured a black boy who dreams of turning white in heaven (fig. 3).[14] This book therefore approaches objects like figure 1 as part of an expansive visual culture that acquired meaning through conversations across media, while remaining attentive to the formal and conceptual particularities of any one example of photographic humor.

Study in Black and White addresses the multiple contexts in which such humor functioned by considering multiple audiences and what they were encouraged to find

A STUDY IN BLACK AND WHITE

BY
CHAS. K.
HARRIS
AND
LEO WOOD

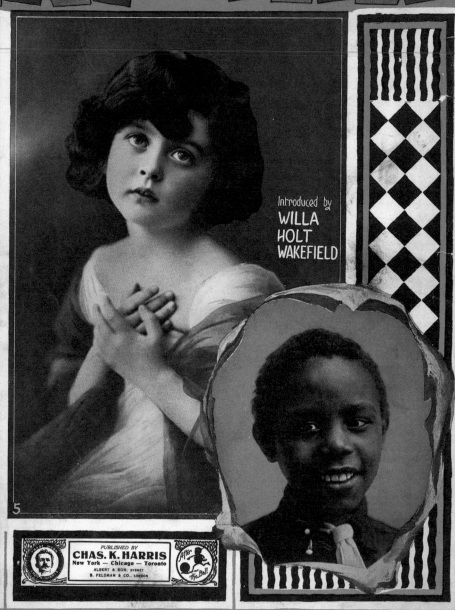

Introduced by
WILLA
HOLT
WAKEFIELD

PUBLISHED BY
CHAS. K. HARRIS
New York — Chicago — Toronto
ALBERT & SON, SYDNEY
B. FELDMAN & CO., LONDON

After the Ball

5

funny. Much of the book focuses on the consumption of racial humor by subjects who saw themselves as white and bourgeois. The objects I describe as "comic" were amusing to this audience, not to this author or her intended readers. I also consider the appropriation of these images and their subversion by black image makers, who have attempted to bridge creatively the perceived divide between blacks and whites. Indeed, the work of late twentieth-century and twenty-first-century black artists offers an invaluable critical framework through which to analyze conceptions of race and racial difference in early photographic humor. Often communicating through the language of caustic wit and ironic appropriation, their art renders photography and its historical operators the object of a radically new and socially progressive joke.

We might point to Adrian Piper's *Political Self-Portraits* (1978–80), for instance, to shed light on the so-called essential incongruity of photography: its bringing together of black and white. In *Political Self-Portrait #2 (Race)*, Piper alters a bust-length, smiling self-portrait, captions it "PALEFACE," and places it over a lengthy typewritten text in which she recounts some of the racist jokes and statements she experienced in her early life (fig. 4). The artist splits the portrait and its caption into two parts, one representing a positive photographic image and the other a negative. We can read Piper's work as demonstrating, through the metaphor of photography, that she must constantly negotiate her own identification as a black woman with the desires of others, who insist on interpreting her light complexion as a sign of racial whiteness or calling her names like "Paleface." As a study in black and white, *Political Self-Portrait #2 (Race)* uses biting humor to critique the psychological need to equate perceivable skin color with race and individual character. It further challenges a concept in which the Universal Photo Art Company's stereocard invested—namely, that humans are clearly either white or black, and can never legitimately live what Piper calls, in the text of *Political Self-Portrait #2 (Race)*, the "Gray Experience."

Also known for critical race humor that combines photography and text, Lorna Simpson situates eleven text plaques between two identical circular photographs of a woman's mouth and chest in *Untitled (2 Necklines)* (1989; fig. 5). Here, too, is a study in black and white; in ten of the plaques, white letters sit upon a black ground, while in the photographs, dark skin contrasts with a starkly white shift. Delicately lit, the photographs adopt the tone of a serious aesthetic study; but when straddling the words at center—*ring, surround, lasso, noose*, and so on—they suggest a self that has been closed in and split apart unwillingly, violently. The largest, eleventh plaque underscores the potential for violence, breaking the symmetry of the composition and containing the phrase "feel the ground sliding from under you" on a blood-red ground. Simpson's artwork forces twenty-first-century viewers of the stereocard in figure 1 to consider the possibility that they are looking at another split subject: a black self surrounded

3. Charles K. Harris (composer) and Leo Wood (lyrics), *A Study in Black and White* (New York: Charles K. Harris Music Publishing Co., 1917). African American Sheet Music Collection, John Hay Library, Brown University.

4. Adrian Piper, *Political Self-Portrait #2 (Race)*, 1978. Collaged photostat, 24 × 40 in. (61 × 101.6 cm). Private collection. © APRA Foundation Berlin.

5. [OPPOSITE] Lorna Simpson, *Untitled (2 Necklines)*, 1989. Two gelatin silver prints and eleven plastic plaques, 101.6 × 254 cm overall. Gift of the Collectors Committee 2005.44.1.1, 2005.44.1.2, 2005.44.1.3. National Gallery of Art, Washington, D.C. © 1989 Lorna Simpson. Courtesy of the artist and Hauser & Wirth.

by whiteness who sits and stares in wonder at her predicament, and a black self who cries out in protest, demanding to be seen not as a contrasting type designed to bring whiteness into view but as a feeling, thinking subject who exists on her own terms. *Untitled (2 Necklines)* also asks us to recognize the coercion and loss of agency that come with inserting black bodies into comic stereocards and other forms of photographic humor. Seeing these bodies through the binocular viewer was to reduce them to mere things, to render them immobile and two-dimensional for the amusement of whites. Significantly, Simpson sets up a binocular arrangement with the two circular photographs but ensures that white viewers cannot resolve them into a single image and thereby trap the black female body within their gaze.

Incorporating contemporary artists, particularly those who foreground their own identities in their critical approaches to racial humor, has helped me speak to my own position in a study that features whites' irreverent fantasies of blackness. When presenting selections from this book in scholarly venues, I have repeatedly been asked how it feels, as a white woman, to write about material that politically liberal viewers today would dismiss as racist. My responses over the past decade could never fully capture the

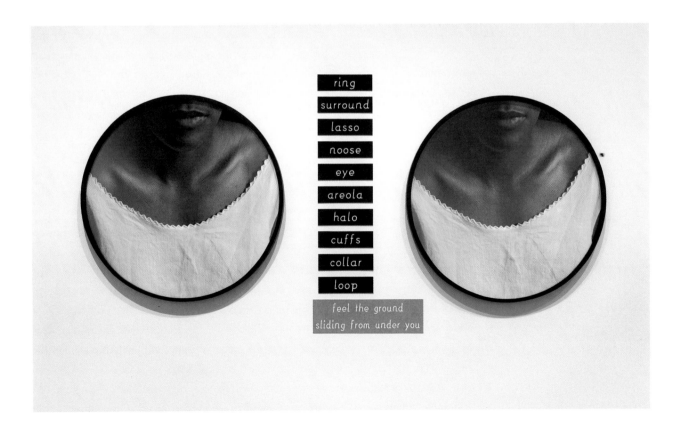

mix of feelings I have experienced living with racist humor (literally in my home), and purchasing it at times from sellers who make it clear that they laugh *with* objects like the stereocard *A Study in Black and White*. Nor have I been able to express effectively the discomfort and shame I have experienced when speaking publicly about images that degrade blackness and yet were designed for someone who looks, superficially, like me. How can I resist the narrative of whiteness that such images convey to my audiences? How do I both acknowledge and resist their desire to see me as colluding with racism by resuscitating images that so many Americans imagine as or wish to be long dead? As contemporary art makes plain, ideas about race that once proliferated in early photographic humor are hardly a thing of the past; when they are not resurging in popular visual culture, they can persist in a collective, racial unconscious. And so I hope that the presence in this book of art since the late twentieth century will remind readers—as such art has continually reminded me—of the political value of asking critical questions about racist humor and its audiences.

OVERVIEW OF THE BOOK

Chapter 1 considers an early variety of humor that highlighted the racial implications of photography's scientific principles. The idea that color is not inherent in a body but is the measure of a body's reflection of light, for example, forms the logical basis of all photographic operations. However, when humorists applied that idea to the United States in the Civil War and Reconstruction periods, it resulted in what they saw as a laughable absurdity—namely, that whiteness and blackness carry the same value in the absence of light. Humorists similarly observed that no bourgeois subject would welcome the sight of his blackened self, produced either through the negative-positive process or through contact with photographic chemicals. My analysis centers on the first book of humor about photography and its prolific references to race in America, and specifically to Harriet Beecher Stowe's international best seller, *Uncle Tom's Cabin*. That this book of photographic humor was written by an English cleric and published in London in 1855 speaks to the transnational character not only of the comic genre but also of the conceptions of blackness and whiteness at its origins. Chapter 1 concludes with a discussion of African American artist Fred Wilson's *X* (2005), which I read as incorporating humor about photography's scientific basis into a contemporary political critique.

Study in Black and White goes on to examine an assumption that once fueled countless racial jokes: that black sitters could never become the proper subjects of photography, just as they could never be integrated fully into conceptions of a white national body. Chapter 2 locates this assumption in theatrically staged encounters between black bodies and the photographic apparatus. Beginning in the mid-nineteenth century, white comic actors

were fond of depicting African Americans and indigenous peoples as buffoons who could not comprehend, and even feared, the technical workings of the camera. These demeaning caricatures gave form to widespread confusion and anxieties about photography once the public learned of its invention; well into the twentieth century, they also fueled stereotypes of primitive "others" as lacking the tools to navigate modern civilization. In its analysis of such humor, this chapter focuses on a wildly popular blackface minstrel show that caricatured a black photographer, his assistant, and their unsuspecting sitter. How did the cultural meanings of the performance evolve as it traveled from U.S. cities to provincial theaters in Britain and popular venues in Australasia between the 1860s and 1910s? My exploration of this question leads me to consider twenty-first-century efforts to work against the show's humor about black bodies and the camera, specifically in writings on early African American photography and the video art of Indigenous Australian artist, curator, and filmmaker Genevieve Grieves.

Chapter 3 further investigates the assumed unnaturalness of blacks to and within photographic culture by proposing a new social history of the photographic smile. While scholars have equated the emergence of the smile with the popularization of Kodak cameras in the late 1880s, enterprising studio photographers in the United States decades earlier staged and recorded the broadly grinning mouths of newly emancipated slaves and of African American children eating watermelon. These images have much to tell us about the affective and social character of blackness in the American cultural imagination. They also set the stage for whites to appropriate the caricatured black smile in commercial photographs.

Chapter 4 considers the intersection of commercially produced images of African Americans and amateur racial humor by analyzing the relationship between words and images in early twentieth-century photographic postcards. Printed and distributed across the United States, these cards offered their predominantly white senders an opportunity to supplement the printed images with their own handwriting and to mobilize stereotypes of black life in a variety of self-motivated ways. While many postcard inscriptions describe African Americans as exotic "others," it was just as common for senders to draw ironically close connections between themselves and the pictured bodies. This chapter attempts to reconcile these efforts to generate both distance and likeness between the races. It also introduces readers to current attempts to rethink the role of African American images on photographic postcards, using the example of the *Harlem Postcards* exhibition series at the Studio Museum in Harlem.

The final chapter acknowledges the regularity with which comic black images supported constructions of white identity in early snapshots, reading these amateur photographic performances as a modern form of minstrelsy. It also focuses on African Americans' efforts to revive and subvert such images in their own vernacular

photographs. In snapshot albums of family, travel, and school pictures, we find traditional racial humor redeployed—not, significantly, to degrade blackness but to assert the agency of the black subject in the context of the New Negro movement. Chapter 5 thus points to the personal and political work of photographic humor for black snapshooters, proposing connections between early twentieth-century album practices and the photographic performances that emerged from Kara Walker's *A Subtlety*, a large-scale artwork installed at the Domino Sugar Refinery in Brooklyn, New York, in 2014.

It was photography's potential to function as much more than a technology of representation—to operate as an instrument of and metaphor for race relations—that made it the object of so much humor, and for so long. Rethinking racial humor through the lens of photography shows us how powerful the juxtaposition of black and white has been in structuring ideas about the modern self and other. Rethinking photography through humor, on the other hand, reveals how much the latter's racial politics has shaped what we now consider essential elements of photographic practice—from the negative-positive process to the convention of the photographic smile. To study photography's racial jokes, then, is to explore the cultural fantasies that came to define the medium.

Chapter 1

Strange Effects and *Photographic Pleasures*

RACE, SCIENCE, AND EARLY PHOTOGRAPHY

Shortly after the public announcement of its invention in 1839, the first practitioners of photography noticed that there was something funny about the medium when it was applied to the human body. Reflecting on what he later named the photographic "negative," Sir John Herschel described the "figures" it represented as having a "strange effect," whereby "fair women are transformed into negresses &c."[1] These private observations, inscribed in Herschel's notebook, would soon develop into a public discourse. In one of the many comparable stories printed in 1839, London's *Foreign Quarterly Review* outlined the difficulties an Englishman faced when trying to reproduce an etching by Rembrandt of an old man reading. When the etching was placed in direct contact with a photosensitive surface and exposed to light, the disappointing result was "a reversed fac-simile," or what the journal described as "a negro face surmounted by locks of silver."[2] Photographic literature on both sides of the Atlantic subsequently described the influence of darkroom chemicals on human skin in similarly racial terms. According to one report published in an American trade journal in 1866, a studio patron used the contents of a photographer's evaporating dish to clean molasses candy off her children's faces before they were to sit for a portrait. After repeated "dipping and washing," the horrified woman "left the place crying, with three little negroes, the artist not even giving her anything to take it off."[3]

How could a technology that was consumed ravenously by white bourgeois subjects depend so much on blackness? Why, moreover, did light-complexioned sitters seeking to look "white" in their portraits apparently require a change of race in the hands of the photographer? Such questions took shape in the immediate wake of emancipation in the British colonies and at the height of abolitionist activities in the United States, when the social implications of bringing *whites* into intimate relation to *blacks* were the subject of heated debate. A photographer's manipulations under the skylight and in the darkroom were seen as a constant struggle to keep these terms in balance, one analogous to conflicts in the British West Indies and the American South.

While early photographers like Herschel looked upon the possible connections between photography and the contemporary social scene with a mixture of trepidation and mild amusement, British and American humorists cultivated a different response: raucous laughter. Their satirical writings and illustrations cast photography's materials, technical requirements, and scientific principles in racial terms, inviting audiences to take pleasure in the medium's many and seemingly essential incongruities. Having witnessed the invention of photography, the proliferation of commercial portrait studios, and the emergence of amateur photographic practices, these humorists attempted to answer a question on the minds of nearly everyone who encountered the camera in the mid-nineteenth century: What made photographic technology so popular yet so estranging? Their comic responses posed additional questions in the context of debates about slavery and its abolition, demonstrating that early photographic humor shaped the cultural identity of photography and defined the medium's relationship to a predominantly white bourgeois public, while at the same time serving as complex social commentary.

CHEMICAL COMEDY

Scholars have credited the English cleric Edward Bradley, better known by his pen name Cuthbert Bede, with writing the first book of photographic humor. Bede's *Photographic Pleasures, Popularly Portrayed with Pen and Pencil* was printed in London in 1855, with its third, final, and cheapest edition appearing in 1863 (fig. 6).[4] Even before the volume's publication, British readers could have encountered a selection of its illustrations in the humor magazine *Punch*. Bede's visual humor also engaged audiences abroad, although it is unclear how many Americans ultimately read *Photographic Pleasures*; what would become the frontispiece to the book graced the back cover of Philadelphia's nationally circulated *Saturday Evening Post* in 1853, alerting readers to the ridiculous dangers that amateur photographers faced in capturing country scenes, specifically impalement by a charging bull.[5]

Contributing to this transatlantic dialogue, the book's racial jokes made reference to African American stereotypes and the institution of slavery. Such a gesture was by no means unique to *Photographic Pleasures*. As Hazel Waters has observed of English theater at midcentury, there was a "general climate that was so fascinated by America, so ready to ridicule it in all its manifestations, so ready, too, to triumph as a monarchy that practised liberty over a republic that practised slavery. The figure of the black was, and continued to be, a conduit for English attitudes towards America."[6] Art historian Marcus Wood has likewise shown how the depiction of African slaves in English print satire served as a vehicle for attacking both the continued existence of slavery and the sentimentalism of abolitionists in the United States, while more generally ridiculing the nation's "democratic pretensions."[7] Although these forms of popular visual culture were directed at "others"—portraying Americans as hypocritical, morally corrupt, and as "uncivilized" as the blacks they enslaved—they simultaneously looked inward, expressing "native" anxieties about race, class, and national identity. This collection of anxieties informed, for instance, the midcentury debates on slavery and sugar in the West Indies sparked by the inflammatory writings of Thomas Carlyle. Black "idleness" constituted an affront to the state, Carlyle argued, insofar as it contributed to the decline of an industry that was essential not only to the economic prosperity of English plantation owners but to the vitality of the rapidly expanding British Empire. If the (white) English could not find "some just manner to command black men," he reasoned, then "they may rest assured there will another come (brother Jonathan or still another) who can."[8]

By the time Carlyle expanded and reprinted his "Occasional Discourse" and Cuthbert Bede published his first satirical illustrations of photography, both writers had found a new object onto which to project "native" anxieties about the slave-owning United States: Harriet Beecher Stowe's *Uncle Tom's Cabin, or Life Among the Lowly* (1852). Within a year of its initial publication, a staggering one million copies of the American best seller had been sold to British readers, providing them with a

6. Cuthbert Bede, *Photographic Pleasures, Popularly Portrayed in Pen and Pencil* (London: T. McLean, 1855), title page.

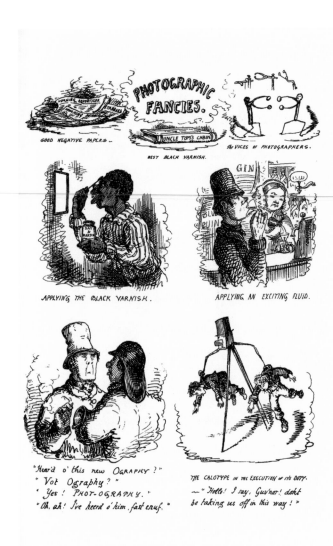

7. *Photographic Fancies*. In
Cuthbert Bede, *Photographic
Pleasures, Popularly Portrayed
in Pen and Pencil* (London: T.
McLean, 1855).

sentimental depiction of black life in antebellum America
that would go on to be represented in numerous editions
(official and pirated) and in plays, musical scores, prints,
commercial advertisements, and memorabilia that fea-
tured characters or scenes from the novel.[9] *Uncle Tom's
Cabin*, in all of these forms, not only set the terms for
debates about slavery and abolition in British political
discourse after 1852; it also became the ground upon
which a variety of questions about social difference were
packaged for both the edification and the amusement
of a popular audience. Marcus Wood's observation that
"strange conflations resulted when the newly expanding
Victorian leisure and entertainment industries engulfed
abolitionist texts" applies directly to *Photographic Plea-
sures*, in which Stowe and her book allow Bede's light
musings on photography to speak to one of the most
serious political issues on both sides of the Atlantic.[10]

 To see how Bede's satire engaged the contempo-
rary discourse on race, consider a page of illustrations
titled *Photographic Fancies*, which is littered with verbal
and visual puns (fig. 7). The "negative papers" in the
upper left corner refer to both the negative-positive
photographic process and London newspapers like the
Morning Advertiser, which were known for their harsh
attacks on the British royal family. The scene in the
upper right, captioned "The Vices of Photographers,"
depicts two posing stands engaged in a fist fight, sug-
gesting that studio portrait photographers' use of these

devices, which gripped a sitter's head like a vise and kept him still, was one of their
most immoral practices. The racial joke on the page consists of a conversation between
two illustrations: an image of *Uncle Tom's Cabin* at the top captioned "best black var-
nish," and a caricatured black figure on the left; described elsewhere in the book as
an "Uncle Tom servant," the latter is shown here "applying the black varnish." While
"varnish" can refer to a chemical compound that commercial photographers spread
on the surfaces of tintypes or on the backs of ambrotypes in the 1850s, the black pig-
ment the "Uncle Tom servant" applies to his skin comes from a bottle labeled "Day &
Martin," a British manufacturer of shoe polish whose name became a colloquial term
for "negro."[11] Relying on his readers' familiarity with such iconography and rhetoric,

Bede thus proposes similarities between four seemingly unlike objects: photographic chemicals, the pigmentation of an African slave's skin, a common shoe polish, and Stowe's popular novel about American slavery. The modern reader is left to ask: On what bases are these similarities constructed, and what cultural work do the resulting ironies perform? More broadly, how and why does a humorist like Bede use the medium of photography to articulate popular ideas about blackness and whiteness?

To begin with, it is important to see Bede's illustrations as conversant with early blackface minstrelsy, an American form of theatrical entertainment first popularized in the 1830s and '40s that featured white actors performing comic songs, speeches, and sketches in a kind of racial drag.[12] By midcentury, blackface acts had been incorporated into existing structures of reputable entertainment in Britain, from the music halls and theaters of London to provincial venues and even the private homes of the wealthy. This meant that they tended to be less raucous and bawdy than the American performances enjoyed primarily by working-class whites in northern cities, and that they increasingly incorporated "local" comic tropes like the English-style puns deployed by Bede. Historians have shown that what most distinguished minstrel shows in Britain from their antebellum American models, however, was that British shows brought audiences into close relation with a "black" population of which they had little direct knowledge but an insatiable curiosity and an (economic) interest. British viewers could sympathize with the plight of the oppressed slaves conjured up before them, relishing the moral superiority of Britain over the United States, all the while imagining that these "emotional and hyperactive blackface characters" needed to be brought under (their) white control.[13] This response to minstrelsy dovetailed with the idea that Britain's colonial presence in Africa and the West Indies, which relied on paternalistic regulation of nonwhite peoples, was not only justified but natural and required.[14]

In Bede's *Photographic Fancies* we find references to minstrelsy in the figure applying the black varnish and the image of *Uncle Tom's Cabin*. While the varnish suggests a theatrical blacking up, the novel borrowed characters and narrative elements from American minstrel shows and became a favorite object of blackface humor in Britain that contributed directly to the genre's surge in popularity there.[15] The racial joke on this page, moreover, shares several important assumptions with the early minstrel show. First, both are based on an objectification of blackness; more specifically, they treat it as a commodity that a white male actor/operator can manipulate for his commercial profit. Substituting burnt cork and shoe polish for the materials of photography, Bede compares racial blackness to photographic varnish and likens the face of the "Uncle Tom servant" to the varnished surface of the photograph, producing a scenario often enacted on the Victorian stage: black bodies are not autonomous subjects, he jests, but physical materials instrumental to the work at hand.

Second, Bede's *Photographic Fancies* shares minstrelsy's assumption that black pigmentation is a sign of the "negro" race, though the stability of that sign is uncertain at best. In the case of the "Uncle Tom servant," the dark color of his skin would seem to require continuous application, as if race were purely cosmetic in character. According to this fantasy, it is the stuff of photography that enables the figure to perform and maintain his blackness, which was crucial to maintaining the value and integrity of whiteness. Bede thus endows photographic chemistry with an invaluable social function: the very (re)production of racial difference. But if blackness and whiteness are imagined as skin deep in this image, what are we to do with the stereotyped physiognomy of the figure "applying the black varnish"? In a period when race science in Britain and the United States was preoccupied by the notion that there are essential, measurable differences between the races, this figure would have signified "black" even in the absence of photographic varnishes.[16] We can make a similar observation about the graphic illustrations of Anglo-American blackface performers at midcentury, which often depict these racially white men not only with darkened faces but also with the facial structure that Samuel Morton and others associated with the "negro." Rather than undermining the logic of minstrel performances, these indications of the so-called fixed character of race were precisely what blackface contributed to *and* satirized. In this vein, Bede's photographic humor acknowledged contemporary thought on the nature of social difference at the same time that it poked fun at its logic.

Time and again, Bede combines such work with a representation of photography's unique powers in matters of race. Anticipating the rhetoric of Victorian soap advertisements, for example, he reminds readers of an ancient fable in which a man attempts to scrub his "Uncle Tom servant" white and clean, assuming that his blackness is the result of neglect on the part of a former master. The reference here would have been all too familiar to British readers, for whom the notion of washing an "Ethiop" or "blackamoor" white had served as a symbol of impossibility and miraculous rebirth, as well as a literary figuration of blackness, since the Renaissance period.[17] While the misguided "sanitarian" in *Photographic Pleasures* was unsuccessful in his efforts, the joke explains that the photographer is not. His "black Positive," or the exposed photographic print, is infinitely more receptive to the whitening effects of repeated washing and soaking than its human counterpart, whom Bede calls the "positive black." Not only is photography responsible for manufacturing an ideal "black" who is obedient and capable of sanitary (read: social) reform, in other words, but its chemistry also has the ability to carry out such reform. Where other social measures had failed, photography succeeded; the medium managed to tame blackness by reducing it to "the desired tint," thereby mitigating its transgressive potential.[18]

As satire, of course, *Photographic Pleasures* cannot celebrate photographic chemistry as a solution to America's race problems or as an ideal means of safeguarding whiteness without ambivalence and irony. In fact, we can read the book's humor as the direct result of Bede's attributing unrivaled social power to photographic chemistry, assuming that readers would see such power as an unlikely characteristic of a popular visual medium. The illustrations in *Photographic Pleasures* encourage viewers to remain skeptical of photography's ability to effect any real, let alone valuable, social change. Consider the book's chapter on amateur photography, in which we find a female photographer who had an unfortunate accident with her darkroom chemicals. The young lady's carelessness with her nitrate of silver, which darkens surfaces in the presence of light, reportedly produced black spots and stains on her otherwise "fair" countenance and "lily white hands," causing her to appear, as Bede puts it, "like a half-washed Othello at some private theatricals." This necessitates a trip to the chemist for immediate remedy, which is where we find her in figure 8.[19]

While Bede claimed in a private letter that this illustration depicts a true incident, it also employs a popular literary trope that represents the blackening of racially white subjects as punishment for their immoral behavior.[20] When Bede published *Photographic Pleasures*, this trope would have been readily associated with Heinrich Hoffman's collection of illustrated stories for children, translated for British and American audiences as *The English Struwwelpeter*. Among the collection's most frequently reprinted stories were those that featured "white" bodies darkened with "black" ink. In "The Story of the Inky Boys," a figure modeled on Saint Nicholas dips three light-skinned lads into an inkwell to teach them not to make fun of a dark-complexioned "blackamoor," while the naughty "Miss Mopsa" accidentally administers her own racialized punishment in "The Girl Who Inked Herself and Her Books." Motivated by carelessness and a general desire to misbehave, she smears the ink at her writing table over her hands, face, and clothes, and even swallows the black liquid, causing her entire body to turn brown, then slate, then "dusky black" (fig. 9). "Blacker than a

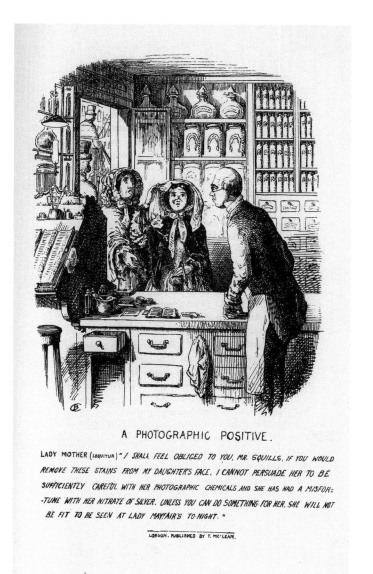

A PHOTOGRAPHIC POSITIVE.

LADY MOTHER (LOQUITUR) "*I SHALL FEEL OBLIGED TO YOU, MR. SQUILLS, IF YOU WOULD REMOVE THESE STAINS FROM MY DAUGHTER'S FACE. I CANNOT PERSUADE HER TO BE SUFFICIENTLY CAREFUL WITH HER PHOTOGRAPHIC CHEMICALS AND SHE HAS HAD A MISFOR: TUNE WITH HER NITRATE OF SILVER. UNLESS YOU CAN DO SOMETHING FOR HER, SHE WILL NOT BE FIT TO BE SEEN AT LADY MAYFAIR'S TO-NIGHT.*"

LONDON. PUBLISHED BY T. MC'LEAN.

8. *A Photographic Positive*. In Cuthbert Bede, *Photographic Pleasures, Popularly Portrayed in Pen and Pencil* (London: T. McLean, 1855).

Guinea negro, / Blacker than the sootiest sweep, / Blacker than the shiny beetles / O'er the chimney's back that creep," Mopsa ultimately becomes "too hideous for a daughter" and is sold by her parents as a "black doll" to a "rag-shop" where she is hung up on an "iron link."[21] Invoking both the so-called ugliness of blackness and the violence of chattel slavery, these are disastrous consequences indeed, intended to encourage right/ white behavior in impressionable readers.

Similar scenarios were entertained by the American photographic press around the time of the U.S. Civil War, as we have already seen in the case of a white mother mistaking photographic chemicals for body wash. That she left the portrait studio with "three little negroes" would have made the commercial photographers who wrote and consumed such stories laugh by confirming the naïveté of their clientele. Bound up with their laughter, however, were serious anxieties about the destabilizing effects that photographic chemistry could have on social identities if it fell into the "wrong" hands. Since women and children were called upon to function as reliable signifiers of whiteness and respectability in and out of the portrait studio, their exposure to photography's many blackening agents posed a troubling threat to such signification, which could be extinguished only if their curiosity about and involvement in photography's operations were carefully controlled by white men, literally or comically.

There was in this humor also the anxious fantasy of blackness posing a sexual threat to young women, as implied by the image of a white mother producing "negro" children. Miscegenation is made a more explicit threat in a British poem from the 1860s titled "Perils of the Fine Arts," which opens with an angry husband interrogating his wife:

> *Good gracious Julia! wretched girl,*
> *What horror do I see?*
> *What frantic fiend has done the deed*
> *That rends your charms from me?*
>
>
>
> *What fiend, I ask, in human mask*
> *Has dared to black your face?*

Describing her as darker than "any black-a-more," he goes on to threaten violence against the "wretch" (consistently gendered masculine) that "painted" the once "stainless pure" woman, whose "black and blue" body has already been violently punished by an "other"—justifiably so, the verse suggests. It is in the last lines of the poem that the wife reveals the source of her defilement as none other than her husband: "'Oh! Charles, 'twas *you*! / 'Nay, dearest, do not shrink— / 'This face and chin!—I've washed it in / 'YOUR PHOTOGRAPHIC INK!'"[22]

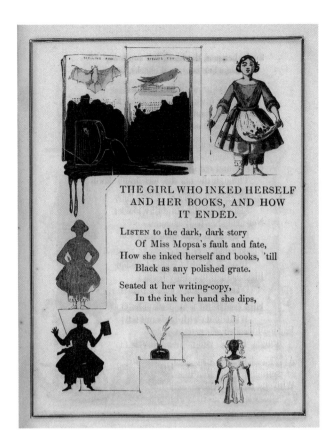

THE GIRL WHO INKED HERSELF
AND HER BOOKS, AND HOW
IT ENDED.

LISTEN to the dark, dark story
Of Miss Mopsa's fault and fate,
How she inked herself and books, 'till
Black as any polished grate.

Seated at her writing-copy,
In the ink her hand she dips,

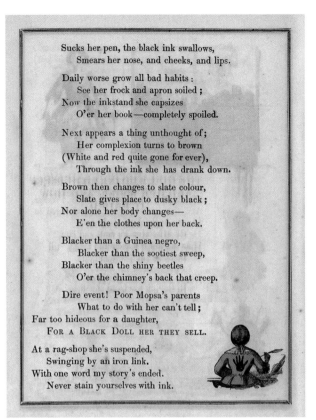

Sucks her pen, the black ink swallows,
Smears her nose, and cheeks, and lips.

Daily worse grow all bad habits:
See her frock and apron soiled;
Now the inkstand she capsizes
O'er her book—completely spoiled.

Next appears a thing unthought of;
Her complexion turns to brown
(White and red quite gone for ever),
Through the ink she has drank down.

Brown then changes to slate colour,
Slate gives place to dusky black;
Nor alone her body changes—
E'en the clothes upon her back.

Blacker than a Guinea negro,
Blacker than the sootiest sweep,
Blacker than the shiny beetles
O'er the chimney's back that creep.

Dire event! Poor Mopsa's parents
What to do with her can't tell;
Far too hideous for a daughter,
FOR A BLACK DOLL HER THEY SELL.

At a rag-shop she's suspended,
Swinging by an iron link.
With one word my story's ended.
Never stain yourselves with ink.

Returning to *Photographic Pleasures*, we find that Bede similarly characterizes the wealthy white women in Britain who picked up cameras in the 1850s as socially and sexually transgressive. In the very first line of the book, he presents these women as objects of disdain by comparing them to white female abolitionists in the United States; these are the days, Bede writes, "when calotyping young ladies in civilised society talk about their 'blacks'—with all the unctuousness of a Mrs Beecher Stow [*sic*], when she converses on a subject of a kindred saturnine character."[23] Framing the discussions of amateur photography that appear later in the text, this remark establishes the growing number of lady amateurs in Britain as a threat to the professional photographic fraternity, to dominant notions of female respectability, and to the integrity of the white bourgeois family.[24] Bede relies on Stowe as a model for such gendered transgression, bringing to mind her much-publicized trip to England in 1853 and its production of a controversial antislavery petition, which led many international critics to condemn the outspoken American as selfish, irresponsible, and even dangerous, having released powers beyond her control.[25] Like the throngs of women who rallied

9. *The Girl Who Inked Herself and Her Books, and How It Ended.* In Heinrich Hoffman, *The English Struwwelpeter, or Pretty Stories and Funny Pictures from the German* (London: Dean and Son, ca. 1860).

around Stowe, Bede suggests, female photographers speak fervently of processes that they don't understand and that take their minds away from their domestic duties, all the while introducing into polite social gatherings topics that were best discussed elsewhere by male authorities. What is more, he imagined that these white bourgeois women shared a sexualized attraction to "blacks" that was as unavoidable as it was troubling.

That attraction is articulated most colorfully in Bede's *A Photographic Positive*, when he describes the blackened young lady as "a half-washed Othello at some private theatricals." Extremely popular on both sides of the Atlantic at this time, Shakespeare's vision of the fair Desdemona falling in love with a dark-complexioned Moor who murders her in their marriage bed posed obvious challenges to Victorian prohibitions of miscegenation and the warnings of race scientists against the dangers of amalgamation. Serious performances of *Othello* on the London stage worked to mitigate these challenges by minimizing the pair's sexual encounters and deemphasizing the blackness of Othello; the many minstrel parodies of the Shakespearean drama did just the opposite, grossly caricaturing Desdemona's sexuality and portraying Othello as either a buffoon in blackface or as a white-washed "negro" in order to render their union a laughable absurdity.[26] With his "half-washed Othello," Bede echoes this latter genre, but he does more than simply reproduce its complex comic relations, or "white men imitat[ing] black men who aspired to be white but were actually black."[27] By inserting these men into the body of an aristocratic (white) lady, the kind of woman who would partake in "private theatricals," Bede brought contemporary criticism of Stowe forcibly to bear on the practice of amateur photography among the upper classes.[28]

What is remarkable about *Photographic Pleasures*, then, is not Bede's stereotyping of the African American slave and the female "amateur," or his references to transatlantic debates surrounding *Uncle Tom's Cabin*; rather, it is the book's insistent insertion of photography into the political and cultural frame occupied by the American best seller. Ironically, this engagement with the serious matters of slavery and abolition, class conflict, imperial power, and the rights of women gave birth to photographic humor.

MAKING LIGHT OF BLACK AND WHITE

In his influential 1859 essay on the stereoscope, Oliver Wendell Holmes devotes considerable attention to the characteristics of the negative, or the "reversed picture on glass" then essential to producing photographs on paper. After a glass plate is sensitized, exposed to light in the portrait studio, and washed in developer, he explains, a set of dizzying relations result:

Every light spot in the camera-picture [the image before the lens] becomes dark. . . . But where the shadows or dark parts of the camera-picture fall, the sensitive coating is less darkened, or not at all, if the shadows are very deep, and so these shadows of the camera-picture become the lights of the glass-picture, as the lights become the shadows. Again, the picture is reversed. . . . Thus the glass plate has the right part of the object on the left side of its picture, and the left part on its right side; its light is darkness, and its darkness is light. Everything is just as wrong as it can be, except that the relations of each wrong to the other wrongs are like the relations of the corresponding rights to each other in the original natural image. This is a *negative* picture.[29]

For Holmes, the negative's reversal of things as they appear in nature is not only curious and "strange," as Herschel once put it; this "mass of contradictions," this "lie," is "perverse and totally depraved"—ungodly even, as if possessing "some magic and diabolical power." Even more extraordinary is that the negative gives birth to a positive print, which the American writer celebrates as a perfect "copy of Nature in all her sweet gradations and harmonies and contrasts." This allows Holmes to conclude that the negative is morally redeemable; like the "temporary arrangements of our planetary life," its ugliness and darkness hold out for him the promise of a "better" world thereafter.[30]

What made the negative-positive process an apt metaphor for the Christian dualisms of evil/good, pagan/holy, and earth/heaven was also what made it common grist for the racial humor mill. The reversals Holmes attributes to the negative—of left and right, up and down, dark and light—constituted the building blocks of a comical world turned upside down, which yielded some surprising things about race in Britain and the United States. Anticipated by Herschel at the moment of photography's invention, the details of such a world were explored in an 1853 issue of Charles Dickens's *Household Words*, which observed of a portrait on paper that "the light parts were all depicted by the blackest shades, and the black parts were left white," such that the subject of the picture "was there represented as a negro." As Holmes would do, the magazine found comfort in the "obvious" fact that the "negro stage" was not the "finished portrait" but rather the glass negative, whose placement on light-sensitive paper and exposure to light would soon set things right: "The black face will obstruct the passage of the light and leave a white face underneath, the white hair will allow the light to pass, making black hair below, and so on."[31] Underwriting these remarks were several important assumptions, so fundamental to midcentury Anglo-American culture as not to require justification: that there was a close connection between lighting conditions and racial identity, that photographic surfaces were intimately related (even analogous) to human

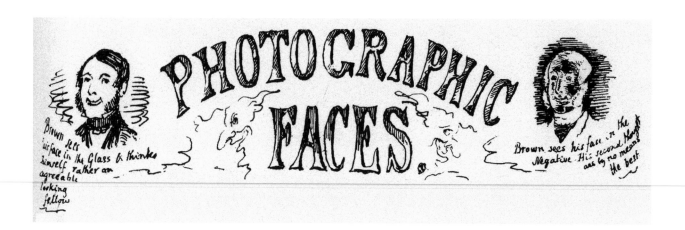

10. Detail of *Photographic Faces*. In Cuthbert Bede, *Photographic Pleasures, Popularly Portrayed in Pen and Pencil* (London: T. McLean, 1855).

skin, and that no bourgeois reader of *Household Words* would welcome the sight of his "negative" or "black" self.

For a contemporary illustration of this last assumption, we need not look further than Bede's *Photographic Pleasures*. A page of cartoons titled *Photographic Faces* presents us with a comic "before" and "after" in which a gentleman named Brown "sees himself in the glass and thinks himself rather an agreeable looking fellow," or one with a light complexion. Brown then "sees his face in the negative," now blackened thoroughly by the strokes of Bede's pen. "His second thoughts," we are told, "are by no means the best" (fig. 10). To find this pair of images entertaining was to acknowledge the absurdity of photography's material effects on the white sitter's body as well as to ascribe considerable value to whiteness as a physical and social ideal. Readers were unlikely to miss its reference to minstrelsy, moreover, just as they would have been attuned to the double entendre of the "negro stage" described in *Household Words*.

Historian Julia Munro has proposed that the racialized description of the photographic negative, such as we find in Bede's and Dickens's texts, is "an exaggeration that reveals an underlying anxiety about photographic representation" and should be treated like the references to magic that pervade early transatlantic writings on photography.[32] While this reading finds support in the examples above, it does not account fully for what nineteenth-century writers found especially absurd about the negative-positive process—that is, its radical reordering of a binary (black/white) whose terms were imagined (or at least deeply desired) to be in a fixed and hierarchical relationship. Significantly, this was what British critics saw as most troubling about abolitionist fiction like *Uncle Tom's Cabin*, whose narrative was built upon shifting and at times incongruous relations between blackness (darkness) and whiteness (light). Stowe allowed the "darkest" African Americans in the novel to embody the "light" of Christian virtue, they

observed with alarm. She also described the "mulatto" slave George in stereotypically "white" terms; well-mannered and highly skilled, he presents himself as "tall, with a dark Spanish complexion, fine expressive black eyes, and close curling hair, . . . aquiline nose, straight thin lips, and . . . finely formed limbs." Such "facts" led a reviewer for the London *Times* to condemn the book on moral grounds, declaring that an "error . . . is committed by our authoress in the pains she takes to paint her negroes, mulattoes, and quadroons in the very whitest white, while she is equally careful to disfigure her whites with the very blackest black. The worst negroes are ultimately taken to Heaven, but few of the fair colored are warranted, living or dying, without blemish."[33] These racial reversals also served as fodder for comic interpretations of *Uncle Tom's Cabin* on the English stage, which were full of puns that challenged audience expectations about what was "black" and what was "white," substituting gales of laughter for moral outrage.[34]

Jokes about the blackness of the negative further dovetailed with period debates about the origins of racial differences. Between the publication of Samuel Stanhope Smith's influential essay on human variety in 1787 and its reprinting in 1810, environmental explanations for skin color dominated Anglo-American scientific thought. According to Smith, mankind had originated in Asia fully civilized and with white skin. Dispersion of the population to different climates across the globe led to unfavorable deviations from this "natural, best, and original" state, with excessively hot regions darkening the skin and generally giving rise to savagery. Focusing much of his observation on the "Negro" race, he further predicted that the mass transplantation of blacks from Africa to the American environment would "whiten" their racial character over time.[35] Smith's views continued to shape discussions of racial change in the early nineteenth century but were increasingly challenged, especially by the rising tide of polygenism, which threw out the very notion that man originated as a single species. Before Darwin, even monogenists were thinking in new ways about the differences among the races, proposing that these may have been caused by breeding or civilization itself, and tracing human origins back to the "Negro."

This latter controversial view received a large international audience when it was promoted by the English physician and anthropologist James Cowles Prichard in the early nineteenth century.[36] Its influence can also be found in John Stuart Mill's vehement response to Carlyle's "Occasional Discourse," which described the "earliest known civilization" as a "negro civilization." According to Mill, the "original Egyptians are inferred, from the evidence of their sculptures, to have been a negro race; it was from negroes, therefore, that the Greeks learnt their first lessons in civilization."[37] While this is not the same as saying (as Prichard did) that blacks biologically gave rise to whites, the equation of civilization and whiteness in bourgeois Victorian culture meant that Mill's "curious" facts pointed to the same radical implications:

Anglo-Saxons had not been born naturally superior to "Negroes" and had no innate rights to dominate them.

Associating the negative with racial blackness proposed a similarly disruptive social view by suggesting that every "white" face in a photographic portrait originated as a "black" one. Whiteness, in other words, depended on blackness for its very existence, for without the negative there could be no paper print. This notion would not have proved so troubling in early writings on photography if those texts had not placed such a strong emphasis on the technology's role in aiding performances of social identity, specifically that of the white lady or gentleman. The reflections on the negative-positive process in *Household Words*, in fact, celebrate such work by concluding that "it is not only—or indeed chiefly—by the reproduction of our own features that we bring photography into the service of our race." It is the repeated "our" in this line and its implication of the magazine's predominantly white bourgeois readers that place strict limits on the word "race," which is being asked here to represent mankind.[38] Ensuring that the blackness of the negative would not interrupt this privileging of whiteness therefore meant stressing the temporariness of the "negro stage," its visibility only to the photographer, as well as the "natural" and "original" character of the body/image before the lens.

The problem of the negative in early photographic discourse speaks to larger concerns about the relationship between light and race that became the frequent subject of comic representation in the second half of the nineteenth century. Take the idea that color is not inherent in a body but is the measure of a body's reflection of the sun's rays. This principle of physics formed the logical basis of all photographers' operations, but when humorists applied it to postbellum America, it resulted in what they saw as a laughable absurdity. Such is the case in Elbert Anderson's *Photo-Comic Allmynack* of 1873, which juxtaposes monthly weather predications with horoscopes, dialect jokes, and caricatures; to these the practicing photographer added satirical commentary on photography in the form of illustrations, poems, and dialogues.[39] The entry for July features a racial joke, made in a fictional lecture that Anderson delivered to the American photographic profession at its 1873 convention:

> Have you ever thought to yourselves, my friends, that when you blow out your candle to go to bed, that you are about as black as the ace of spades? Because, if you hav'n't, it's time you did. Yes, my friends, it is believed that *nothing* of itself has any color; and that a yellow cat and a green man are certainly of the same complexion in a totally dark cellar. You are not to suppose that because it is *dark*, you cannot see the colors of these animiles [*sic*]! . . . As the saying is, they are perfectly *black*, which means destitute of color.

At this point in Anderson's speech the audience interjects. One voice explains, "According to that, then, a nigger is just as good as a white man"; a second voice tells the first, "Close your head."[40] The implication of Anderson's claims in this exchange—that whiteness and blackness carry essentially the same value—is so disruptive to conceptions of white dominance in the wake of black emancipation in the United States that it can only belong to the world of humor. For Anderson's fictional audience and his readers, "color" was much more than a "property of light," just as reflection and absorption were much more than physical principles; in Reconstruction America, it was a sign of racial identity whose boundaries were anxiously being drawn and redrawn, as much by Republican legislation as by popular humor.

In a period when cultural anxieties about integrating blacks into a predominantly white social body reached new heights, the challenges of photographically "exposing" raced subjects frequently found comic expression. These jokes were based on serious discussions in American trade journals about the difficulties portrait photographers faced when illuminating different sitters in their studios. The specific arrangement of top and side lights that a photographer would employ on a given subject, this literature surmised, depended upon the relative whiteness of the sitter, for a face with a "rather fair complexion" and "regular features" would imprint itself rapidly on a photographic plate and was most likely to generate a "pleasing" print. Dark-complexioned sitters, on the other hand, "required" lighting at a much greater intensity in order for their skin to be "properly" exposed, which often meant looking as "white" as possible.[41] In this way, photographers' lighting schemes were predicated on a taxonomy of social difference whose disruption was likely to have extreme consequences not only for the technical quality of a finished portrait but also for photography's capacity to serve "our race."

Like the many other American photographers who embraced the comic mode, H. J. Rodgers chose to express and assuage the anxieties generated by the possibility of such "failure" by satirizing the expectations of sitters when it came to photographic lighting. In his popular memoir, *Twenty-Three Years Under a Sky-Light* (1872), Rodgers recounts a case in which one of his colleagues was asked to sit a "gentleman of dark brown complexion and black hair" with "two ladies of blonde complexion and hair." When the photographer presented the picture to the group, the dark-skinned sitter declared the portrait

"horrid! altogether too dark and the ladies are too light; I shan't take that"; and at the same time with an air of dignity taking a faint, indistinct vignette card picture of himself from his pocket, "There! that's white. I want mine in the group white as that." . . . The artist politely in forms [*sic*] him that all things are *not* possible with a photographer; that by sitting him *alone*, with a

view of producing a "white picture," he would be required to sit longer. The clear white and rosy complexion of the ladies did not require *one half* as much time in the light, as his dark hued features, black hair and coat absorbing the rays of light.[42]

Rodgers anticipates that his readers will find such a scenario amusing, just as he assumes that the object of their laughter is plain: the ridiculousness of the "dark" sitter's desire to look "white" when he is obviously "otherwise." He could also count on readers' sympathy with the "impossibility" of the group portrait he describes. The only solution it presents, after all, is a photographic segregation of the sitters based on their "natural" inequalities. Like the burlesque performances of *Othello* that graced the Victorian stage, Rodgers's "light" humor proposes a justification for, and a means of, severing the intimate relations between "dark" men and "white" women. That photography seemed to preclude such mixing—even if only in the realm of representation—would continue to make the medium a powerful tool for addressing fears about miscegenation and African American citizenship after the close of Reconstruction.

A POSITIVE INVERSION

British readers who laughed at Bede's *Photographic Pleasures* and Americans who were entertained by Rodgers's *Twenty-Three Years Under a Sky-Light* occupied very different historical moments, but they shared anxieties about the relations between blacks and whites in the face of evolving racial and national politics on both sides of the Atlantic. These anxieties dovetailed with a growing faith in photography's ability to stabilize these relations in ways that privileged white bourgeois culture—that is, to clearly distinguish *black* from *white*. That a vision of the photographic medium as instrumental to the dominant order could emerge from humorists' efforts to poke fun at its relationship to social identity was the most intriguing incongruity of their work and arguably its greatest legacy. Indeed, the humor outlined above, which racialized the positive-negative process and the actions of photographic chemicals, endured well into the twentieth century.

How are we to understand the persistent preoccupation with photography's blacks and whites as a source of laughter long after photography was eclipsed by newer, stranger technologies and in a time when whites considered slavery a thing of the past? And what are we to conclude about the photographic medium and the racial mutability it has been said to enable? Is it possible to harness the medium's potential to change races and force it to serve a political agenda other than the one embraced by Bede and Rodgers? Could photography's interplay of blacks and whites, in other words, serve

the logic of progressive social action and foster black agency? The following chapters explore these questions by examining efforts by black image makers to turn the tradition of photographic humor on its head and disrupt the medium's historical privileging of whiteness. For now, I will introduce the work of contemporary artist Fred Wilson as an example of how we might think in radically different ways about photography's racialized incongruities.

Best known for his installation at the Maryland Historical Society (MHS) in 1992, titled *Mining the Museum*, Wilson's career has been built on remaking the history of transatlantic slavery with gestures of wit and irony. The principal gesture in *Mining the Museum* was sardonic juxtaposition: unearthed from storage at the MHS, finely crafted silver vessels were exhibited with iron slave shackles, the whipping post of the Baltimore city jail with Victorian chairs, and a baby carriage with a Ku Klux Klan hood. While incongruous at first glance, *Mining the Museum* argued for the significance of these pairings and what they can tell us about the history of racial violence. Their organization under seemingly innocuous display categories (metalwork, cabinetry, and modes of transport, respectively) injected an additional element of humor into the exhibition, forcing viewers to see the profound hypocrisies and absurdities that run through American history.[43]

A little more than a decade after this groundbreaking project, Wilson embraced the strategies of photographic humor to create a digital collage titled *X*.[44] Here again, the work depends on a juxtaposition of found historical objects: Marion S. Trikosko's photograph of Malcolm X (1925–1965), taken as he waited for a press conference with fellow civil rights activist Martin Luther King Jr. in 1964, and expatriate American artist John Singer Sargent's controversial 1884 painting of the Parisian socialite Virginie Amélie Avegno Gautreau (1859–1915).[45] Has there ever been a more unlikely pair? What could a black man born in Nebraska, the son of a Baptist minister who went on to became a leading figure in the Nation of Islam, have to do with the daughter of a wealthy white Creole family from New Orleans, a woman who grew up in Paris and married a French banker twice her age in an effort to secure a place in the city's most elite circles? Aptly, the two figures face away from each other, as if resolute in their apparent opposition.

If we look closely, however, we see that Wilson manipulated the collage so that Madame Gautreau's hand appears to rest on Malcolm X's shoulder, suggesting a possible connection between them. Clearly, the choice of these subjects was no accident. Both Malcolm X and Madame Gautreau were public figures whose adult lives took them far away from their American origins. Both figures tragically lost their fathers when they were young children: one died in the U.S. Civil War, fighting for the Confederate army, while the other was found dead close to the family's home in Michigan,

probably murdered by a white supremacist organization. Both subjects could also claim a familial connection to chattel slavery; the Avegnos owned a large plantation in Louisiana run on slave labor, and Malcolm X descended from generations of enslaved people. Of course, there is the matter of their strangely similar public names. Malcolm Little changed his name after being released from prison in 1952, explaining in his autobiography that black Muslims can replace their slave names with the letter "X" in order to memorialize their lost African names. Sargent's subject experienced two name changes, neither of her own deliberate choosing: first, when she became Madame Gautreau through marriage to banker Pierre Gautreau, and subsequently when Sargent renamed her "Madame X" upon selling her portrait to the Metropolitan Museum of Art in 1916, one year after her death. For both figures depicted in Wilson's composition, then, the incorporation of an "X" into their identities signifies their rise to celebrity *and* their cloaking in anonymity; the more they became objects of the public gaze, the more their "true" identities as vulnerable, feeling individuals had to be concealed.

By motivating viewers to dig deeply into his juxtaposition and seek out its foundations in biography and history, Fred Wilson deconstructs the simple binaries that underwrite the racial jokes of early photographic humor. *X* challenges not only the idea that any body can be reduced to a set of predictable characteristics defined by its race, and nothing more, but also the assumption that black and white subjects relate to one another only in strict opposition as a result of their stark differences. The artwork asks viewers to consider possible points of connection between raced subjects that are unseen by the naked eye—not to arrive at a utopic vision of interracial solidarity, but to witness how much the lives of Anglo-Americans and African Americans have been linked by personal, social, political, and economic circumstances throughout modern history. Certainly, if the viewer can create associations between Malcolm X and Madame X, the artwork suggests, then the lives of other raced subjects might be placed in productive conversation.

These associations are made all the more strange and poignant by the fact that Wilson photographically inverts the pigment of the figures' bodies, rendering them as "negative" visions of their "positive" selves. The light falling on Malcolm X's right arm, forehead, nose, and mouth in the black-and-white press photograph is rendered in *X* as dark shadows; his hair, previously pictured as dark gray, becomes light gray mixed with near white. His suit and glasses undergo inversions of a similar variety. Madame X, on the other hand, stands in Wilson's rendition in a nearly all-white gown that matches the new shade of her hair. The artist's photographic manipulation has further transformed what was once a strikingly white, blue-tinged complexion in Sargent's painting into unambiguously black flesh tones. This transformation of Madame X is so radical that it

strikes the viewer as plainly comical; a woman who once took life-threatening measures to ensure that she would be known as a great beauty in elite Parisian circles, including the ingestion of arsenic to whiten her skin,[46] is made to resemble a caricatured black body, such as one might find on the nineteenth-century minstrel stage. In fact, Wilson makes visible what we know to be true of Madame Gautreau: that she was a painted lady whose extreme, artificially created whiteness might be seen as an entertaining racial impersonation.

In the hands of Cuthbert Bede or the American humorists discussed in this chapter, the photographically enabled inversions of the kind we see in X would have spoken to historically specific fears that racial identities were unstable, if only to ease them. Their humor proposed radical inversions of blacks and whites, but there was nothing radical about the politics that fueled those changes. Every joke was designed to assure viewers that white was right. In the art of recent decades, however, the facilitation of what Susan Gubar calls a "racechange" can accomplish something quite different. As a transgressive gesture, it can "test the boundaries between racially defined identities" in creative and complex ways, "functioning paradoxically to reinforce and to challenge the Manichean meanings Western societies give to color." The "racial metamorphosis" staged by Wilson "functions self-reflexively to comment on representation in general, racial representation in particular," and thus "illuminates the power issues at stake in the representation of race."[47] The chapters that follow show how contemporary artists have worked to expose and overturn the political gestures of early photographic humor, fostering faith in photography's potential as a positive instrument in matters of race.

Chapter 2

The Darkey Photographer

CAMERA COMEDY AND THE MINSTREL STAGE

On December 6, 1859, the Dublin-born playwright Dion Boucicault debuted *The Octoroon, or Life in Louisiana* at New York's Winter Garden Theatre. Within two years *The Octoroon* became an international sensation, traveling to London and several Australian cities. Not since *Uncle Tom's Cabin* had a theatrical representation of slavery and race relations in the antebellum American South so captivated audiences. Combining elements of Anglo-American melodrama and blackface minstrelsy, *The Octoroon* seemed to have it all: a slave-owning family on the brink of financial ruin, a villain with designs on their possessions, a slave boy viciously murdered, a "savage" Indian framed for the crime, a collection of caricatured plantation "negroes," and a beautiful multiracial girl whose relationship with the family's expatriate son results in her suicide.[1] There was, moreover, much in this tragic love story that most audiences had never before witnessed onstage, and this included the actions of a photographic apparatus. The camera in question belonged to Salem Scudder, a Yankee character and former portrait photographer who oversaw the family's estate after the death of its patriarch, Judge Peyton. As if by miracle, one of Scudder's photographic plates was exposed just as the villainous McClosky bludgeoned the slave boy, Paul, preventing the boy from delivering a letter that would have relieved the Peytons of their crippling debt. It is

through the "self-development" of this plate and its fortuitous discovery that the evil doings of the Irishman are largely undone.[2]

It was not Salem Scudder's operation of the photographic apparatus that resolved the Peyton family's crisis, however; that work belonged to Paul and his devoted Indian companion, Wahnotee, the principal characters in *The Octoroon*'s few comic scenes. We first learn of the young slave's fascination with photography in the second act, when he observes Scudder taking a portrait of the heiress, Dora Sunnyside. "I feel it all inside," Paul remarks during the exposure of the plate, "as if it was [*sic*] at a lottery." Alone onstage with Wahnotee, the boy seizes the opportunity to learn more about "dat telescope" and peers through the camera as if to "take a likeness of dis child." But the infantilized Indian "springs back with an expression of alarm," mistaking the instrument for a gun and requiring Paul to try his hand at self-portraiture instead. The difficulty, as Paul experiences it, is in figuring out how to "operate and take my own likeness, too—how debbel I do that? Can't be ober dar an' here too—I ain't twins." So he convinces Wahnotee to open the shutter for him before the Indian runs away from the dreaded apparatus, leaving the boy vulnerable to McClosky's attack. When Wahnotee returns to the stage to find his beloved friend dead and his fears of photography confirmed, he seizes his weapon and "smashes [the] camera to pieces." The destroyed device reappears onstage in the fourth act, this time attracting the attention of "Ole Uncle" Pete, an aged slave on the Peyton plantation. Looking closely at the camera, Pete begs the white folks to do the same, as he finds "a pictur' . . . in that yar telescope machine." This, Scudder declares, is the image of the dead boy Paul and his murderer.[3]

Reviewing *The Octoroon* in 1861, the editor of London's *Photographic Journal* expressed little surprise that photography had found a "fair place within the drama" or that it was "made subservient to laughter-moving farces," given the fondness of playwrights for "any new invention" if it can "assist them in working out the plot." He also appreciated Boucicault's depiction of photography as a "silent and certain witness of a foul murder," since it celebrated the medium's veracity and moral character when both were the subject of much public debate.[4] The professionalizing photographic community nevertheless found cause to attack the play's portrayal of its practices. "Our notions of photography hitherto have been that it has been necessary . . . that an operator who knows a little should prepare a plate, and pose the person, and develop it," the *Photographic Journal* explained, "and that, except when he wants a 'ghost picture,' he is satisfied with one thing on the plate at once." To think that "people" will "accept the *Scudderotype* process as genuine photography," the review concluded, was to imagine them as "ignorant of photography and its processes."[5] Regarding the performance from a technical perspective, the journal's editor made a point that modern readers

can appreciate: In 1860 it was impossible for a moving figure, such as the murderous McClosky, to be captured instantaneously on a photographic plate, and for that plate to develop itself, à la Polaroid.

These critiques of the treatment of photography in *The Octoroon* addressed a burning social question at the time: Who was fit to possess and act upon knowledge of photographic operations? The *Photographic Journal* accepted an ignorance of photography in the characters of Paul and Wahnotee while objecting to Boucicault's presumption of such ignorance among the people who might pay to see a staging of *The Octoroon*. Audiences could be entertained by the play's attribution of ignorance about photography to a black man or an Indian, in other words, but commercial photographers were reluctant to laugh about the medium in the hands of the white bourgeois patrons they hoped to attract to their studios in London, New York, and other cosmopolitan locales. Boucicault's melodrama and its critical reception paved the way for others to invest in the idea that unfamiliarity with photography's technical workings produced and maintained social difference. The 1860s thus saw the popularization of comic performances that invited audiences to laugh at the placement of cameras in the hands of "others."

Of course, *any* technology might have posed questions about the social fitness of its operators. American and British humorists in the late nineteenth and early twentieth centuries were fond of pairing newly freed and colonized peoples with novel forms of transportation and a host of mechanical devices marketed to middle-class whites, like bicycles and the phonograph, amusing them with visions of nonwhite bodies as poorly prepared for modern civilization. In his study of ethnic humor in the United States, historian John Lowe observes that references to a subject's ignorance about technology implicated that subject in a process of Americanization.[6] And yet something more than a centuries-long struggle for nonwhites to represent themselves as fully fledged Americans was expressed by pairing their bodies with *photography*.

This chapter takes a close look at that "something more" by exploring the development of a comic genre, common to popular visual culture and the theatrical stage, whose protagonist responded with curiosity, anxiety, and naïveté to the photographic apparatus. This caricatured dialect, exaggerated gestures, and application of burnt cork, and the name that often identified it—*the darkey photographer*—together framed its fascination with and fears of photography in specifically racial terms.[7] Unlike the jokes and images discussed in the previous chapter, where photographic humor was built upon the perceived incongruity of black and white, those addressed here worked largely to degrade black bodies and, in effect, reinscribe the superiority of whiteness. They rendered it impossible for whites to conceive of blacks acting as modern subjects or to imagine the possibility of black agency.

As a transnational performance and comic trope, the darkey photographer accommodated multiple discourses about technology and race across the many decades of its popularity. My study of its place in visual humor similarly works across texts and contexts—from the figure's earliest appearance on the American and British stage and in images during the U.S. Civil War to its proliferation in minstrel productions and other forms of racial humor in Australia and New Zealand. This approach emerges from interpretations of *The Octoroon* as a circum-Atlantic performance in a period of nation and empire building, specifically one characterized by an "astonishing multiplicity of cultural encounters." As scholars have shown, it was through the unequivocal whiteness of the Peytons, the blackness of the "negroes" on their estate, the devotion of a "red" man to the murdered "black" man, and the precarious placement of the "tragic octoroon" (Zoe) between them that Boucicault constructed a "dramatization of Anglo-American contact with the creolized interculture of the Latin Caribbean."[8] The depiction of McClosky as Irish and savage, moreover, allowed him to be read (in period terms) as white, black, and red, but never unequivocally one or the other.[9] The darkey photographer likewise drew together multiple cultural codes, borrowing from the history of black caricature and infusing it with other constructions of racial difference, within and outside the United States.

This chapter thus adopts the critical framework of transnational performance studies to read the darkey photographer and its significations across place, and yet my focus remains on the space between the emancipation of black Americans in 1863 and the emergence of the United States as an imperial power at the turn of the twentieth century. Within that context, I am concerned with what a particular variety of racial humor can teach us about the politics of the everyday work of black photographers, from the early days of studio portraiture to the amateur boom. Scholars in African American studies have consistently celebrated this work for its creation of alternative images of blackness, including positive pictures of black bodies as *subjects* and as skillful *operators* of a vital modern technology. The following discussion complicates their vision of cameras in black hands as unequivocal signs of political agency by analyzing comic performances that pictured "black" bodies as photographers, only with obviously different aims. My analysis points to what black subjects have had to work against, and how hard, in order to fashion the vernacular camera as a political instrument and a means of resisting misrepresentation.

SETTING THE STAGE

While it is difficult to say when the first reference to photography appeared in American minstrelsy, comic interpretations of blacks' relationship to the medium had made

their way into blackface performances by the time armed conflict broke out between the Northern and Southern states. They appeared, for instance, in theatrical productions organized by men enlisted in the Union army during the Civil War—largely amateur productions that aimed to insert some "fun" into the serious work of rebuilding the nation. Among these was a farce titled *The Nigger in the Daguerreotype Saloon*, known to have concluded a minstrel show performed aboard the bark HMS *Brazileira*, in which three white actors (the enlisted men themselves) blacked up to caricature a photographer, a "mischievous boy," and a "stupid fellow." Union soldiers held captive by the Confederate army at Libby Prison in Richmond, Virginia, staged a similar three-person farce titled *Countryman in a Photograph Gallery*. Constructing a stage out of kitchen tables and repurposing army blankets as curtains, the inmates organized full-length and fully outfitted minstrel shows weekly. According to one surviving program, *Countryman in a Photograph Gallery* took place in the third part of a show performed by the Libby Prison Minstrels on December 24, 1863, which also included songs, dances, performances on banjo and violin, a short comic sketch, a masquerade ball, and a "grand walk-around" (fig. 11).

Saying more about the work that these farces enabled during the war, in the absence of extant scripts, involves relying on the recollections of men who witnessed them. Recording his observations in the ship's log, one man on board the *Brazileira* recalled seeing *The Nigger in the Daguerreotype Saloon* on New Year's Day in 1863. He remembered the audience as consisting of white officers and "sixty or so" sailors; they were seated before a "Colored Gallery," which he reduced in his mind to "a row of white teeth and eyes."[10] A correlation between the black contrabands on the U.S. Navy vessel and the blacked-up white actors who operated it was articulated in the evening's opening act, a burlesque operetta titled *Bombastes Furioso*, which featured characters "fumbling

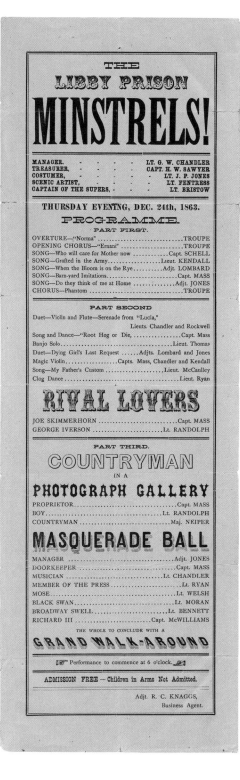

through military drills armed only with broomsticks and stereotypical black stupidity."[11] These degrading images of African American recruits enabled the officers and sailors on board the ship to envision their difference from and assert their authority over the crew members they labeled "darkies." Articulated in many forms of visual humor during and immediately after the Civil War, such imagined difference caused the white men to "laug[h] heartily from beginning to end."[12]

The published memoirs of Libby Prison inmates offer comparable reflections on *Countryman in a Photograph Gallery*, noting that it stimulated "unbounded enthusiasm" in the Union soldiers and eased their homesickness. Like *The Nigger in the Daguerreotype Saloon*, the farce communicated a message about white superiority by representing blacks as technically ignorant and socially inferior. This was a message that the inmates extended beyond the photographic apparatus when they reflected on the "colored men" in their presence—former servants of the Union officers whom the Confederates employed to help maintain the prison. In a description of those workers by one attendee of the Christmas Eve performance, we can detect echoes of the minstrel show itself: caricatured actions, ironic names, and illogical observations rendered in thick dialect.[13] The soldiers dubbed the "General" one of the "colored men" put in charge of fumigating the prison, pointing to the absurdity of his leadership; another reportedly woke the inmates by calling out the morning news, mangling place-names and displaying a general confusion about their geographical location.[14]

Ideas about African Americans' inability to comprehend the workings of the camera ran through other wartime minstrel farces, including *Carte de Visite*, *The Daguerrean Artist*, and the immensely popular *Scenes in the Studio*.[15] By 1865, *Scenes in the Studio* had been performed in the United States by high-profile comedians Billy Birch and David Wambold of the San Francisco Minstrels, which toured major cities on the East and West Coasts.[16] Set in a commercial photographic parlor and running no more than twenty minutes, it featured three characters in blackface: a portrait photographer struggling to keep his business afloat (Collodion), his assistant, described as a "boy up-at-all-fuss" (Adolphus), and a man from the countryside who becomes the pair's unwilling sitter (Felix Gumbo). Collectively, these men displayed fear, curiosity, ignorance, and ineptitude in relation to the machine that dominated their interactions on the stage, providing minstrel show audiences with lots to laugh at.

By 1867, the same brief script began to be repackaged under the title *The Darkey Photographer* (and subtle variations thereon) and was finding its way into numerous minstrel productions, both professional and amateur, across the United States.[17] It first appeared that year in *Spencer's Book of Comic Speeches and Humorous Recitations*, a widely available publication describing itself as "crammed full of Comic Poetry, Laughable Lectures, Irish and Dutch Stories, Yankee Yarns, Negro Burlesques, Short Dramatic

Scenes, Humorous Dialogues, and all kinds of Funny Speeches" that were "Suitable for School Exhibitions and Evening Entertainments."[18] Newspapers reported that Americans throughout the country deemed *The Darkey Photographer* appropriate for such venues because the setting was unelaborate, the props required were few and easily constructed, and only three actors were needed. Time and again, the farce drew crowds and laughs. So it began making regular appearances in schools, churches, and community centers, typically concluding a full evening's entertainment intended to raise funds for a worthy cause—from the convalescence of the sick to support for a local sports team.

The Darkey Photographer communicated to audiences much about photography, including questions about its artistic character as a practice and its respectability as a profession, questions that had plagued the photographic medium and its operators on both sides of the Atlantic since around 1839. Many elements of the set therefore worked to convey a sense of decorum—from the room itself, described as a "rather nice parlor" outfitted with a carpet and a table draped with a "fancy cloth," to the "pictures on the walls" and the "statues in the corners."[19] These would have suggested to American and British theatergoers in the 1860s that they were witnessing one of the finest photographic establishments of the day, like those illustrated in bourgeois periodicals.

Readers of *Gleason's Pictorial Drawing-Room Companion* may have recognized in the set of *The Darkey Photographer* elements of J. P. Ball's Great Daguerrian Gallery of the West, a Cincinnati establishment credited in 1854 with producing portraits "with an accuracy and softness of expression unsurpassed by any establishment in the Union" (fig. 12). *Gleason's* lavished its highest praise on its spacious "great gallery," which contained sculptures of classical goddesses, luxurious furnishings, and a piano from which "sweet notes" emerged. These complemented the display of "one hundred eighty-seven of Mr. Ball's finest pictures," including portraits of "distinguished personages" and "five or six splendid views of Niagara Falls." The photographs, we are told, hung alongside a selection of Robert Duncanson's landscape paintings that "rank . . . among the richest productions of American artists." Through these details, *Gleason's* presented to readers a "scene replete with elegance and beauty," which it illustrated with fifteen potential sitters, each with a lily-white complexion and wearing the finest fashions.

Conspicuously absent in this celebration of the Great Daguerrian Gallery of the West, however, was the racial identity of both its African American daguerre-otypist-proprietor (Ball) and the landscape painter who served as his collaborator (Duncanson). *Gleason's* tells us that Ball was "the very essence of politeness" and that he was "responsible for elevating the art of daguerreotypy from its very low state" in Cincinnati, when "few engaged in the profession, without means, enterprise or

BALL'S GREAT DAGUERRIAN GALLERY OF THE WEST.

12. William J. Pierce, *Ball's Great Daguerrian Gallery of the West.* Wood engraving published in *Gleason's Pictorial Drawing-Room Companion* 6, no. 13 (April 1, 1854): 208.

instruments, and customers were like angels' visits, few and far between."[20] By omitting mention of Ball's blackness, *Gleason's* chose to "whiten" the space of the gallery and thereby corroborate the fine-artistic and professional character of the photographs it produced. As art historian Margaret Rose Vendryes reminds us, it would have been important for an "ambitious artist and a free man of color in antebellum Cincinnati" to find ways to "transcend racial classification altogether."[21] Like Duncanson's adoption of a subject matter and style associated with the mainstream Hudson River school, Ball's portrayal of predominantly white sitters in a manner then conventional for studio portraiture was probably a deliberate attempt to acquire recognition for himself as an *American* artist. This was not an unusual gesture for a photographer with ambitions in the 1850s, when studio operators of all races fought public perceptions of them as unskilled mechanics.

By deliberately writing caricatured blackness *into* its image of a commercial photographic studio, *The Darkey Photographer* worked against everything that Ball hoped to achieve and everything that *Gleason's* celebrated as his achievements. The farce undermined hard-won associations between photography and bourgeois whiteness, mocked efforts to elevate the medium's status above that of a lowly trade, and posited the notion of a "black photographer" as absurd. Racial difference, wrought larger than life, marked itself not only on the characters and their antics but also on the instruments and materials onstage. These included an "*exaggerated* apparatus, consisting of tripod of man's height, with camera" made from a box, a tin tube, and a dark baize cloth; a "*large* pantomime watch" to time the exposures; and a "photograph" constructed out of "paper on which are *rudely* outlined two faces of the same size, the other a little transversely, *as large as may be*."[22] Caricature was written into the very design of these objects, providing a comic backdrop for the action that followed.

TRANSNATIONAL TRANSLATIONS

While U.S. audiences were amusing themselves with the antics of Collodion, Adolphus, and Gumbo, minstrel troupes across the Atlantic were also incorporating into their programs a comic scenario set in a photographic studio. *Scenes in the Studio* opened at London's Polygraphic Hall in 1865, where it was played by the Matthews brothers (William and Harry) and their partner, G. Beckett of Christy's Coloured Comedians.[23] Another troupe, which fancied itself the "Veritable and Original Christy's," took on tour the same year its performance of the burlesque *The Photographic Studio*, bringing it to audiences in India, Java, China, and Australasia.[24] The published scripts and basic format used for all of these shows were generally the same, but as they circulated across continents, performances continuously accommodated new political contexts and meanings. This malleability helps account for the global popularity of the darkey photographer trope.

The British troupe known as the Mohawk Minstrels, established in the 1870s, was well known for incorporating national and imperial rhetoric into its programs. The English press praised, for instance, a comic sketch it developed in 1888 as "a melange [*sic*] of topical and semi-political tendency in which sturdy John Bull is seen consoling his brother Pat and exchanging pleasantries with Taffy of Wales, and the 'Highland Laddie,' and finally surrounded by his colonial dependencies." Meanwhile, "old Father Christmas appears in the clouds evidently enjoying his plum pudding and bottled Bass to the tune of 'Rule Brittania' [*sic*] and 'God save the Queen.'"[25] At least one of these national anthems followed the Mohawk Minstrels' performances of *The Darkey Photographer* in the 1880s, as was customary in closing a British minstrel show, whether

it was staged in Islington or Tasmania. The melodious assertion of Britain's imperial might and rightful dominance across the globe had special resonance with minstrelsy's caricature of black people as primitive, foolish, uncouth, and deserving of enslavement or colonization. Incorporating the minstrel farce into contemporary politics and public life, both "God Save the Queen" and "Rule Britannia" promised the continuation of black subordination under colonial rule; while the former anthem appealed to the Christian God to "scatter [Britain's] enemies" and "frustrate their knavish tricks," the latter repeated the phrase "Britons never will be slaves."[26]

Comedies featuring the darkey photographer continued to delight large audiences in England and the British colonies and former colonies through the early twentieth century, as they were performed by schoolboys, military men, members of cricket clubs, churchgoers, and concerned citizens who saw minstrelsy as a lucrative source of charitable fundraising. These amateur minstrel shows performed important cultural work for the middle class, much as they had in the United States. Not only did they help members of the audience affirm their whiteness, but they also enabled them to assert their economic superiority, given that most amateur shows involved the purchase of instruction manuals, ticket sales, and raising money for those regarded as "in need." At the same time, historian Susan Smulyan has argued, minstrel show manuals designed for amateur performers "made local productions part of a commercialized and national arrangement that allowed for some local autonomy while connecting people to larger trends."[27]

Extending these observations to the global stage, we can see amateur theater as localizing frameworks that were produced nationally and disseminated internationally. And so in the 1890s a school group in Illinois could acquire a script for a darkey photographer farce from *De Vere's Negro Sketches, End-Men's Gags and Conundrums*, while a ladies' club in Norwich, England, could obtain the same text from *Heywood's Stump Speeches and Nigger Jokes, Etc.* But their resulting productions could—and almost necessarily would—look very different. Performers, for instance, could choose to read the scripts of the farces with or without caricatured black dialect. By 1900, American amateur performers were generally discouraged from using dialect, for, as one minstrel guide put it, "it spoils the stories and is often unintelligible to the audience"—or, simply, because it challenged the respectability of the performance.[28] To suit the needs of a particular event or to engage local audiences, moreover, characters in a published script were sometimes assigned alternative names, just as the scenery, costumes, makeup, and props outlined in minstrel instruction manuals could be varied. *Scenes at Gurney's* in the United States and *Tait's Photographic Studio* in New Zealand are good examples of such adjustment, as both retitled *Scenes in the Studio* to invoke the names of locally prominent photographic studios.[29]

The biggest adjustments that occurred in theatrical performances of the darkey photographer were less material than stylistic and conceptual, stemming from the particularities of minstrelsy in the British colonies. As Richard Waterhouse has shown in his history of blackface minstrelsy in Australia, the popular stage was once a space influenced by ideas about Africans and African Americans that originated in the United States and England.[30] What was imported from abroad in the 1850s and 1860s was repackaged carefully for colonial audiences, which tended to be more bourgeois and thus averse to overtly political or sexual humor. American minstrels who performed Down Under therefore softened their portrayals of southern African American slaves, accommodating antislavery sentiments among middle-class Australians. The touring companies that flocked to Australia and New Zealand, including notable African American minstrel troupes, began to include more unrefined elements of "negro humor" in the 1870s, but they continued to adapt their representations of blackness to suit the Australian racial landscape—or at least they set the stage for critics and audiences to do so. Minstrel troupes of local origin also adapted the racial iconography of blackface minstrelsy to "flexibly encompass indigenous groups" and the stereotypes that audiences associated with them.[31]

How these cultural translations occurred and the actual forms they took onstage are subjects that few scholars have explored deeply, in part because they exist outside published scripts and other forms of textual documentation. There has also been some reluctance to acknowledge the indebtedness of Australian ideas about race to Anglo-American discourses of whiteness and blackness, given the potential challenge it poses to certain notions of Australian national identity and history. We know, however, that the derogatory terms for African Americans that minstrel shows made popular—words like *nigger*, *coon*, *mammy*, and *pickaninny*—entered the Australian vernacular in the nineteenth century to describe Aboriginal people, as did many of the images with which such terms were associated in the United States. Similarly, in Australian melodramas, Aboriginal characters could take on caricatured African American dialect, perform songs about plantation slavery, and behave in a deferential and childlike manner associated with American stereotypes of blackness; with these characteristics Australian playwrights combined local ideas about indigeneity, some degrading and others ennobling.[32] At the same time, blackface characters in the Pacific had the capacity to invoke much more than African American or indigenous stereotypes. As Waterhouse explains, the "stage Negro" at the turn of the twentieth century could embody "all allegedly inferior ethnic groups" in the Australian cultural imagination, including Chinese, Japanese, and Indian immigrants. As these ethnic groups were being remade into black caricatures in the minstrel show, they became the subject of legislation that restricted the literal and symbolic entry of nonwhites into Australia and provided for the segregation of

"full-blooded natives" from the population of European settlers.[33] The caricatures were thus incorporated into the specific history and logic of race relations that were well understood by Australasian audiences and that differed markedly from contemporary performances in the United States and elsewhere.

The endlessly various, wildly popular, and broadly disseminated forms of the darkey photographer could thus accommodate the desires of seemingly any community concerned with locating racial others outside its peculiar conception of civilization. Through this figure's efforts to operate a camera and to photograph an impossibly difficult sitter, audiences across several continents and many decades sought to align themselves with, and effectively construct, particular notions of modernity and whiteness. Let us begin to examine those efforts in detail by considering the troubling notion that underwrote them: that black bodies, political agency, and technologies of representation were hopelessly incompatible.

ANTICS AND AGENCY

Enter Adolphus, the studio assistant. The show opens with this figure dusting tables, wondering out loud why he should bother to keep the place looking clean and respectable when they haven't seen a customer in a fortnight. Mr. Collodion, the aptly named photographer, admits to having a hard time "raising the wind" (procuring money) and to having sold everything except the contents of the studio. Collodion's financial problems, as he sees them, result not from his lack of technical ability or business savvy but from the precarious status of the photographic medium; "de public won't appreciate high art—on de sixth story!" he proclaims, parodying decades of complaints by portrait photographers who operated under top-floor skylights. This perception—that the public failed to recognize the specialized knowledge and skills required in studio operations—was expressed often in photography's trade literature and became a frequent object of ridicule in American and British theater.[34]

The opening exchange between Adolphus and Collodion does more than poke fun at the photographic community's pretensions and insecurities; it challenges, through humor, the compatibility of blackness and professionalism. Such humor was common in early minstrel shows, often taking the form of "stump speeches depicting blacks as incompetently trying to follow the white examples of famous speakers like Daniel Webster and scenes involving blacks failing to act as lawyers, doctors, and such."[35] Blacks were further pictured in minstrelsy as slovenly, ill-mannered, dishonest—in short, as lacking the markers of class and moral character regarded as essential to the professions. Ironically, Collodion displays these unbecoming traits precisely through his desperation to be seen as a legitimate, professional artist. Anxious to present a respectable

appearance and demeanor to his customers, he exits the stage to "exchange my suit for more artistic habiliments," returning with an "assumed French accent."[36] At the same time, he realizes that in order for "an artist like me" to get customers, he has but two options: either "descen' to dem and make dem dib us a chance" or "get up a raffle, all de prizes blanks! and gamble off de tings, from de baths to de cam-e-ra obscura (and likely to go away still more obscurely)."[37] Here, the character of the darkey photographer faces an impossible choice between varieties of racially stereotyped behavior; he must put on airs, accept his place among the lowly, or resort to trickster ways.

It seems that this figure can exert agency without compromise only in his relationship with Adolphus, which caricatures that of a master and slave. Collodion, whom Adolphus calls "massa," instructs the boy to bring a man from the street up to the studio—in exchange for dinner, a salary raise, and the opportunity to sleep on top of (instead of under) the table. As the darkey photographer's assistant, Adolphus is therefore deprived of basic human needs and the ability to improve his own social condition; as he puts it, "I can't raise any [salary] myself."[38] What he can do is cultivate his own master-slave relationship with the third character onstage: Mr. Felix Gumbo, a "man from the country" and the unlucky victim of Collodion's ploy to boost business. That Adolphus imagines Gumbo as his victim is signaled by the boy's adoption of the attitude of a "highwayman," an outlaw who preys on travelers, declaring that the sitter will have to offer up his "likeness" or his "life." Adolphus and Collodion force Gumbo to sit in front of the camera despite his obvious nervousness in its presence. When the anxious sitter tries to escape the machine's gaze, Adolphus pulls his chair away, causing Gumbo to fall to the floor, while Collodion "*collars* GUMBO, *and drives him back*."[39] Collodion then resorts to intimidating the uncooperative sitter, threatening to "light the magnesium," which would cause a fire in the studio, and recalling the prolific humor about blackness and light that we saw running through early photographic discourse (chapter 1).[40] International audiences in the late 1860s were well prepared to laugh not only at the virtual enslavement of a "man from the country" in a photographic studio but also at the idea that this man's body, and its presumably dark complexion, might pose a technical problem that "requires" a potentially life-threatening intervention.

What provided audiences with great amusement was thus a cycle of abuse whereby subjects gained a sense of their own power only by robbing it from others. Within the world of the farce, none of the characters is ultimately allowed any real or enduring agency. The script assures us, moreover, that this peculiar condition—the inability to act of one's own will or create freely one's own image—will always define blackness. That politically charged message was conveyed throughout the life of *The Darkey Photographer* but obviously carried different implications at different moments in its performance history. In the United States, for example, the cycle of abuse and

unrealized agency onstage in the 1860s and 1870s would have assured Americans that black emancipation and citizenship would *not* immediately reconstruct the nation or fundamentally change race relations. One thing that would have signaled this historical moment for audiences was Gumbo's conspicuous attachment to a carpetbag, a piece of luggage pejoratively associated with northerners who moved opportunistically to the southern states after the Civil War and joined freed African Americans in support of the Republican cause. Decades later, the sight of a black figure forced to offer up his body to the camera would have activated memories of chattel slavery; these, in turn, would have been mapped onto the nation's new efforts to assert itself as a white power through the construction of a global empire.

MEN AND MACHINES

While Gumbo spends much time wandering about the stage, remarking on the many objects he encounters in the studio, none captivate his attention as much as the camera does. "Hullo! what's dis machine, I wonder," he remarks; "looks like a new-fangled hash-cutter, on'y don't see no crank. . . . It's kinder scurious!"[41] Gumbo's failure to recognize this machine for what it is—a modern technology of *representation*—accounts for his confusion about the spaces and rhetoric of photography. The unsophisticated character initially mistakes the portrait studio for a hotel, remarks upon the glass roof with wonder, and imagines that the pictures Collodion produces are paintings. A photographic likeness becomes for Gumbo "like-en-ess" (i.e., resembling the letter "s"), while he mistakes a portrait for a "poor-Trayt" or "curicature," a full-length picture for a "fool-length," ovals for "orfal things," a pose for "paws," and so on. He further misunderstands the relationship between photography and the physical body before the camera's lens, recalling a similar error made by the slave boy Paul in Boucicault's *The Octoroon*. When posing for his picture, Gumbo "*imagines that all his sensations are caused by the camera,*" including the feeling of "pins and needles" that overtakes him when mischievous Adolphus secretly tickles him with a feather. He also feels "terrified" when the studio assistant inserts his face and then his feet in front of Gumbo's eyes while the sitter is staring intently at the camera. This causes the poor man to suspect foul play—even "Murder!"—on the part of the strange apparatus.[42]

The idea that scientific knowledge and technical skill constituted social and intellectual achievement, and thus distinguished "civilized" white subjects from "primitive" others, was hardly an invention of the American theater. It was, after all, an important argument for slavery in the British colonies in the eighteenth century. In his *History of Jamaica* (1774), Edward Long famously declared "Negroes" to be "incapable of adopting European technology or inventing their own" and generally lacking in "a genius either

inventive or imitative. . . . Among so great a number of millions of people, we have heard but of one or two insignificant tribes, who comprehend any thing of mechanic arts, or manufacture; and even these," Long added, "are said to perform their work in a very bungling and slovenly manner, perhaps not better than an orang-outang."[43] Although *History of Jamaica* was published well before the theory of the Great Chain of Being took hold in Britain, we can recognize in these lines an image of different races existing in hierarchical relation to one another, with the "negro" at the bottom of that scale and in comparison with the ape.[44] Americans readily adopted the notions promoted by Long, incorporating them into their own justifications for chattel slavery and into the concept of Yankee ingenuity. As historians Ronald Takaki and Bruce Sinclair have observed, the latter concept was "always framed in racial terms," such that a capacity for "creative technical thought" became synonymous with Americanness and whiteness.[45]

The caricatured American Indian character in *The Octoroon* demonstrates how these scholarly ideas about racial difference shaped popular representations of indigenous peoples and their "first" encounters with photography. Indeed, we have many accounts from explorers and photographers of the American West in which "natives" approach the camera as Wahnotee does, assuming that the instrument will cause physical and spiritual harm.[46] Across the Pacific, newspapers carried similar reports from white men who observed Australian Aboriginal peoples at mission stations and reserves, or who ventured into remote indigenous territories; these men noted their uncertainties about and fears of the camera, which made photographing a significant challenge.[47] From New Zealand emerged one of the most widely read cases for imagining indigenous peoples and photographic technology as incongruous: photographer Alfred Burton's diary of his travels in the King Country of New Zealand in 1885, which represents the Maori as either submissive or hostile before the *pakeha* (white man) and his camera. Burton describes his encounter with "a specially villainous-looking scoundrel and his *wahine* [wife]," who "at once covered their faces with their clothes" at first sight of the apparatus. Responding to their presumed transgression, the photographer "turned the laugh against them when the bystanders learned that he had 'taken' the group muffed just as they were, and would exhibit it through New Zealand as a specimen of Maori good manners."[48] Burton later followed through on his intentions, allowing his photographs to be reprinted on postcards, including the print titled *Unwilling Sitters* (fig. 13).[49] It was through this discourse—in which Europeans imagined the Maori as a savage, exotic, and soon-to-be-extinct race that viewed the camera as *taipo* (an evil spirit or devil)—that antipodean audiences would have interpreted Gumbo's technical incompetence and anxieties about photography.[50]

It remained common in the twentieth century for Europeans to emphasize the wonder that colonized peoples experienced when confronted with Western technology.

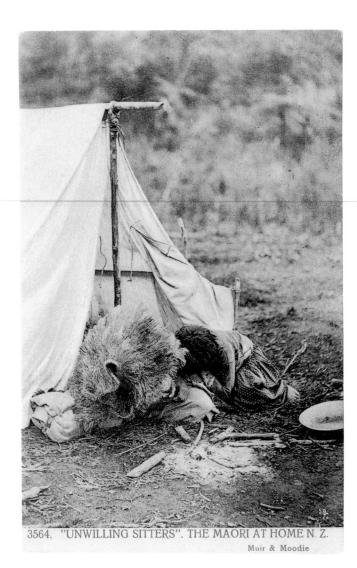

3564. "UNWILLING SITTERS". THE MAORI AT HOME N. Z.

Muir & Moodie

13. Muir and Moodie, *Unwilling Sitters, The Maori at Home, N.Z.*, ca. 1910. Postcard. Collection of William Main, New Zealand.

Not only were white travelers and missionaries astonished by Africans' apparent failure to adopt the tools introduced to them through colonization, but they also stressed the amazement Africans displayed around clocks, musical instruments, firearms, telescopes, and other "simple" mechanical devices, including photographic equipment.[51] Describing an expedition in British East Africa that he undertook in 1908, for example, the Welsh-born American writer and artist Arthur Radclyffe Dugmore recalled visiting a village in Meru after photographing big game. "Nearly everything we possessed was new to these unspoilt people," he observed, "and their childlike pleasure in seeing novelties was positively refreshing." Dugmore's reflex camera was one of their "favorite objects." "It was interesting to see how well they behaved [in its presence]. No matter how anxious they were to see anything, they never crowded or pushed; each one would take his turn. Then again we were greatly surprised at their intelligence in looking at pictures. Even a negative they would understand far better than most white people do, recognizing immediately each member of a group. When taking a print into their hands they would handle it with the greatest delicacy, never smearing their fingers over it as one might have expected." Illustrated with photographs by Dugmore (figs. 14 and 15), these lines portray African peoples as "untouched by the slightest suggestion of Europeanism," and yet the existence of the camera among them ostensibly civilizes their "primitive state."[52] Rather than mistake photography's inversion of lights and darks as a racial reversal, like so many subjects of early photographic humor, the people of Meru astutely perceived in the negatives individual portraits, which they treated as a "civilized" person should—with respect and care.

In promoting the Anglo-American photographer as a civilizing force in "wild" Africa, Dugmore's *Camera Adventures* falls significantly short of challenging stereotypes of blacks as disorderly and unintelligent; if anything, these views are reinforced by Dugmore's description of the Meru as decidedly "otherwise." What is more, the image of the tribe's encounter with the camera tells an old story about white men's efforts to photograph "under difficulties," or in the presence of black bodies. "The natives were

THE NATIVES OF MERU WERE MORE INTERESTED IN THE REFLEX CAMERA THAN IN ANYTHING ELSE WE POSSESSED

14. Arthur Radclyffe Dugmore, "The natives of Meru were more interested in the reflex camera than in anything else we possessed." In *Camera Adventures in the African Wilds; Being an Account of a Four Months' Expedition in British East Africa, for the Purpose of Securing Photographs of the Game from Life* (New York: Doubleday, Page, 1910).

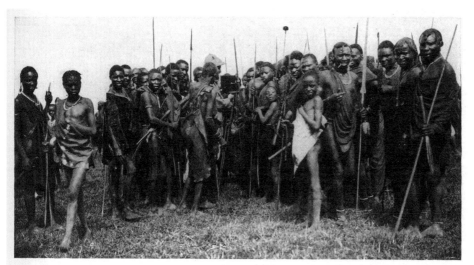

PHOTOGRAPHING UNDER DIFFICULTIES. THE NATIVES WERE SO ANXIOUS TO SEE THE CAMERA THAT THEY CROWDED ROUND AND OBSTRUCTED THE VIEW

15. Arthur Radclyffe Dugmore, "Photographing under difficulties. The natives were so anxious to see the camera that they crowded round and obstructed the view." In *Camera Adventures in the African Wilds; Being an Account of a Four Months' Expedition in British East Africa, for the Purpose of Securing Photographs of the Game from Life* (New York: Doubleday, Page, 1910).

NOT A FAVORABLE OCCASION.

MISSIONARY.— I have come, my benighted brother, to lead your people to a better life.

NATIVE.— Got no time now. King taking amateur photographs, queen trying on crinoline, and people all learning to ride bicycles. Better try the next village.

so anxious to see the camera," the caption for figure 15 explains, "that they crowded round and obstructed the view." That is indeed what we see in the illustrated photograph: a man in a pith hat (presumably Dugmore, but symbolic of European colonial authority) stands at center alongside his reflex camera, with dozens of semiclothed Africans surrounding him. Their eyes are trained not on his apparatus, however, but on one present outside the frame. As viewers of the photograph, we occupy the perspective of that invisible instrument, suggesting that the intended "view" to which the caption refers is that of the white man and his wondrous machine. We might also interpret the "view" that the black bodies "obstructed" as the colonial project itself; doing so would help account for the frequency and anxiety with which writers sought to document the action of native peoples crowding around a foreign camera between the 1880s and the early 1900s, a period of considerable expansion for the empires of Europe.

As the United States was establishing itself as an imperial power in the same period, American visual humor took up photography's relationship to the "civilizing" native. Perhaps no other publication was fonder of the subject than the illustrated comic magazine *Puck*, which printed with great regularity encounters between cameras and caricatured Africans and Pacific Islanders. Typical of this humor, one cartoon from 1893 features a white missionary announcing that he has come to Africa to "lead [its] people to a

better life" (fig. 16). To this a native replies, "Got no time now. King taking amateur photographs, queen trying on crinoline, and people all learning to ride bicycles." In the background, the most lavishly attired figure in the scene—presumably the "king"—peers through the lens of a camera to photograph a figure toppling from his bicycle.[53] Thus pictured in *Puck* were moments when the colonizer was losing control over the march of civilization and when indigenous peoples were making demands on *how* they were made over by encounters with the West. What the magazine and its readers took for granted was that colonized subjects *desired* such makeovers, that they wanted to adopt Euro-American gestures, habits, and clothing. By rejecting white men's offerings, in other words, the cartoon figures are not objecting to the "civilization" those "gifts" represent but expressing a desire for particular forms of Western culture over others. The very target of *Puck*'s humor, I would argue, was this expression of desire. It would have appeared just as laughable to readers as the idea of an African chief demanding that an explorer share with him the royalties from his next book, or Hawaiian natives attempting to control the local real estate market—both subjects of satire in *Puck* around 1900.[54] The inclusion of modern technology in the scene would have been an especially effective means of undermining indigenous agency, given that the machine, an embodiment of Western hegemony, was precisely what colonized subjects were believed to fear.[55]

Comic images of dark bodies as incompatible with modern technology raised important questions about cultural assimilation and imperial power. As historian Gretchen Murphy asks in her study of race and U.S. imperialism, "What if the inhabitants of new territories could never be made over in the image of the White Man?" What would it mean for whiteness and manhood in the United States, that is, if the emerging empire were to fail in its mission to "civilize" indigenous peoples?[56] And what if the same could be said of emancipated African Americans and their supposed lack of scientific and technical knowledge? Would the presumed racial inferiority and unmanliness of the "negro" enable or impede national progress at a moment when Americans invested heavily in the notion that machines were the tools of men and the instruments of a rapidly industrializing civilization? *The Darkey Photographer* staged possible responses to these questions, and greeted them with reassuring laughter.

CLOSE LOOKING

Uncertainties and fears about the strange machine before him do not curb Gumbo's desire to take a closer look. His first close encounter with the camera takes place while Collodion has his head under the focusing cloth, preparing to take the country man's portrait. Eager to know more about the operation, Gumbo "*leaves his chair, and goes straight to the camera's front, when he looks into the tube.*"[57] The only extant photographs of

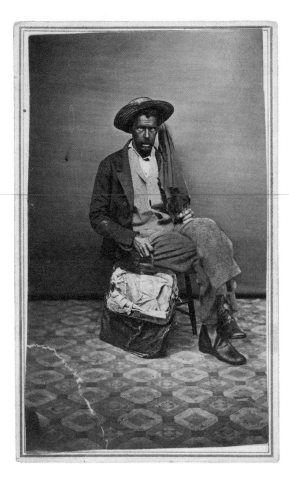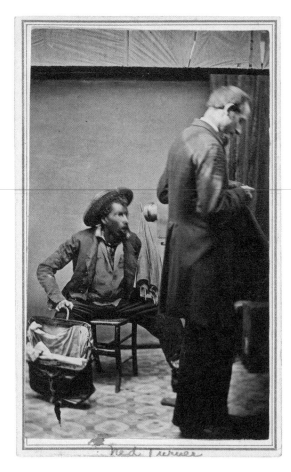

17. [LEFT] Actor Ned Turner in the role of Gumbo, ca. 1860s. Albumen print mounted on carte de visite. Houghton Library, Harvard Theatre Collection, Harvard University.

18. [RIGHT] Actor Ned Turner in the role of Gumbo looking into a camera, ca. 1860s. Albumen print mounted on carte de visite. Houghton Library, Harvard Theatre Collection, Harvard University.

an actor playing Gumbo that I have located include a re-creation of this very moment, suggesting its significance in performances of *The Darkey Photographer* and its variations. With a carpetbag in hand and an umbrella slung over his arm, the American actor Ned Turner stares with mouth agape into the lens of the apparatus, while another actor appears to prepare the plate, not yet aware of his sitter's move (figs. 17 and 18).[58]

The image of an actor in blackface peering into the tube of a camera was a common sight on the minstrel stage. In *Daguerreotypes, or The Picture Gallery*, for instance, an "extravagant and funny" Gumbo-like character named Mr. Thompson fails to comprehend the operator's instructions to sit still, approaches the camera, and ends up shaking the operator's hand, repeating an action also scripted in *The Darkey Photographer*. After continued efforts and a bit of taunting from the photographer's assistant, the nervous sitter in *Daguerreotypes* finds himself alone and with an opportunity to inspect the camera. Thompson "*jumps up inquisitively, and walks about the room whistling, etc. with*

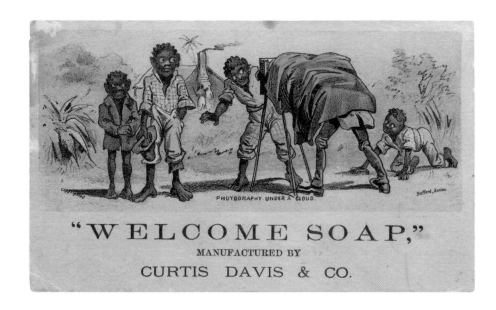

19. J. H. Bufford, *Photography Under a Cloud*, 1880s. Chromolithograph with advertisement printed on recto. Private collection.

his hands in his pockets; he finally goes over to the apparatus, and begins to meddle with it." Henry, the photographer's "Negro" assistant, then "*cautiously slips from behind the screen, and finds* THOMPSON *with his face in the end of the camera.*"[59]

International audiences were well prepared to witness these encounters with cameras on the minstrel stage, having been fed a healthy diet of mass-produced images that uncannily pictured black bodies in the same act of close looking. Someone who attended an American performance of *The Darkey Photographer* in the 1880s, for example, could have collected the trade card in figure 19, personalized by businesses that catered to the middle class, from a soap manufacturer in Boston to a dry goods and clothing dealer in Missouri. The photographer under his canopy takes on the appearance of a cloud, accounting in part for the image's title (*Photography Under a Cloud*) and the wide-eyed expressions of the caricatured black figures. One of those figures inspects the apparatus on all fours and another peers directly into the camera's lens, while two maintain nervous poses at a safe distance. For them, photography is "under a cloud," or under suspicion. Theatergoers in London or Otago would not have consumed this particular example of photographic humor, but they would probably have been familiar with sketches of Alfred Burton's attempts to "shoot a native" in the King Country while surrounded by "anxious" observers or "terrified" subjects who "take to their heels." Published in the *Illustrated London News* in 1887, these images were accompanied by a depiction of a Maori woman looking intently into Burton's camera (fig. 20). The figure operating the camera was meant to be the famed English-born New Zealand photographer himself, but the focusing cloth, which obscures his face

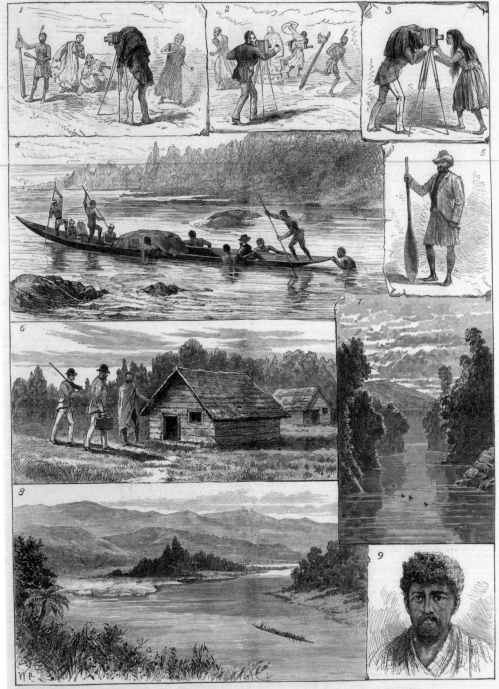

1. "Shooting" a Native: an anxious moment.
2. Terrified, they take to their heels.
3. Reciprocity.
4. Our Mode of Progression over rocks and shallows.
5. Taitua, our Helmsman, in full dress.
6. The Largest Whare in the Settlement.
7. Tangarakau, a hundred miles up the Wanganui River.
8. Mouton Island, the scene of battle between friendly and hostile natives.
9. Ngatai, Chief of the Ngatiawa Tribe, our host at Taumarunui.

PHOTOGRAPHS IN THE "KING COUNTRY" OF NEW ZEALAND.

and upper body in two of the images, allows him to take on a devil-like form and invokes the reported Maori view of the camera as *taipo*.

In both the trade card and the sketches of Burton's travels, black figures expect to discover something about photography by looking *into* the camera instead of *out of* its lens. Always presented as looking *in the wrong way*, this action points to their foolishness and more specifically to their fundamental misunderstanding of how images are created photographically. It further suggests that photography has fallen into disgrace because its subject has become the black body. We can assume from the position of the camera in figure 19, for instance, that the intended object of the photographer's gaze was not the ridiculous grin and bulging eyes of the caricatured black boy who peers into the lens, but rather the idyllic scene behind him, which features a black woman engaged in rural labor outside a rustic cabin, the palm tree suggestive of the coastal southern states. Photographs with similar scenes of the Old South were sold by the tens of thousands in the postbellum period to middle-class whites, who delighted in the fantasy that blacks were contented to function as instruments of a white economy before and (crucially) after emancipation. By asserting themselves as the subjects of the camera, then, the black figures in *Photography Under a Cloud* literally interrupt photographic fantasies of black labor and docility. At the same time, they call into question the degree to which photography could be trusted in matters of race. Would a technology that captured these grotesque faces, the card seems to ask, also be suitable for portraying the countenances of light-complexioned ladies and gentlemen? Humor reassures viewers that photography is unlikely to find itself under such a cloud; only in a world turned upside down can blacks' apparent fascination with the technology replace its so-called rightful practice and consumption by respectable white subjects. Funnily enough, that was precisely what the peering subject would have seen when looking into the lens: an image of himself *upside down*.

The sketches of Burton that appeared in the *Illustrated London News* lack the gross caricature of black bodies evident in *Photography Under a Cloud*, but they still poke fun at the idea that anyone other than a white gentleman could control the photographic situation. In the case of the sketch of a curious Maori woman, the image's comical tone is emphasized by its single-word title, *Reciprocity*, which relates the figures on either side of the machine through mutual action or exchange. Of course, the newspaper that published this sketch intended that readers would interpret the scene quite differently—namely, as an action that moved in one direction, stemming from the camera operator and interrupted by his subject—and therefore be compelled to laugh at the apparent incongruity. British readers could have been amused not only by the idea that the white photographer and the indigenous woman had something in common (a reciprocal relationship with the camera), but also by the fact that it seemed to produce

20. *The "King Country" of New Zealand. Illustrated London News,* September 3, 1887, 277.

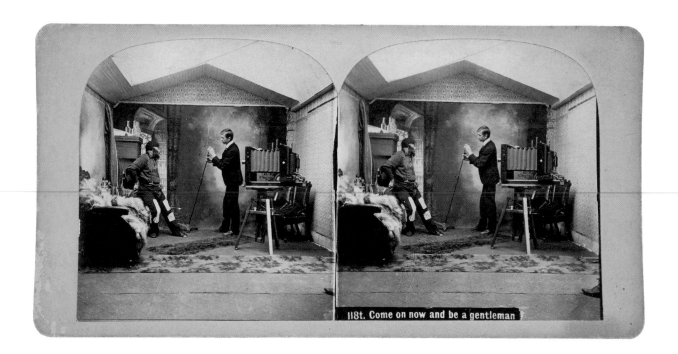

118t. Come on now and be a gentleman

21. Unidentified photographer, *Come on Now and Be a Gentleman*, ca. 1890. Gelatin silver prints mounted on stereocard. George Eastman Museum. Purchase, 1969.0021.0009.

a physical likeness between them (both stand with legs apart and hands on the tripod, the dark hair of the woman mirroring the dark mass of the focusing cloth).

These images of racial "others" looking into the camera bring to mind many comic depictions of too-inquisitive country folk and members of the lower class; these circulated in the United States and Britain when the photographic experience was still relatively new and often anxiety-producing for visitors to the portrait studio. Within this form of visual and literary humor, unsuspecting studio sitters, from rural Pennsylvania, to Lancashire, England, to "Croajingergolong," Australia, refused to sit still before the camera and suspected strange, even immoral intentions on the part of the operator and his instruments.[60] Represented in photographers' trade journals, popular magazines, and staged studio photographs, these fictional sitters spoke of the cold iron grip of the headrest, the muzzle of the camera, the torture of the sitting, and the humiliation of being rendered a fool through the photographic experience. Comic stereocards provided a similar source of laughter inside the American bourgeois parlor. Part of a series that begins with a studio operator inviting an uneasy sitter to sit down for a portrait, the card in figure 21 pictures a bearded man in shabby clothes lurching away from the photographer and his posing apparatus. We can assume that the man is frightened of the device, imagining it will do more than simply keep him still during the exposure, since another card in the series reveals that he has mistaken the camera

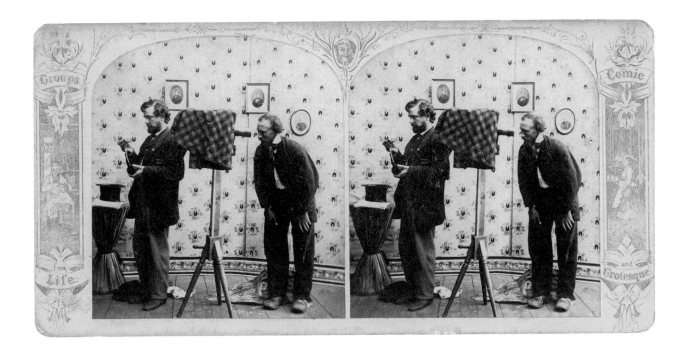

for a gun. Elsewhere in the three-dimensional world of the stereograph, we find naïve studio patrons expressing their confusion about photography, and thereby revealing their lowly class status, by looking directly *into* the camera.[61] Time and again, these overcurious, often shabbily dressed, unsophisticated sitters confront the mysterious machine head on, just as Thompson and Gumbo would do on the minstrel stage, hoping to discover its secrets (fig. 22).

These scenes consistently elevate the social status of the photographer above that of the sitter, offering bourgeois viewers a pleasurable comfort in imagining that unfamiliarity with and suspicion of the camera were markers of social inferiority. As theater writer and scholar Harley Erdman has observed of *The Octoroon*, audiences in 1859 "knew little more than Wahnotee about the workings of the photographic apparatus," and so their "position towards the camera in effect mirror[ed] that of the Indian." Projecting their own "bewilderment" onto the body of an "ignorant 'redskin'" therefore reduced white audiences' serious fears about the camera to the "laughable overreaction of a savage to a mystified and inaccessible machine" while at the same time replacing any "potential identification [with Wahnotee] with bemused condescension."[62] The urban middling sorts therefore found in photographic humor a means of confronting their own confused and uncomfortable responses to a novel technology by locating them in the caricatured bodies of others. While obviously concerned with

22. Unidentified photographer, *Seeking to Penetrate the Mysteries of Photography*, n.d. Albumen prints mounted on stereocard. Courtesy American Antiquarian Society.

constructions of class and gender and invested in clear distinctions between city and country life, jokes about naïve photographic subjects also questioned the fragility of racial identity. In each of the illustrations and stereocards just described, the unsophisticated manner of the light-complexioned sitter and his irrational response to the machine before him place him outside respectability and potentially outside whiteness.

According to the minstrel show, when black subjects inspect a camera intently, it is not their identities but their very bodies that come under threat, as their actions are presented as transgressive. In *The Darkey Photographer* and *Daguerreotypes*, respectively, Gumbo's and Thompson's curiosity about the camera compels them to disobey orders to sit still, which leads to their corporal punishment by the photographer and his assistant. The moment that Thompson peers into the camera, for example, is the moment that Henry (the assistant) *"throws a handful of flour through the instrument, and* THOMPSON's *face gets nicely covered, which frightens him, and he quickly runs and takes his seat."* Once Gunny (the photographer) returns, he declares that Thompson is essentially unfit for photographic portraiture: "It is quite impossible for me to succeed with a subject like you. The muscles of the mouth and features are horribly distorted." He then turns the operation over to his assistant, who resumes Thompson's punishment by pushing a cannon onto the stage. Gunny *"makes believe he is getting a focus through that as he could through a camera,"* and after quite a fuss discharges a pistol through the cannon that strikes Thompson's body with a rubber ball.[63] Gumbo's disobedience elicits a comparable, though not quite as violent, response in *The Darkey Photographer*. Discovering the country man with his head in the camera, Adolphus proceeds to "strike" him while he "can offer no defence."[64] The farce ends with Collodion presenting a ruined portrait to the disobedient sitter, who smashes the framed picture over his head just before Adolphus throws flour into Gumbo's face.

That Gumbo's actions were deemed worthy of punishment on the minstrel stage shows us how much *The Darkey Photographer* adhered to the superiority theory of humor; audiences were invited to laugh at the misfortunes of "others" and thereby reassure themselves not only of their difference but also of their greater social fitness. During the dismantling of slavery as a national institution in the United States, such reassurance would have played a particularly important role in the American cultural imagination. To see a black subject as needing to obey the studio operator's instructions—to sit still and look straight into the camera's tube, eschewing his freedom to move and his right to control his own body—was to participate in a fantasy of African Americans as dutiful and docile that dominated antebellum visual culture. In performances of *The Darkey Photographer*, then, white audiences in the United States witnessed the resurrection of popular images of the faithful slave; that Gumbo challenged that stereotype through his refusal to be a right and proper photographic subject only reinforced the notion that emancipated blacks should, indeed must, *know their place.*[65]

Gumbo transgresses white desires for black subservience not only by looking *into* the camera's lens but also by attempting to look through the apparatus, as a real photographer would. Just before Adolphus strikes him violently upon the head, Gumbo seriously contemplates his own agency for the first time. "I'd juss like to know wedder any man couldn't do it," he wonders. Could he, too, become an *operator*, a thinking and feeling subject who acts upon the world through the image-making machine? To find out, Gumbo sets about making a portrait of his own, with a sitter of his creation. Constructing a body out of his umbrella and hat, he poses the thing on a chair, just as he has been posed, and then puts his head "in" the camera. At first he "can't see nuffin'" and declares it "don't seem to work," but he quickly realizes that he has forgotten to take off what he calls the "sasspan lid." Gumbo proceeds with the gestures that he (and we) saw Collodion perform, including the *"business with [the] watch"* to time the exposure, *"only still more extravagant."*[66]

What we witness in Gumbo's attempt to take a picture is not simply a comic exaggeration of Collodion's actions but a caricature *of* a caricature. The black(face) sitter mimics the actions of the black(face) photographer, who is a comical imitation of a white model. This set of relations made it impossible for audiences to take the idea of a black operator seriously, or to see this figure as anything other than a derivation of or substitute for a "real" photographing subject. The problem, to be sure, is not the quality of Gumbo's or Collodion's imitations of photographic work but rather the audience's inability to recognize either character as meeting the prerequisites for technological knowledge and agency. Gumbo, in other words, wants to know if "any man" could operate the machine, but he fails to ask whether anyone in the white audience would categorize him as a *man* in the first place. The farce repeatedly puts this question to its spectators, inviting them to take pleasure in the idea that Gumbo, as a black subject, is more *thing* than *man*. We see this in Gumbo's interactions with Collodion, who is angered by his inability to sit still, and again in his decision to construct a sitter out of an umbrella and a hat. Gumbo envisions these inanimate objects as logical replacements for himself, and in many respects they make a better subject for the camera than he has proved to be. Through his improvised gestures and makeshift attempts to take a photograph, the character of Gumbo places himself squarely within the realm of the "mere" amateur.

When Eastman Kodak began to market its handheld camera to middle-class Americans around 1890, and amateur photography became a veritable craze, photographic humor placed just about anyone and anything behind a camera. From cats and dogs to dolls, these improbable operators leaned over tripods, looked into cameras, focused the device, and posed sitters—skills they could have learned from the white children with

23. N. E. Clark, *Amateur Photography*. In Arthur Hewitt, "Amateurs and Their Failures: Certain Maxims Not in Text Books," *American Annual of Photography* 17 (1903): 175. Courtesy American Antiquarian Society.

24. A. S. Daggy, *An Amateur*. *Harper's Young People*, August 27, 1889, 741. Brown University Library.

whom they often shared the scene. Framed as innocent play, such images articulated both the middle-class desire to "take" the family picture and the fears of professional portrait photographers that their livelihoods were being "taken" from them by hordes of eager snapshooters.

Indeed, commercial photographers in the United States were exclaiming with regularity at the turn of the twentieth century that "the amateur is spoiling our business" and would continue to do so if they "don't watch out." As one authority observed, "quality is the only weapon the professional has left to fight with" in the battle for control over photographic operations. The amateur, however, wielded a weapon of his own—namely, the practical knowledge "with all kinds of apparatus, all sorts of subjects and conditions, tackling the most difficult problems, often with inadequate tools."[67] Others took a more cynical view of the amateur's knowledge, seeing in his or her work "an absolute disregard that photography is a very delicate chemical and extremely scientific process." The author of these words was the photographer Arthur Hewitt, who went on to take a portrait of President Theodore Roosevelt and his sons at the White House in 1904, so it is not surprising that he was quick to dismiss the work of amateurs. "Most look upon the camera," Hewitt pronounced with disdain, "as the ordinary individual does a watch: wind daily, alter the hands occasionally and it goes; the camera, push the button or squeeze the bulb, keep the light out, and your pictures will be made."[68] The illustration accompanying his reflections, titled *Amateur Photography*, nicely summarizes this point; it features an ass with his head under the focusing cloth, photographing a "friend" outdoors (fig. 23).

Depicting American amateurs through racial caricature in *The Darkey Photographer* would have lent support to a professional war against the ubiquitous dilettante while reinforcing Kodak's image of the ideal camera operator as white and bourgeois. That audiences were witnessing Gumbo's *very first* effort to take a photograph underscored his difference from "every" American, for only subjects on the fringes of society would have yet to encounter the seemingly ubiquitous camera by the 1890s—or so Kodak and countless photographic humorists encouraged consumers to believe. Audiences in this period would have registered this difference as remarkable and funny, on the one hand, and predictable, even comforting, on the other. If amateur photographers were to remake American life through their images of the middle-class family, as Kodak charged them to do, then it would seem unthinkable for that image to come under the control of black hands.

An engraved cartoon drawn by the American illustrator A. S. Daggy and published in *Harper's Young People* in 1889 gave form to the unthinkable, its comic tone ensuring that it would remain the stuff of fiction (fig. 24).[69] The cartoon portrays a young African American man posing five figures on the seashore. Their tattered, worn appearance

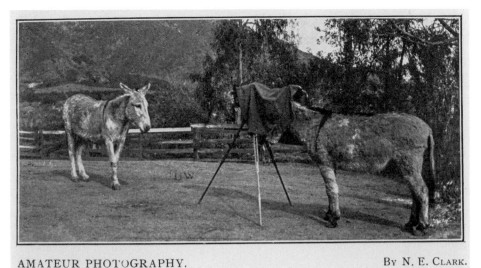

AMATEUR PHOTOGRAPHY. By N. E. Clark.

175

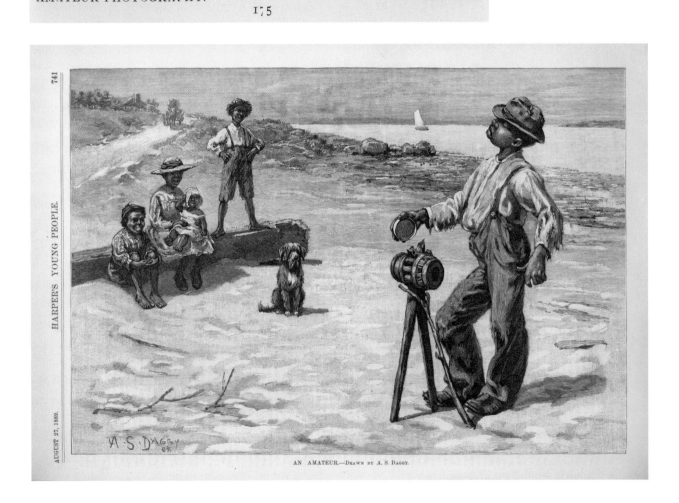

HARPER'S YOUNG PEOPLE.

AUGUST 27, 1889.

AN AMATEUR.—Drawn by A. S. Daggy.

contrasts with the signs of leisure and rural gentility in the scene, such as the sailboat offshore and the covered wagon advancing toward them. At the apex of the pyramidal group is a boy standing with his legs apart and arms akimbo; next to him is a mother with a baby on her lap whose raised arm suggests that the little one is difficult to keep still. At the base of the pyramid sit a young boy with his legs tucked into his chest and a dog who just as obediently does not move. Set apart from the group, the amateur photographer stands proudly in contrapposto, his upper body arched backward and his chin held high, a little *too* high. His attitude evokes the overconfidence of the caricatured black dandy—the progeny, as it were, of the minstrel show's Zip Coon.[70] That attitude distracts us, so much so that we may not notice right away that this amateur is operating the most improvised of instruments. His camera and tripod consist of a hub and two spokes of a wagon wheel leaning against a stick.

Positioned as white middle-class adolescents, the readers of *Harper's Young People* may have enjoyed mocking the arrogance of the amateur and the seriousness with which the sitters posed for his inoperative device. They may also have been amused by the idea that the components of this "camera" were taken from the approaching wagon, thereby jeopardizing the safety of the vehicle and its fine passengers. The incorporation of the *Harper's* cartoon into the advertising campaign of a commercial studio photographer in New York State, whose work is examined further in chapter 3, points to other reasons to laugh at the scene. Printing the cartoon on a cabinet card, the studio of C. H. Gallup & Co. treated its potential patrons to an extended description of the amateur on the back of the card. "How well we all know him, for through his persistent attempts at picture making he has become almost a part of the scenery as it were," the card explained. "We find him in the woods and on the sea, in the foreign city and on the plains at home. . . . With his instantaneous camera he is the terror of spooney couples, whom he surprises in quiet nooks. He constantly follows after prominent men who learn to dread the clock of the drop shutter, which tells them he has bagged another victim." It was one thing to poke fun at the ubiquity of the camera fiend, a popular subject of satire after the advent of the Kodak camera; it was quite another to racialize that figure and imagine him bagging victims with his instrument, especially at a time when African American men were lynched by white mobs for the imagined threat they posed to white women. The card goes on to admit that the "subject of our Photo is not an Amateur in the strict sense of the word, since his camera might be called *bogus*." And yet "his subjects seems [*sic*] to enjoy 'having their picture took' just as much, and the same invincible determination to get a picture or 'bust the machine,' which sparkles in the eye of his white brother, is shown likewise in every line of his sable countenance."[71] These lines attempt to redeem the amateur, figuring him not as a danger to white America but as sympathetic to its obsession with

picturing the family group. The comic stereotype of the black amateur, in other words, borrows and exaggerates to the point of absurdity something believed to exist already within white bourgeois subjectivity. And so the consumer of the cartoon could enjoy a light chuckle at himself.

To be sure, there was nothing innocent about that chuckle. For insisting on seeing the amateur photographer as a reflection of (or vessel for) whiteness meant stripping away any agency the black subject might exercise through his operation of the camera. Nowhere in the comic depiction of amateurs are blacks allowed to take pleasure in the act of creating an image of family or friends—without, that is, that pleasure being seen as transgressing or imitating white conventions for vernacular portraiture. One wonders whether this is what the creators of *The Darkey Photographer* and *Daguerreotypes* hoped to communicate to audiences through a curious action in both scripts: the flouring of the black(face) sitter's face. This literal whitening of Gumbo and Thompson immediately follows the characters' attempts to operate the camera, and therefore can be read as a response to those efforts. Consider this: A white actor in blackface is put into whiteface at the very moment he decides to *operate* the machine, or to assert himself as an agent of modern technology and civilization. Within this scenario, the flouring of the characters' faces serves as a mocking gesture that says, *Look at you, shame on you, playing the part of the white man!* This was, as we have seen, a common sentiment in transnational racial humor, one that in the United States sought to curtail the power of emancipated African Americans to control their own representation.

Australasian performances of the *The Darkey Photographer* incorporated a more local tradition of poking fun at black subjects who tried their hand at photography. Historian of photography Melissa Miles has recently uncovered comic images published in the *Australasian Photo Review* that feature two characters: Austral and Brownie Kodak. In a crudely drawn cartoon from 1906, they appear in the bush among a group of grotesquely caricatured Aboriginal men participating in an amateur photographic club (fig. 25). A reference to a local photographic supply company as well as a symbol of Australian photography, Austral bears a resemblance to these men and to Brownie, an embodiment of Kodak's early box camera.[72] Adding to Miles's efforts to connect the cartoon to white Australia's official policies regarding Aboriginal people, I read the actions of Austral and Brownie Kodak as particularly important to the image's political message. Together, the characters are demonstrating for a group of bare-chested, shaggy-haired, indigenous men the use of hypo, developer, and a photographic paper known as "gaslight pearl," while Austral displays gleefully a small portrait of a dark-complexioned sitter for all to admire. This, we are to imagine, would be the goal of the "boomarangaroora photographic club"—that is, fostering a community of indigenous amateurs who would share knowledge of photographic technology and

ANOTHER QUAINT POST-CARD.

set about producing their own photographic likenesses. According to the *Australasian Photo Review*, this possibility could not be taken seriously.

A pair of staged photographs from New Zealand's *Auckland Weekly News* tell a familiar, sobering story about the Maori. Published in 1901 and 1905, respectively, figures 26 and 27 reduce the indigenous photographic amateur to a child who sets about photographing friends with a box camera on a makeshift tripod. In *Posing for His Portrait on Lake Rotorua*, a young Maori girl positions her head under the focusing cloth and trains her lens on a naked boy who attempts to cover his head and genitalia, overcome by laughter or shame; we cannot tell which. Other children support the girl playing photographer with their broad smiles and their placement behind the naked boy, who is to become, willing or not, a photographed subject. In *The Camera Among the Maoris: A Reluctant Subject*, that unwillingness is made clear, as the boy before the photographer's lens holds up his fists in a combative gesture. Here again, the amateur appears unwavering in his desire to take the picture; holding the brass cap of the camera's lens in one hand, he times the exposure with a pocket watch held in the other. But this time the onlookers seem either uninterested in or bothered by the subject's response to the photographic operation. This image of indigenous life in the *Auckland Weekly News* is demeaning not only because of its stereotyping of the Maori as childlike

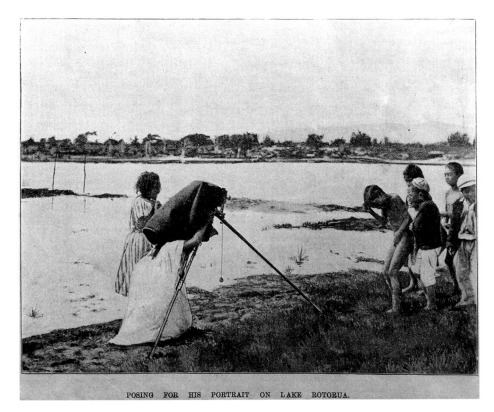

POSING FOR HIS PORTRAIT ON LAKE ROTORUA.

26. *Posing for His Portrait on Lake Rotorua. Supplement to the Auckland Weekly News*, January 4, 1901, 7. Sir George Grey Special Collections, Auckland Libraries, AWNS-19010104-7-5.

27. *The Camera Among the Maoris: A Reluctant Subject. Supplement to the Auckland Weekly News*, April 13, 1905, 11. Sir George Grey Special Collections, Auckland Libraries, AWNS-19050413-11-4.

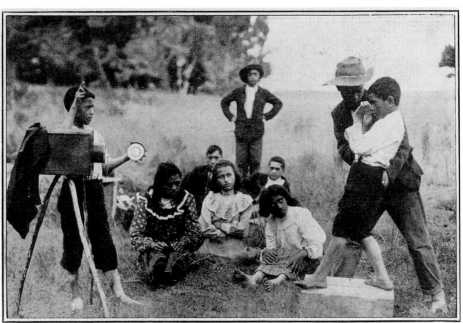

THE CAMERA AMONG THE MAORIS: A RELUCTANT SUBJECT.

and violent, but also because of its stage management of the amateur photographer's potential agency. Finally standing alongside the camera—no longer made to peer into the camera's lens with suspicion—this amateur has very little control over the results of the operation at hand, confronted as he is with an unruly sitter.[73]

It was precisely the potential for a shift in power relations between whites and blacks that the representation of Gumbo as an amateur in *The Darkey Photographer* sought to undermine. To the audiences who were entertained by the minstrel farce, the black(face) sitter-turned-photographer could only ever be a mere imitator of the men who "properly" operated cameras in photographic studios and in private homes throughout the English-speaking world—white, bourgeois gentlemen whose artistic skills ran as deeply as their technical knowledge of the medium they controlled. We are asked to see this as the character's (and, by extension, African Americans' and indigenous subjects') inevitable failure to assimilate fully into dominant culture, to suppress or otherwise rectify his apparent social difference. Thus the agency of the darkey photographer was staged only for the sake of its spectacular disavowal.

IN OTHER HANDS

In a crowd of finely dressed African Americans, the men wear dark jackets and ties with straw hats or bowler hats, the women, fine dresses, white gloves, and broad-brimmed hats trimmed with ribbons, flowers, or feathers (fig. 28). The few children in the group adopt fashions similar to those of the adults. Expressions on the faces vary; some look serious, intent on some action outside the frame of the shot; others sport a half smile, including the two men along the central axis who seem to register our presence. Between these two figures, and precisely in the center of the crowd, sits a camera, its dark canopy draped over the top of the box, its lens and its operator focused on us. Or so it appears. Their true focus is not pictured, but we know it to be Booker T. Washington, the African American educator and activist who embodied a turning away from the memory of slavery and the cloud of racist humor, and a turn toward "an irresistible, spontaneously generated black and sufficient self," as Henry Louis Gates Jr. puts it.[74]

Orchestrated around 1910 by Arthur P. Bedou, an African American portrait-ist from New Orleans who became Washington's official photographer, this image became an emblem for Deborah Willis's groundbreaking survey of African American photography, *Reflections in Black* (2000), also the title of an accompanying exhibition. In the three years that the exhibition toured the United States, and in the nearly two decades during which its catalogue has been read avidly by students, historians, and practitioners of photography, *Reflections in Black* has exercised a powerful influence on

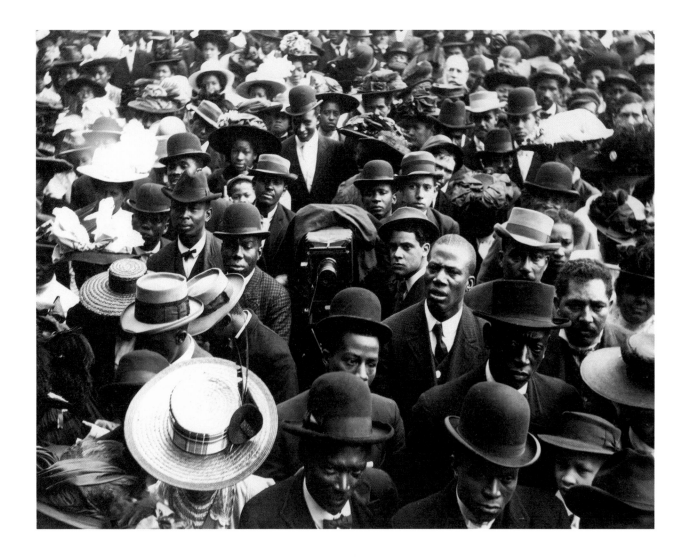

how we think about black self-representation. Willis taught us how to look for and at images that do not grossly caricature but instead "celebrated the achievements" of their subjects and "conveyed a sense of self and self-worth."[75] Her work has further shown that placing cameras in black hands made such counterrepresentation possible; writing a different history of African American life and culture depended for Willis on rediscovering the earliest black photographers. Shawn Michelle Smith has elaborated on readings of figure 28 as a symbol of black agency by observing that it can be interpreted as a self-portrait of Bedou, literally or metaphorically. As a photograph that captures the act of taking a photograph, Smith argues, it highlights Bedou's "self-conscious understanding of his role as a maker of images." She extends this

28. Arthur P. Bedou, *Photographer in a Crowd*, ca. 1910. Photographs and Prints Division, Schomburg Center for Research in Black Culture, The New York Public Library.

self-consciousness to Booker T. Washington, from whose perspective on the speaker's platform the picture was made, pointing to "an exchange of gazes between orator and photographer, a playful reversal of roles in which the photographer becomes subject and the subject becomes photographer, and both collude in the knowledge of their image making."[76]

Working together, Washington and Bedou toppled the tradition of the darkey photographer, which remained popular in 1910 and for decades thereafter. Comparison of Bedou's self-portrait to the trade card in figure 19 is irresistible, given their shared subject: black bodies surrounding a canopied box camera. It is in the considerable differences between these images, however, that the critical work of Bedou's photograph comes into focus. Perhaps most obviously, the nostalgic plantation scene in *Photography Under a Cloud* is replaced by a nondescript urban space defined by the presence of the crowd, while tattered clothes and woolly hair give way to fine attire and smartly hatted heads. In place of the figures' wide-eyed fascination with photographic technology in the trade card, moreover, Bedou presents an image of concentration, introspection, and self-awareness. The bodies in his photograph are the objects of our gaze, certainly, but they also assert gazes of their own. We (in the position of an invisible cameraman) train our lens on *them*, while they surround a camera directed at a subject (Washington) beyond our vision. The photographic apparatus, finally, does not function as an extension of a white body, as it does in *Photography Under a Cloud*. Instead, the depicted camera clearly belongs to the man beside it—presumably Bedou himself—who confronts us as its agent. Alternatively, the camera in the scene can be read as a black body that *operates itself*, or as a technological extension of the politically empowered community that surrounds it.

Today, scholars are working hard to bring to light the agency that black subjects hoped for and expressed through their early experiences of photography. Exemplifying their efforts in the United States is *Pictures and Progress* (2012), a volume edited by Shawn Michelle Smith and Maurice O. Wallace (from which I quoted Smith above). This book builds upon Willis's scholarship by "recover[ing] the various ways in which nineteenth- and early-twentieth-century African Americans viewed, conceptualized, and most importantly *used* the new technology of photography to chart and change and enjoy new social positions and political identities." "We know more about the imagery of racism than we do about what African American men and women did when they took photography into their own hands," the editors write, defining the central problem they seek to address. For Wallace and Smith, the act of taking the medium into one's hands is symbolic of agency and should be understood in both literal and figurative terms. Adding this figurative dimension allows them to include discussion of some "prominent African American intellectuals, authors, orators, and activists" who

"may never have picked up cameras themselves"—among them Frederick Douglass, Sojourner Truth, Ida B. Wells, Paul Laurence Dunbar, and W. E. B. Du Bois, who all "put photographs to striking use in their varied quests for social and political justice, plumbing and expanding the political power of the photograph."[77]

Douglass not only plays a central role in *Pictures and Progress*, inspiring the volume's title; the ideas about photography espoused by this leading black abolitionist and former slave have also inspired an extraordinary number of recent publications.[78] These studies remind us how much Douglass had to say about the photographic medium from the 1840s through the 1860s. In a series of lectures, he promoted "picture making" as a skill that distinguished men from animals and that could serve as the "primary catalyst for social change." The key to such change was "making ourselves and others objects of 'observation and contemplation.'"[79] In Douglass's view, members of the African American community, on the eve of emancipation, had first to *picture* themselves in order to achieve social *progress*. It was this ability to create pictures of the world that he believed distinguished humans from any other animal. And so by participating fully in the act of representation, black subjects could assert their own humanity and declare that their lives mattered.

In Australasia, a similar effort to recover agency has led artists and historians to seek evidence of early photographic practices among indigenous people. In his study of early photography in Papua New Guinea, for example, Max Quanchi notes Papuans' assistance to traveling photographers on expeditions, through which they acquired some knowledge of (and perhaps control over) the local production of photographs.[80] Quanchi further mobilizes evidence that Aboriginal people, after encountering cameras in the mid-nineteenth century, "were soon adept at stage-managing the European visitors [to Australasia] and demonstrating an awareness of the medium and the European's fascination with taking photographs."[81] Both Roslyn Poignant and Jane Lydon offer examples of such awareness in their studies of the interactions between Australian Aboriginal people and the white men who photographed them in the late nineteenth century. It would seem that these Europeans and Americans were just as curious about their "uncivilized" subjects as those subjects were about them. What is more, Aboriginal sitters became aware of the depths of white photographers' curiosity and recognized its exploitative potential. Their documented efforts to engage willfully in the creation of stereotypical representations, to procure compensation for those pictures, and to appropriate colonial photographs in their own cultural practices can all be read as expressions of power, or as strategic resistance to oppression that had potentially significant economic and political consequences.[82]

Some of the most creative representations of those consequences are voiced today by artists like Genevieve Grieves, whose family belongs to the Worimi people of New

29. Genevieve Grieves, still photograph from *Picturing the Old People*, 2005. Five-channel color video installation with single-channel audio. Art Gallery of New South Wales. Gift of the artist 2009. Donated through the Australian Government's Cultural Gifts Program. © Genevieve Grieves.

South Wales. In 2005 she produced a video installation titled *Picturing the Old People*, based on the photographs of Aboriginal people that she found in historical archives in Australia. The viewer watches five video screens simultaneously, with action unfolding slowly in each; that action displays what Grieves imagines took place in early Australian portrait studios, when indigenous peoples were instructed to perform "Aboriginality" for the camera. We see, for instance, the white photographer, replete with bowler hat and dark suit, arranging against a studio backdrop props that would support that performance, such as a spear and other traditional tools. He then sets about preparing two Aboriginal men for the scene—removing some of their clothes, decorating their bodies with ornaments and animal skin, and introducing them to the tools (fig. 29).

The humor of Grieves's work rests with the men's reactions to this staging. Their air of reluctance, confusion, and suspicion—in relation to everything in the contrived studio, it seems, *except* for the photographic apparatus—points to the absurdity of the white photographer's vision of Aboriginal life as essentially primitive and savage. It is at this vision, whose artificiality Grieves exposes brilliantly, that viewers of *Picturing the Old People* are compelled to laugh.

The placement of cameras in black hands on the international minstrel stage demands further study of how particular racial groups fashioned photography as an instrument of political empowerment. Without denying the medium this potential function, we must never forget that such fashioning is neither easy nor self-evident. As Gumbo and his camera antics demonstrate, it involves refusing to accept traditional relations between the self and other, subject and object, active and passive, modern and primitive, civilized and savage, and ultimately black and white. It means looking at an apparatus designed to privilege whiteness *in the wrong way* and reimagining the camera operator as anyone seeking to construct a likeness.

Chapter $\{3\}$

Look Pleasant, Please!

A SOCIAL HISTORY OF THE PHOTOGRAPHIC SMILE

Close-lipped, serious-looking faces that appear to convey melancholy, surprise, or fear, if any feelings at all, confront anyone who studies early American portrait photography. Where are the toothy grins that would become aesthetic conventions and social expectations at the turn of the twentieth century, when Eastman Kodak began marketing these expressions to middle-class Americans as markers of happiness?[1] The technical realities of the photographic medium have provided historians with a simple and much-recited explanation: Before the 1880s, exposure times ran anywhere from several seconds to several minutes, depending on the light conditions and materials used, which made transient (e)motions nearly impossible to record on a photographic plate. The fact that studio sitters often had to remain still for a considerable time, with their bodies uncomfortably secured in a viselike posing apparatus, made good feelings especially difficult to conjure up and fix under the skylight.[2]

As appealing as such an explanation might be, approaching the smile as a technical problem that Kodak successfully resolved eclipses the ways in which commercial photographers had been invested in the smile's conception and meanings since the first portrait studio in the United States opened its doors in 1840. Indeed, the American photographic community spilled much ink in the 1860s and '70s thinking about how to arouse each sitter's "happiest mood" and translate it into a "pleasing expression" that

could be quickly, faithfully, and permanently recorded. Heavily influenced by eighteenth-century aesthetic theories and popular treatises on physiognomy, such writing approached the human face as an index of a subject's thoughts and feelings; these, in turn, were taken to be signs of his character. The practical aim of the studio photographer was to produce a "smiling picture," which described a highly conventional facial aesthetic. The present chapter explores the social dimensions of this aim by considering how early photographic discourse, both serious and comic, sought to define, value, and depict happiness within a politically evolving and racially charged landscape. The very possibility and elusiveness of the smile, I argue, performed important cultural work in the Civil War and postbellum period.

Motivating this discussion are questions about the cultural character of affect and its representation, specifically those that ask, as Sara Ahmed puts it, "how happiness and unhappiness are distributed and located within certain bodies and groups." Ahmed's own prolific writing on ideas of happiness points to the "social as well as moral distinctions" on which they are founded—distinctions, in her words, about "who is worthy as well as capable of being happy 'in the right way'" that have been used to justify various forms of social oppression in Western culture.[3] Applying this critique of "good feeling" to the trade literature and material practices of early American photography, the pages that follow examine the complex and historically specific assumptions that commercial portrait photographers made about what their subjects should feel and how visual representation could best give form to "good" feelings. Their reflections on the subject point to photography's role not in merely illustrating happiness but in actively contributing to its cultural production in the United States.

PLEASING EXPRESSIONS

As the preeminent American daguerreotypist Marcus Aurelius Root explained in his 1864 treatise *The Camera and the Pencil*, the essentiality of facial expression to portraiture stemmed from the fact that it marked the very "individuality" and "selfhood" of a sitter, the depiction of which determined a picture's worth and spoke to the "genius" of its maker.[4] What the face expressed and the "self" it embodied were nevertheless strictly curtailed by photographers' primary aim, as one contributor to the *Philadelphia Photographer* put it, "to render into respectable appearance all the variety of human character itself." This meant that photographers were trained to be attentive to the peculiarities of each sitter's features at the same time that they developed strategies to ensure that those features conformed to an ideal norm. The public's facial responses to the photographic medium—variously motivated by anxiety, vanity, or sheer ignorance about the camera's technical workings, which frequently cut across social lines—made

this challenging work. Indeed, the commercial photographic community complained in the 1860s and '70s that people sitting for their pictures either appeared before the camera as (e)motionless corpses or assumed "unaccustomed and absurd" expressions when, ironically, attempting to portray their "best" selves. They "set their lips, or enlarge their eyes, or widen their mouth, or affect the expression of meekness, or benevolence, or heroism, as it may be," which "make[s] them look like a gallery of Bridewell patients."[5]

This reference to London's infamous detention facility for the criminal and insane suggests that the (re)production of a "true and pleasant" expression was seen as analogous to the discipline of social deviance. In fact, nineteenth-century photographic literature in the United States functioned much like etiquette manuals of the period, adopting class-based rules that governed how one should look and behave.[6] Although these texts discussed every part of the face, outlining what each conveyed about a subject in its most ideal and degraded forms, they placed particular emphasis on the contours of the mouth, essential as they were to social discourse, the consumption of food and drink, and the communication of feeling.

As Root acknowledged in his extended meditation on "expression" in *The Camera and the Pencil*, the lips are both "exceedingly expressive" and the "most flexible feature" of the face, which makes them "capable of manifesting every cast of character, from the most delicate sensibility to the lowest brutality," and marking "every passing emotion." "How plainly, in the close-shut mouth, with its encircling muscles rising into a sort of ridge, do we read firm, resolute will, while in loose flabby lips we seem to behold not less plainly a vacillating, irresolute disposition. In unusually thin lips we discern sharpness and asceticism of temper; while in extra thick lips we find sensual proclivities accompanied mostly by good nature and generous tendencies."[7] Associating consistency and evenness of temper with respectability, bourgeois ritual clearly dictated which of these presentations of the mouth were most becoming of ladies and gentlemen, who were Root's most desirable clientele.[8] His Philadelphia studio patrons, in other words, could not afford to display "extreme" emotion, such as might cause their lips to part and allow the instruments of mastication beneath them to come into view, without undermining their social performances.

Excessive laughter and its most characteristic expression—the toothy smile—thus came to be regarded as aesthetically and socially transgressive in early photographic culture, finding its way most readily onto the faces of subjects situated on the fringes of society by virtue of their age, mental state, moral character, class status, or racial identity. Following the example of European painters and printmakers, nineteenth-century photographers took as their models the academic studies of character and expression undertaken by the French academic painter Charles Le Brun, the influential

physiognomist Johann Kaspar Lavater, and the English anatomist Charles Bell, who associated the wide grin with the mischievous child, the merry-making peasant, the silly fool, the lecherous old maid, and "others."[9] Informed by the same studies, men of science who relied on the camera to investigate the physiology of feeling made similar assumptions about the social character of the smile, which led them to select as ideal subjects those deemed most "free" to express their emotions. In his electro-physiological experiments at Salpêtrière Hospital in Paris in the 1850s, for instance, Guillaume-Benjamin-Amand Duchenne de Boulogne described his "principal subject" as "a toothless man, with a thin face, whose features without being absolutely ugly, approached triviality and whose facial expression was in perfect agreement with his inoffensive character and his restricted intelligence."[10] Charles Darwin supported Duchenne's findings and reproduced some of his photographs of the toothless man

30. Charles Darwin, *The Expression of the Emotions in Man and Animals* (London: John Murray, 1872), 202, plate 3.

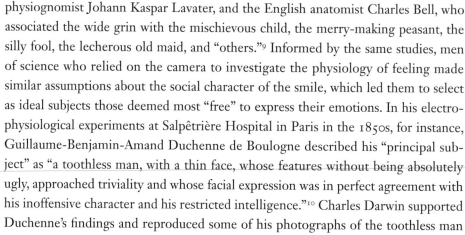

in his 1872 study *The Expression of the Emotions in Man and Animals* (fig. 30). He likewise admitted that he found "idiots and imbecile persons" valuable studies since they displayed a remarkable propensity for smiling and laughing, particularly when "food is placed before them, or when they are caressed, are shown bright colours, or hear music." It was in children, however, that Darwin found his best sources of knowledge about how and why humans exhibit emotion, for their feelings (in his view) were rich in variety, were conveyed with "extraordinary force," always stemmed from a "pure and simple source," and were not subject to the social rules adults imposed upon them.[11]

OBJECTS OF HAPPINESS

The figure of the child constitutes an important point of connection between these scientific studies and American portrait photographers' own efforts to record "excessive" feeling in the 1860s and '70s. In preparing his treatise on emotional expression, for example, Darwin collected the work of James Landy, a commercial portrait photographer from Cincinnati whose *Expressive Pets* made him the acknowledged master of the emotive baby picture (fig. 31).[12] Sold as individual prints to a predominantly urban and middle-class studio public, Landy's array of twelve "laughing, crying, and screaming" babies presented what the American

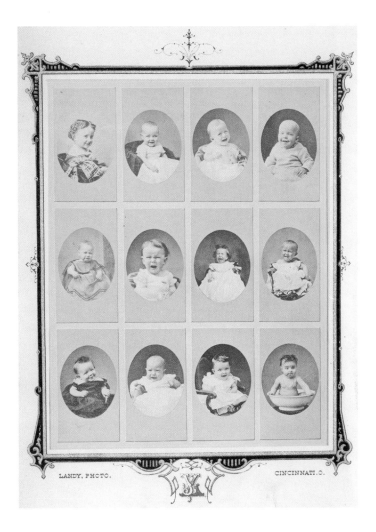

31. James Landy, *Expressive Pets*, ca. 1872. *Philadelphia Photographer* 9, no. 104 (August 1872): opposite 273. Albumen print. The Library Company of Philadelphia.

photographic press described as a remarkable variety of expressions, from a "gentle smile" in which cheek muscles subtly contract, to "a glorious ha! ha! such as only the fond mama understands" in which the tiny mouth more freely opens, to "a subdued resistance" marked by a close-lipped pout, to "complete, yelling defiance" with the jaws stretched wide.[13]

What attracted urban American photographers and their patrons to these studies, however, was not precisely what motivated Darwin to collect them. According to the leading photographic journals in New York and Philadelphia, what made *Expressive Pets* a desirable commodity was its potential to incite an eruption of good feeling in adult viewers, such as "violent laughter," which would then give way to a "calm repose." This sequence of affective responses, they explained, would be particularly

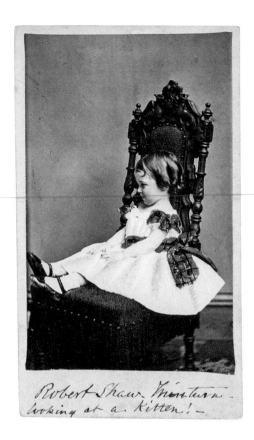

Robert Shaw Minturn looking at a Kitten!

32. J. Loeffler's Photographic Gallery, portrait of Robert Shaw Minturn looking at a kitten, ca. 1865. Hand-colored albumen print mounted on carte de visite. Courtesy American Antiquarian Society.

valuable in portrait studios, where the prints could be shown to especially "restless" patrons, taking their thoughts away from the pain of portraiture and generating the "pleasant expression" so essential to performances of respectability. Reading this praise for Landy's photographs in terms of social theories of affect, we might say that they promised happiness to a particular class of viewers by orienting them toward objects that carried positive affective value. As Sara Ahmed has argued, to feel good in the presence of these "happy objects" (in this case, the bodies of bourgeois children and photographic representations thereof) marked one's participation in a particular social group (the white middle class). It further contributed to the cohesion of the group itself, which relied on certain things being seen and agreed upon as legitimate sources of happiness, or "the necessary ingredients for a good life."[14]

The idea that there were high social stakes in the production and circulation of *Expressive Pets* was alluded to in photographers' own reflections on the series. Its appearance in the August 1872 issue of the *Philadelphia Photographer* was accompanied by the editor's frank admission that "in the cities, at least, the studios are filled daily with babies borne in the arms of frantic mothers and aunts, wishing to secure the shadows of the tiny beings ere they become the victims of cholera infantum or dysentery."[15] There is no better moment to (photographically) preserve babies as happy objects, the journal suggests, than that in which their lives, and hence the integrity of the ideal bourgeois family, appear to be most at risk. The racial identity of the babies made their reproduction especially urgent, at a time when fears were widespread that white children were languishing in unhealthy urban homes, while European immigrants and newly emancipated blacks were contaminating the imagined purity of America's "native" population.[16] It is to this dominant group, who could readily imagine themselves as the parents of the excessively emotive little ones, that photographers hoped and anticipated Landy's prints would have their strongest appeal.

While exceptionally popular at the time of its production, *Expressive Pets* by no means constitutes the only instance in early American photographic culture when the happy objects generated by and circulated within urban portrait studios were tied to performances of social identity. In fact, photographers' choice of objects with which to stimulate the "best" and "right" feelings in a sitter shaped, as much as they were shaped by, perceptions of the sitter's "appropriate" place within the dominant social order. Suggestions on this point were plentiful as early as midcentury, when authorities like

Root catalogued the things most productive of a "genial, elevated tone of sentiment and emotion." These included books that could be consumed in a short space of time, portfolios of the "finest" prints, ephemera that have "classic, romantic, and historic associations connected with them," stained glass draped with "splendid curtains," and paintings and marble busts of the "choicest quality" and sufficiently "various" as to "correspond to the leading types of character which might be expected among the sitters."[17] To this list Root added the cages of brightly colored and "graceful" singing birds, which would become one of the most common "happy objects" in American portrait studios, taking both real and mechanical forms and leaving us with the popular phrase "watch the birdie." Taken together, these "fine" things—literature, art, furnishings, and music—were deemed "appropriate" to the cultivation of gentility under the skylight and closely tied to the "pleasing expressions" of ladies and gentlemen precisely because they were highly valued in the bourgeois imagination.[18]

If each sitter who entered the studio was taken as a collection of individual peculiarities that the photographer had to observe carefully and work to normalize, then it follows that different people expressed their "highest and best" or "genuine, essential self" in the presence of different things. The carte de visite in figure 32 illustrates this notion beautifully; it suggests that the "proper" mood of an impossibly fidgety or indecorous toddler might best be achieved by allowing him to gaze upon a kitten, whose innocence and cuteness could serve as alibis for the preciousness of the bourgeois child. While delightful to the historian, it is exceedingly rare to find the identity of the "happy object" presented to a sitter inscribed directly on a photograph, as it is in figure 32. Most often it was in the genre of photographic humor that the social basis of pairing sitters with particular happy objects would be laid bare in nineteenth-century America. Observations about the emotional states of stereotyped studio patrons were exceedingly common in popular periodicals, as were jokes about what would (or would not) make them smile.[19]

Consolidating decades of such humor, a satirical illustration published in the comic magazine *Puck* in 1895 (fig. 33) shows us the work of an enterprising photographer who "provides appropriate views for his sitters to look at, and always gets a pleasant expression."[20] In each of its six vignettes, a subject is placed in the iron grip of a posing stand and set before a unique backdrop: Mr. Wuffingham, a well-dressed black man and the only subject to fully bare his teeth in the illustration, is treated to a view of a watermelon patch; Mr. Burnupski, a Jewish merchant, watches his "fully insured" clothing store go up in flames; a middle-aged maid observes a high-society wedding; Dean Clearwater, a "total abstinence advocate," is shown a popular symbol of the lost days of youth; the sportsman Brute Brogan watches a "championship fight" between two black boxers; and Squire Corncobbe has the pleasure of looking at a man incarcerated for swindling a "countryman" like himself. What made this cartoon so funny

to *Puck*'s readers was their readiness to accept the idea that different (and variously marginalized) social types were "naturally" brought to a state of happiness in the presence of objects that spoke to their most "essential" desires. Further inciting laughter was the fact that the affective desires of "others" were taken to be always-already "excessive"—whether they were to partake in base physical pleasures like ravaging a melon or watching two men brutalize each other, or to dramatically improve their social status by marrying up or collecting insurance, or to embrace radical visions of moral reform such as depriving the body of food and sex and severely punishing petty crimes.

Although presented here as the stuff of humor, a similar belief in individual emotional "nature" underwrote serious aesthetic choices, material practices, and assumptions about the "truth" of a portrait in commercial photographic discourse. Like the fictional Mr. Cabnitts, American studio photographers based their efforts to stimulate and record "real" emotional feeling under the skylight on the construction of distinct, yet mutually dependent, affective communities: a community of white bourgeois subjects whose expressions of pleasure were among photographers' chief preoccupations, and a collection of social others whose continued subordination

33 [a,b]. *Great Scheme of Mr. Cabnitts. Puck*, November 13, 1895, 196–97. Courtesy of Dartmouth College Library.

depended on their perceived ability to feel *too much*, but only in relation to a limited range of things and experiences.[21] A close look at the marketing strategies developed by a once prominent commercial portrait studio will allow us to understand how these ideas contributed to the commodification of happiness, and ultimately the naturalization of the smile, in the history of American photography.

SELLING SMILES

During the roughly thirty years (1885–1917) during which Charles H. Gallup ran his successful studio in the heart of Poughkeepsie's business district, Gallup arguably did more to promote photography's development and popularity in the city, and indeed in the region as a whole, than any other photographer before him.[22] He accomplished this in part through his commitment to producing high-quality work at a reasonable price; a local farmer, businessman, or teacher living in the Hudson River valley in the 1890s could well afford the three dollars Gallup charged for a dozen of his cabinet cards, which consistently won top prizes for their artistic merit at the Dutchess County Fair. To meet the demand, Gallup also employed a number of "specialists" to operate the

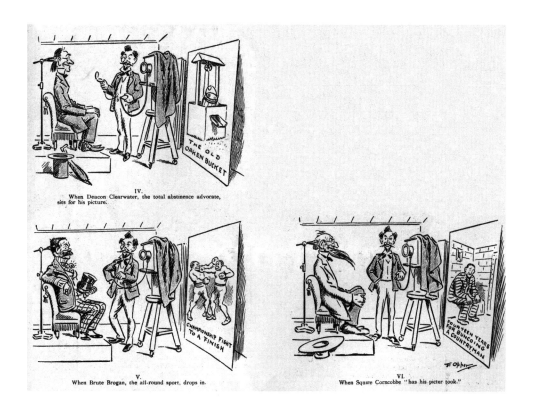

IV.
When Deacon Clearwater, the total abstinence advocate, sits for his picture.

V.
When Brute Brogan, the all-round sport, drops in.

VI.
When Squire Corncobbe "has his picter took."

latest photographic apparatus and technologies, which ranged from "new accessories, back-grounds, and scenic effects" to the process of "instantaneous photography," by which exposure times under the skylight were greatly reduced.[23] Promises of material comforts, short exposures, and endless opportunities to sit and re-sit encouraged countless respectable families, particularly those with young children, to seek Gallup's services.[24] In the case of the cabinet card in figure 34, we find that members of a prominent Huguenot family with ties to Poughkeepsie and nearby New Paltz sat together for his camera. The finely dressed Mr. and Mrs. Deyo pose on either side of their son, Walter, whose left hand rests meaningfully on his father's downward pointing finger. White lace curtains, wooden screens, and a fur rug frame the family group, throwing their bodies and respectability into sharp relief.

What brought many sitters to Gallup's Poughkeepsie studio was, if nothing else, the impressive multimedia advertising campaign he launched in the late 1880s. Working with several enterprising partners, Gallup published advertisements in local newspapers, promoting his ability to pose and light "every-day" people and make them appear as "easy and natural" as possible.[25] The primary instrument of the campaign was a series of cabinet cards that he distributed for free at his studio and displayed at public events in and around Poughkeepsie. A dozen different cards in the series probably circulated by 1900, each featuring an image on the front and an extended commentary on the back.[26] Many of these combined a celebration of Gallup's technical achievements in photography with popular assumptions about the social character of emotion in the United States at the turn of the twentieth century.

One such card, titled *Anticipation and Reality* (fig. 35), presents us with a sequence of six bust portraits of the same male figure, each conveying a different emotion associated with romantic love.[27] The three portraits at the top of the card document the sitter's "anticipation" of asking the woman of his dreams to marry him. The appearance of his face radically changes as these thoughts evolve. At first his eyes look directly but coolly into the camera, the corners of his mouth ever so subtly upturned to convey controlled contentment. He then squints before shutting his eyes altogether, while his mouth proceeds from a toothy grin to a wide-mouthed expression suggestive of raucous laughter; chivalrous thoughts, we are to imagine, give way to an ungentlemanly fantasy of another man's "feeling sick." The man's appearance continues to undergo radical changes in the lower three pictures, as the "reality" of his situation sets in: she is engaged to another man. Alterations in hairstyle and costume—locks now curled and a rose in his buttonhole—parallel a shift in the kind of feeling the man's face expresses: first surprise, then sadness, and finally heart-wrenching anguish. The text on the back of the card narrates the sitter's physical and emotional transformation, revealing that the purpose of this "study" is to celebrate the "possibilities of modern photography in

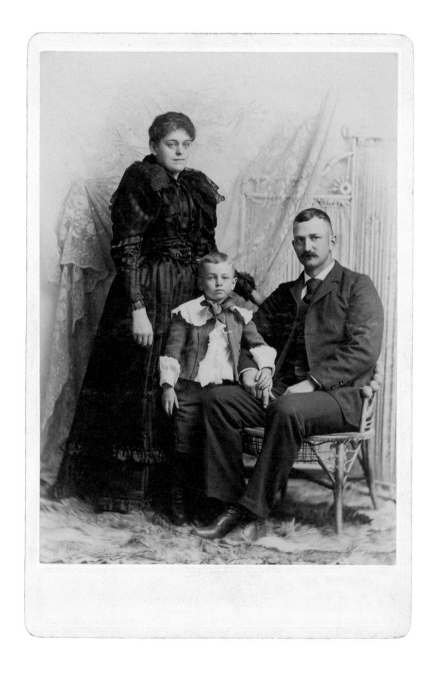

34. C. H. Gallup & Co., portrait
of Mr. and Mrs. Perry Deyo
and their son, Walter, ca. 1890.
Albumen print mounted on
cabinet card. Reproduced
with permission by Historic
Huguenot Street, New Paltz,
New York.

35 [a,b]. C. H. Gallup & Co.,
Anticipation and Reality, ca. 1890.
Albumen print mounted on
cabinet card (recto and verso).
Reproduced with permission by
Historic Huguenot Street, New
Paltz, New York.

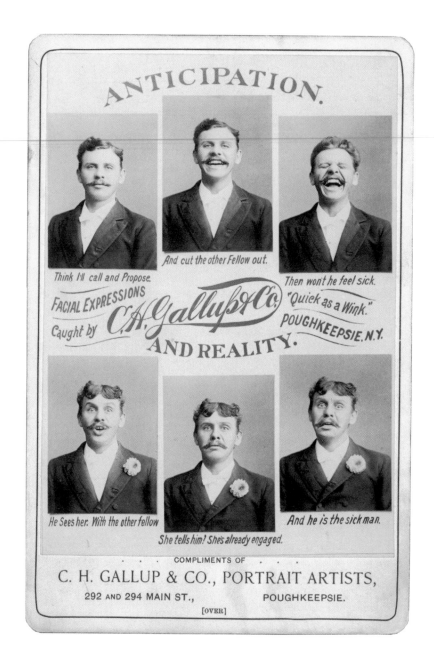

ANTICIPATION AND REALIZATION.

————————◁◇▷————————

IN this picture we present a study in facial expression. It represents a young man undergoing some of the emotions which accompany that state popularly known as being " in love."

With evident delight written upon his countenance, as a prospect of the realization of his hopes dawns upon him, he " gets himself up quite regardless," as the rose in his buttonhole and his carefully curled locks testify, and sallies forth to test his fate. How different is the realization from the anticipation, the picture plainly tells. Poor fellow! let us hope he will have better luck next time.

The possibilities of modern photography in recording the different expressions of the human countenance, are wonderful. Smiles, tears — " quick as a wink" they are indelibly recorded.

C. H. GALLUP & CO.,

MODERN PHOTOGRAPHERS,

292 and 294 MAIN STREET, POUGHKEEPSIE, N. Y.

BRANCH STUDIOS:
DANBURY, CONN., HOLYOKE, MASS.,　☆　☆　☆　☆
FISHKILL AND MATTEAWAN, N. Y.

Headquarters for finely finished CRAYONS at the most reasonable prices. A large stock of FRAMES and MOULD-INGS constantly on hand.

Jennie E. Elmore
N. P. W. A. 18

recording the different expressions of the human countenance." "How different is the realization from the anticipation, the picture plainly tells. . . . Smiles, tears—'quick as a wink' they are indelibly recorded."

Through word and image, Gallup claimed to have fulfilled a seemingly universal wish for photography to be "instantaneous" and permanent, one that had motivated the medium's inventors along with those who struggled to refine its chemical and physical requirements in the decades after 1839.[28] Casting this technical achievement in terms of his ability to "catch even the most fleeting expression" allowed Gallup to represent his portraits as "life-like" and naturalistic, trustworthy and truthful—to market, that is, the authority of his photographic work.[29] What Gallup was not proposing, however, was a shift in the conventions of bourgeois portraiture, for his typical studio patrons displayed neither a considerable variety of feeling nor any kind of affective excess. Rather, the fact that *Anticipation and Reality* begins with the "pleasing expression" modeled in the cabinet card of the Deyo family and countless other commercial portraits since the mid-nineteenth century underscores Gallup's appreciation for its essentiality to serious performances of gentility under the skylight. Subverting the gentlemanly character of the sitter in the remaining portraits on the card would therefore have entertained a class of viewers who had absorbed the social codes that governed such character. It was for these studio patrons, Gallup's most wished-for clientele, that *Anticipation and Reality* ideally functioned as a happy object that both evoked laughter and held out a promise—namely, that C. H. Gallup & Co. understood what was technically and socially at stake in controlling emotion.

In *The Melon Story*, Gallup returned to comic exaggeration as a means of constructing a close connection between performances of social identity and expressions of happiness in conventional studio portraiture (fig. 36).[30] This card features two scenes on the front: at the top, three smiling black boys eat slices of watermelon that they've stolen from a farmer's garden, while in the "after" scene below the white farmer arrives on the scene, catches the boys in the act, and wipes the smiles off their faces. The back of the card interprets the scene for Gallup's patrons:

> From time immemorial, the small boy has been celebrated for his fondness for the melon patch, and nothing satisfies the aching void within, so well as does a generous slice of the succulent watermelon. . . . We were asked, how did you *ever* get them with such a natural expression. This is accounted for by the fact that they were engaged in eating a *bona fide* watermelon, under which condition no darkey boy could help looking happy.
>
> As a general rule, people do not *feel* happy, when sitting for a photograph . . . [but] we will do our best to make you *look* happy no matter how you may

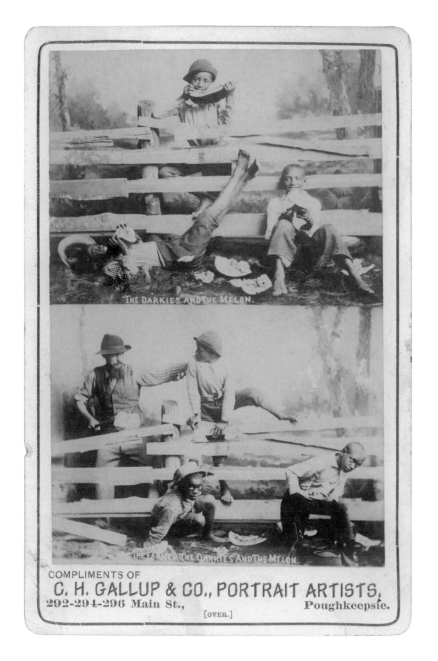

36 [a,b—OVERLEAF]. C. H. Gallup & Co., *The Melon Story*, ca. 1890. Albumen print mounted on cabinet card (recto and verso). Private collection.

THE MELON STORY.

FROM time immemorial, the small boy has been celebrated for his fondness for the melon patch, and nothing satisfies the aching void within, so well as does a generous slice of the succulent watermelon. As will be seen from the pair of pictures on the reverse, the farmer does not sympathize with the aforesaid longing, and when he catches the small boy in the act, frequently produces an ache in some other part of his anatomy. We were asked, how did you *ever* get them with such a natural expression. This is accounted for by the fact that they were engaged in eating a *bona fide* watermelon, under which condition no darkey boy could help looking happy.

As a general rule, people do not *feel* happy, when sitting for a photograph, indeed, the saying "I would rather have a tooth pulled than have my picture taken," is an old "chestnut" to the photographer, he has heard it so often. However, to such we would say that we will do our best to make you *look* happy no matter how you may feel and that we are generally successful in our endeavor, thousands of our patrons in every locality will attest.

N. B.—Having lately fitted up our studio with a large stock of new backgrounds, accessories, draperies, etc., in the latest style, we can safely promise our patrons many new and beautiful effects in portraiture. Our offer of a large Photo-Crayon and one dozen Cabinets for $5.50, has been an immense success.

C. H. GALLUP & CO., Photographers,

292, 294, 296 Main St., Poughkeepsie, N. Y.

BRANCH STUDIOS: Holyoke Mass., Danbury, Conn. Fishkill and Matteawan, N. Y.

feel and that we are generally successful in our endeavor, thousands of our patrons in every locality will attest.

Repeated in the *Great Scheme of Mr. Cabnitts*, the racial joke the card stages would have been familiar to Gallup's target audience, or the white middle class of the Hudson River valley that had been consuming caricatures of African Americans with widely grinning mouths and slices of watermelon in hand since the antebellum period. Commonly found in illustrated periodicals, sheet music, comic paintings, and commercial advertisements, such representations became increasingly prolific in both the North and the South in the wake of the Civil War, when whites looked to the visual language of racial humor to reinforce the color line symbolically threatened by the abolition of slavery. It was through the watermelon that they could portray African Americans as lazy and incapable of productive labor; greedy and mischievous, having stolen the fruit from white farmers; unrefined, even brutish, as they ripped into its juicy flesh with their teeth and indulged their base desires. More than any other "thing" associated with the black body in the postbellum United States, the watermelon came to embody the limited range of black feeling in the white mind; it was the "darkey's" most beloved happy object and a primary instrument through which African Americans were themselves made to function as the objects of white pleasure.

It was at the same historical moment that American photographers began producing commercial photographs by the tens of thousands in which black sitters bare their teeth for the camera, often at the sight of the overdetermined fruit. In these images, smiling black bodies challenge the dominant social order, insofar as they refuse to (or simply cannot) contain their emotions, suggesting that they may not easily be contained and controlled by white society. Any social power we might imagine melon-eating sitters could derive from such transgression is mitigated by the fact that middle-class whites in late nineteenth-century America associated blackness with a primitive state of human evolution recapitulated in the life of the white subject only in childhood.[31] Much like the emotive subjects of Landy's *Expressive Pets*, African Americans were granted the freedom to convey the deepest grief and the heights of joy before the camera, but only if they became widely circulated commodities for the amusement of paternalistic white viewers. This idea was put on spectacular display in blackface minstrelsy, which expressed the presumed "natural freedom" of black bodies through the "grotesque, gaping, perpetually smiling mouth that was always part of the minstrel mask."[32]

Speaking to the raced character of emotion at the turn of the century is a pair of comic stereocards published in 1892 by Underwood & Underwood, then the leading stereographic firm in the United States (figs. 37 and 38). In the first of the cards, viewers are encouraged to read a common romantic scene featuring two lovers stealing a

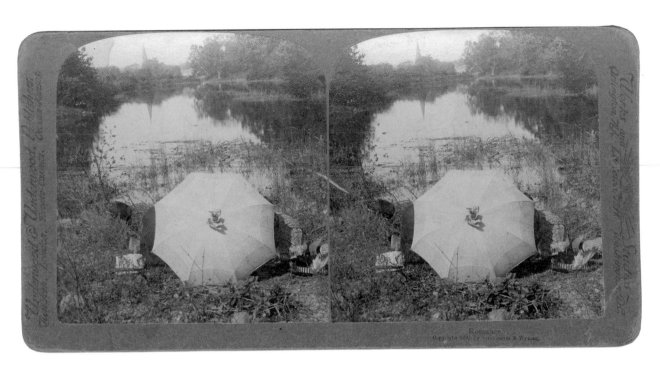

Romance.
Copyright 1897 by Strohmeyer & Wyman.

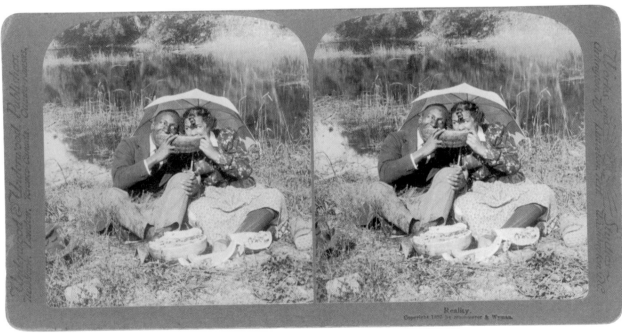

Reality.
Copyright 1897 by Strohmeyer & Wyman.

kiss beneath a parasol. The next card delivers the punch line, as they are offered what had been hidden from view: a black couple feverishly consuming watermelon. Within this fantasy of blackness, the figures can never escape their "true" (that is, racially stereotyped) character, despite their best efforts to leave behind the "uncivilized" ways of the slave. Portrayed as a naïve, childish pair capable of feeling only simple pleasures, the black couple in this commercial photograph, as in so many others of the period, is decidedly not the complex emotional subject that Gallup presented to us in his own romantic vision of "anticipation" and "reality."

As literary scholar Saidiya Hartman has argued, the image of the "happy darky" with his watermelon smile helped white Americans in the antebellum period imagine the slave as not only contented but happier than they were. The trope thus became a means of justifying, and effectively perpetuating, the violence of slavery. It would remain important for whites to assert control over emancipated blacks by defining themselves against their affective experience, synonymous as it was with "excessive enjoyment," and justifying their continued exclusion from hegemonic culture.[33] That the trope continued to derive its power in relation to white violence against African Americans can be demonstrated by its frequent appearance in the 1880s and '90s in northern newspapers like the *Poughkeepsie Daily Eagle*, which regularly juxtaposed accounts of singing, dancing, and watermelon-stealing "darkies" with reports of black crimes, usually punished by lynching or murder. What specific work, then, was the image of the "darky and the melon" called upon to do within the local photographic context in which Gallup inserted it? Significantly, we are presented in *The Melon Story* not only with a popular caricature but with a comparison between the smile that appears on a black boy's face when presented with the fruit and the appearance of happiness that Gallup believed he could capture on the faces of his studio patrons.

This may strike the modern reader as strange, given the abundant visual evidence of his (and their) commitment to cultivating whiteness and gentility in his studio. The only white sitters who ever brazenly bared their teeth for Gallup's camera were actors and actresses, whose theatrical portraits allowed for such challenges to social convention in the second half of the nineteenth century. What is more, when Gallup did take portraits of free African Americans, who had settled in modest numbers in the Hudson River valley before and after the Civil War, he often employed the same poses, backgrounds, props, and furniture he had established for white portraiture (fig. 39).[34]

To understand what it meant for Gallup to rely on the "happy darky" to advertise his skills as a photographer of respectable subjects, we must look elsewhere and consider that this was not the first, nor would it be the last, time that a black smile addressed American consumers in commercial visual culture. Indeed, it was instrumental to selling everything from soap and soup to footwear and other manufactured

37. Underwood & Underwood, *Romance*, 1892. Albumen prints mounted on stereocard. Private collection.

38. Underwood & Underwood, *Reality*, 1892. Albumen prints mounted on stereocard. Private collection.

39. C. H. Gallup & Co., portrait of an unidentified couple, ca. 1890. Albumen print mounted on cabinet card. Private collection.

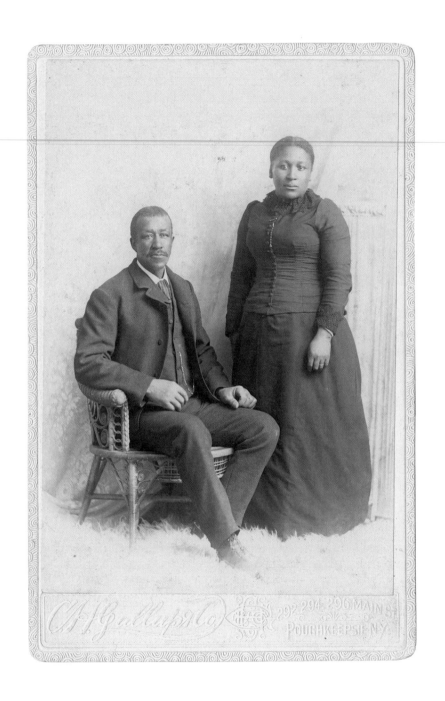

goods, including photographic equipment. In the last category we can place a series of advertisements produced around 1900 by the Scovill & Adams Manufacturing Company of New York to market their aptly named "Improved Dixie Vignetter." A descendant of the first company to produce daguerreotype plates in the United States, Scovill & Adams designed this apparatus to create an "artistic" (and decidedly white) halolike effect around the subject, describing it as "practicable, cheap, simple, durable, and indispensable" to the amateur photographer. Further, to promote the vignetter's unique adjustability and the pleasure the user derived from it, the company adopted an image of a caricatured black boy, pictured as if he were bursting off the page and holding a slice of melon to his widely grinning mouth (fig. 40). Now that it is "more convenient to adjust and operate, and is more durable," indeed "more adjustable than a darkey's mouth in watermelon season," the advertisements explain, the "Improved Dixie Vignetter" "delights all who use it."[35] In this pairing of text and caricature, Scovill & Adams brought into dialogue two popular assumptions about the black body at the turn of the century: As a commodity, it was infinitely adaptable to the needs and desires of the white consumer, and as an emotive subject, it had a unique ability to feel and express happiness. Similarly, Gallup assumed that the young black boys who posed for his camera were "convenient to adjust and operate"—necessarily so, as he instructed them to perform a racial stereotype—all while celebrating their "natural" affective responses to the object he placed before them.

By comparing the marketing strategies of C. H. Gallup & Co. with those of Scovill & Adams, we can begin to see how *The Melon Story* participated in a popular discourse through which whites' apparent emotional deficiency, or their inability to *feel* truly happy, ironically functioned as a source of power. I refer here to the power to represent the black body as nothing more than an instrument of and for white happiness. This ironic gesture was common in white images of the black, both in the context of slavery and long after emancipation, though in no other cultural practice was it more spectacularly evident than in blackface minstrelsy. It was through the comic songs, dances, and skits of the American minstrel show, which enjoyed a popular revival in Poughkeepsie and other northern cities in the last decades of the nineteenth century, that blackface performers and their largely working-class audiences were invited to appropriate exaggerated "black" affect.[36] As Hartman observes, such appropriation did much more than imagine blackness as an "abject and degraded condition"; it fulfilled a "desire to don, occupy, or possess blackness or the black body as a sentimental resource and/or locus of excess enjoyment" without compromising the audience's "serious" performances of whiteness and respectability elsewhere.[37] In fact, critical studies of minstrelsy have shown that this form of social parody could make those performances

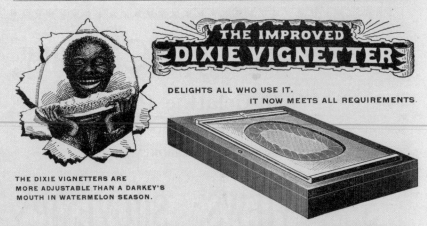

THE IMPROVED DIXIE VIGNETTER

DELIGHTS ALL WHO USE IT.
IT NOW MEETS ALL REQUIREMENTS.

THE DIXIE VIGNETTERS ARE
MORE ADJUSTABLE THAN A DARKEY'S
MOUTH IN WATERMELON SEASON.

IT IS THE ONLY SUCCESSFUL ADJUSTABLE VIGNETTER.

As now made it is much more convenient to adjust and operate, and is more durable. It fully meets the requirement of the most exacting. It can now be adjusted to the negative from the face side. The light-diffusing medium can be removed or attached instantly, and any kind the operator desires may be used, or it can be used without any on dark days. And the disks composing the adjustable diaphragm are protected and held in place while in use; and many kinks and turns can be worked that the old style would not allow.

IT IS PRACTICABLE, CHEAP, SIMPLE, DURABLE, AND INDISPENSABLE
TO ALL PHOTOGRAPHERS WHO KEEP UP WITH THE TIMES.

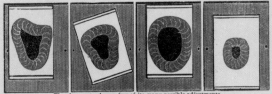

It is attached to the ordinary printing frame, and can be quickly, easily, and accurately adjusted to any Negative—the Pear, Oval, Round, Square, or any desired opening can be produced of any size required, and right where it is wanted.

It will save enough in time and material to pay for itself a dozen times in a year, to say nothing of the superior results produced.

The above cuts show a few of its many possible adjustments.

It will enable the amateur to obtain beautiful results from many of his faulty plates, and give a variety and charm to his work that will give endless satisfaction.

PRICE LIST.

3¼ x 4¼ Size 30 cents each	-	$3.50 Per Dozen.	5 x 8 Size 30 cents each	-	$3.50 Per Dozen.
4 x 5 " 30 " "	-	3.50 "	6½ x 8½ " 45 " "	-	5.00 "
4½ x 6½ " 30 " "	-	3.50 "	8 x 10 " 60 " "	-	7.00 "
4¾ x 6½ " 30 " "	-	3.50 "	10 x 12 " 75 " "	-	9.00 "
5 x 7 " 30 " "	-	3.50 "	Sample by mail, post paid, 10 cents additional.		

Try some, and if you are not satisfied, return them and get your money back. For sale by all Photo-Stock Dealers

SOLE AGENTS, THE SCOVILL & ADAMS CO. OF N. Y., 60 AND 62 EAST ELEVENTH STREET, NEW YORK.

KINDLY MENTION THE PHOTOGRAPHIC TIMES.

appear more credible, even seem as if they were not performances at all, since acting as the "other" implies the preexistence of a "real" and coherent self.[38]

PLAYING THE OTHER

The Melon Story reproduces the logic of blackface in the context of the commercial portrait studio by treating the black body as an authentic site of emotion and suggesting that it can be used as an object of comic imitation by whites. Simply put, the caricatured black smile functions, in the studio and on the stage, as a vehicle for the performance of white bourgeois identity. That this relationship between studio and stage is more than an immaterial fantasy conjured in the mind of one Poughkeepsie photographer is suggested by the existence of commercial photographs that paired white bodies, often those of children, with large slices of melon. Ironically, images like figure 41 construct a physical *resemblance* between white subjects and caricatured African Americans in order to bring into focus their profound social *differences*.

The stereocard in figure 41, titled *"Oh, Dat Watermelon," Each One with a Slice* appeared in multiple comic stereographic series in the 1890s and early 1900s. The text on the back of the card describes an idealized scene of white childhood and innocence. "Boys are boys," it explains, "and boys do boyish things." With watermelon slices in hand, these white children scrambled to the pier, "sank their teeth into that rosy pulp, and closing their eyes had the first good taste and grunted with pleasure." The image's title, however, maps racial politics onto the boys' seemingly innocent actions. Caricaturing southern black dialect, the phrase "Oh, Dat Watermelon" was the title of a popular minstrel song written in 1875 and performed by whites in blackface into the twentieth century. Thus framed, the white boys' watermelon smiles become comic gestures that imitate the exaggerated expressions of happiness associated with the pickaninny stereotype. Significantly, a card featuring precisely that stereotype, in the form of a black girl eating a large slice of melon, was included in 1905 with the stereocard *"Oh, Dat Watermelon"* in the same set of comic views, encouraging a conversation between the images (fig. 42).[39] According to the logic of the stereographic series, the white boys are merely enjoying the delights of summer available to white middle-class families on holiday, while the smiling black girl in *"Did You Say Watermelon Was No Good?"* embodies the perceived simplemindedness of an entire race; boys are boys, the cards assert, while blacks are blacks.

Less common than these stereocards were actual studio portraits in which white sitters posed with melons under the skylight, proudly displaying their happiness for the camera. In one such photograph taken around 1900 (fig. 43), the subjects are respectably dressed, much as one would expect a middle-class family to be, although

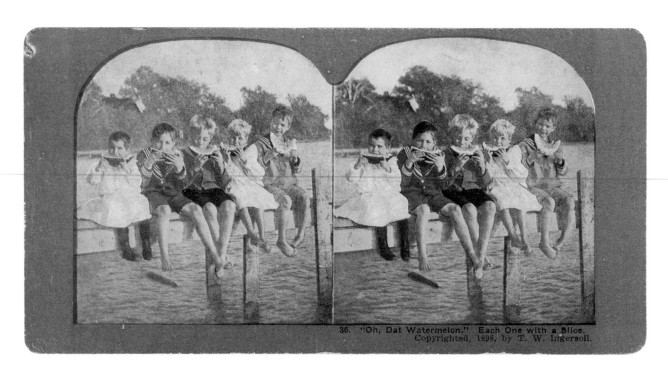

36. "Oh, Dat Watermelon." Each One with a Slice.
Copyrighted, 1898, by T. W. Ingersoll.

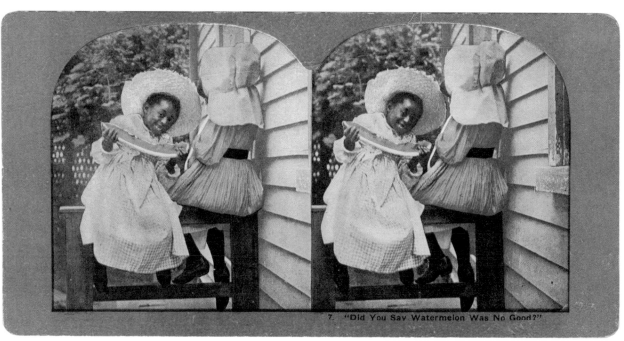

7. "Did You Say Watermelon Was No Good?"

their casual poses, direct gazes, broad smiles, the odd inclusion of a doll, and a gesture of greeting to the viewer—all of which break with the conventions for early studio portraiture—suggest that the picture was taken in a self-consciously performative, if not comic, mode.[40] Without any other information about the sitters or their photographer, we are left to wonder who or what motivated them to pose with the happy object most closely associated with caricatured blacks. Had the camera operator offered the fruit to stimulate exaggerated expressions of happiness in a particularly stern group? Or was it brought to the studio by the sitters themselves, who may or may not have been thinking about the watermelon's prominent role in racial humor of the period?

These are the kinds of questions that historians of early photography might be most keen to answer. But, as historian Alan Trachtenberg has observed, it may be in acknowledging the ambiguities of sitters' smiles that we can do some of our most productive work—in this case, thinking about what the expressive faces in the picture *don't* tell us about the photographed subjects and how they invite us to create narratives about what those subjects think and feel.[41] Like the raised hand of the man at left, the watermelon functions as a gesture of inclusion, an object that seems to say to the viewer, "come, laugh with us and join in our pleasure." This gesture can be said to have a politics insofar as it creates the conditions for a viewer to be "in" on a joke—to see how the consumption of melon comically interrupts the performances of respectability in which we would expect these "white" sitters to engage, and to imagine oneself as belonging to a social group for whom such self-presentation was not only expected but apparently natural.

It would take important changes in middle-class urban culture in the United States for appropriations of stereotypical black attributes, as imagined by C. H. Gallup & Co., to become possible and meaningful for white sitters before the camera. It would require a newfound interest in self-expression, self-confidence, and self-fulfillment to liberate these subjects from the social restrictions placed on bodily comportment in the nineteenth century, to encourage them to externalize their thoughts and feelings through the face, and to generally enable an individual to stand out in a group and attract the attention of others. The new presentation of self that cultural historians have associated with rapidly expanding and industrializing urban culture at the turn of the century, in other words, set the stage for the toothy smile to become an icon of individual personality.[42] That the introduction of broad grins into commercial portraiture around 1900 came by way of the watermelon further connects the photographic smile to the raced and gendered anxieties about civilization that were then beginning to dominate popular literature, scientific studies, and a wide variety of bourgeois cultural practices. It was in 1905 that U.S. president Teddy Roosevelt warned Americans of an impending "race suicide," which he believed required that Anglo-Saxon women give

41. T. W. Ingersoll, *"Oh, Dat Watermelon," Each One with a Slice*. Color lithoprint on stereocard, published by Sears, Roebuck & Co., 1905. Private collection.

42. T. W. Ingersoll, *"Did You Say Watermelon Was No Good?"* Color lithoprint on stereocard, published by Sears, Roebuck & Co., 1905. Private collection.

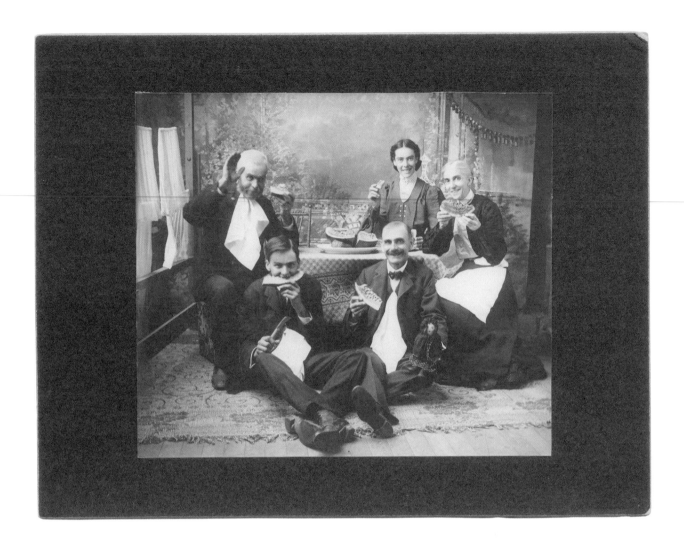

43. Unknown photographer, group portrait with watermelons, ca. 1900. Gelatin silver print mounted on cardboard. Private collection.

birth to at least four children if whites were to surpass the procreation rate of ethnic minorities. He also warned that an excess of civilization connoted cultural and bodily weakness. And so holding a melon to one's lips became an opportunity to indulge safely in the powerful emotions and physical force of "primitive" man, without ever leaving the bourgeois environment of the portrait studio. Although cultivating primitive passions was seen as particularly important for white men as they worked to reinvigorate their sexual powers and reassert their racial dominance, children and even women were also invited to embrace the habits, pleasures, and self-possession of the "savage" or "natural" man.[43] Coinciding with the popularization of Social Darwinism, the rise of the physical culture movement, and the proliferation of opportunities for white ladies and gentlemen to "go native," C. H. Gallup & Co.'s promise to make its sitters look

as happy as caricatured blacks may thus be seen as extraordinary in form, but not in content.

By placing ideas about social identity at the center of photographers' efforts to arouse "true and pleasant" expressions, this chapter demonstrates that one of the most interesting and challenging questions we can ask about the toothy smile is not *where* but *how* to locate it in the history of photography—technologically, aesthetically, culturally, and politically. What I am calling for, in other words, is for scholarship to be conscious of the intersection of emotion and identity that has given rise to innumerable photographic smiles over the past century. This will involve radically rethinking contemporary photographic practices and implicating our own family portraits in ideas that might cause discomfort, guilt, and even pain—very little, as it were, to arouse a pleasing expression.

The narrative outlined here further disrupts the assumption that Eastman Kodak offered middle-class Americans, beginning in the 1890s, a radically new means of performing and documenting good feelings, one enabled by technological advances and a democratic spirit previously unknown in commercial portraiture. Not only did figures like C. H. Gallup imagine that they were in direct competition with Kodak, which first marketed its handheld camera to amateurs at precisely the same time that the Poughkeepsie photographer launched his advertising campaign, but their fantasies of what it would take for white subjects to look happy in a photograph were remarkably similar. The final chapter of this book explores this connection, reminding us how much performances of joy for the camera continued to depend on the subjugation and unhappiness of "others" well into the twentieth century.

Chapter 4

Writing the Self Through Others

RACIAL HUMOR AND THE PHOTOGRAPHIC POSTCARD

"Thursday. Dear Frederick, Well here we are away down South, it is very nice here just now, have had lovely weather—Uncle Henry is feeling fine, walking just now—going to play golf." So begins one of the many postcards that Frances Mathews sent to her sister's grandson, Frederick Hoeing, from her winter retreat in Ormond Beach, Florida. The boy was six years old on February 3, 1913, when this particular missive was posted to Frederick's home in Rochester, New York.[1] For the occasion, "Auntie Frank" selected from the sizeable stock of the Detroit Publishing Company a card titled *A Native Product* and featuring two African American boys in tattered clothing (fig. 44). One holds a thumb to his mouth and gazes back at us over his shoulder; he appears the younger of the two, as the taller boy on the right grips his shoulder and looks at the viewer attentively, protectively. These children, in the absence of any visible adult care, resonate with the motherly reminders that Frances scribbled to young Frederick on the back of the postcard: to visit "Jennie" while "Morten" is away, to "take good care of Betty" while Frances is not with her, and to "be a good boy as you always are." That the black boys pictured on the front of the card stand at the edge of railroad tracks makes the postcard a fitting carrier for further messages, specifically concerning Frances's travels from upstate New York to the southeastern corner of the United States.

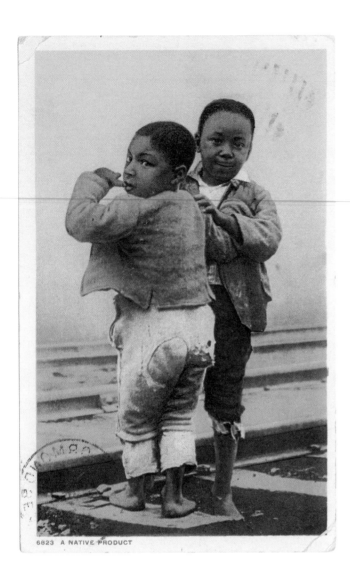

6823 A NATIVE PRODUCT

In subsequent winters, Frederick continued to receive cards from his relatives in Florida that featured racial stereotypes, including many that paired what northern whites considered the state's most exotic native creatures: African Americans and alligators. At times, Frances's inscriptions on these cards make explicit references to the scenes at hand, as in figure 45. Titled *Alligator Bait*, this view of five naked black boys perched on a fallen tree, prey to the hungry animal at the edge of the swamp, is among the most disturbing and most popular representations of black children designed to solicit white laughter in the early twentieth century. It was, however, intended as nothing more than harmless drollery by Frances Mathews, who wrote on the back side of

the postcard, "How do you like these black boys. What you see down here," before signing off with "a big kiss." On another card, *The Home Stretch in Florida*, Frederick would have seen a black boy turn the tables on an alligator by tying a rope around its mouth and using the beast as a means of transportation—indeed, to run a race. To this image his aunt added, "How would you like to take this same ride" (fig. 46). At other times her engagement with the image was less direct, but still meaningful in relation to the news she sent home to Rochester. On January 23, 1917, for example, Frances penned on *A Joy Ride in Florida*, illustrated by a group of black boys seated along an alligator's back: "Tuesday. Well how was the dinner—great success I hope—well how is everything at 69—hope Jennie and Wade <u>is</u> <u>all</u> <u>safe</u>. Uncle Henry is looking fine eating <u>every</u> <u>thing</u> will soon play golf. <u>Hot</u> here today—80 on piazza—a big kiss from Auntie" (fig. 47). Here, the sender's invocations of *dinner*, *eating*, and *heat* do more than offer an account of her daily life of leisure in Florida and differentiate it from that of Frederick's snowy Rochester; they play with what literary scholar Kyla Wazana Tompkins has identified as a potent racial fantasy of the period, namely, that of "the edible and delicious black subject."[2]

 The racial humor in this correspondence, preserved in the collection of the Schomburg Center for Research in Black Culture, was highly conventional and appeared with great regularity in American postcards in the early twentieth century. As cultural historian Brooke Baldwin has observed, of the nearly one billion picture postcards sold annually between 1905 and 1915 in the United States, some of "the most popular and profuse were those portraying blacks," often stereotypically. During this period, which overlapped with the golden age of postcards (1898–1913), images of African Americans "were considered appropriate illustrations for holiday greetings, exchanges of neighborhood gossip, expressions of concern for bed-ridden loved ones, and declarations of both familial and romantic love."[3] While the images selected by Frances Mathews bore some relevance to her travels in Florida, such depictions were common on early twentieth-century postcards even when there was not a clear connection to the occasion for sending a card. That is to say, the connection becomes apparent only when we consider the role that racially charged images played in the identity formation and social cohesion of white middle-class Americans.

 My analysis of racial humor in this chapter shows that it was through the interplay of commercial images and captions with handwritten inscriptions that early photographic postcards accomplished the social and cultural work that historians have attributed to the popular genre. Attending to the back side of posted cards—where one typically finds the names and addresses of recipients, stamped postmarks, the signatures of senders, comments on the commercially printed images, and personal messages—has become a key method of interpretation in the burgeoning field of postcard studies

44 [a,b]. Detroit Publishing Company, *A Native Product*, ca. 1902. Offset photomechanical print (recto and verso). Posted from Ormond Beach, Florida, to Rochester, New York, February 3, 1913. Photographs and Prints Division, Schomburg Center for Research in Black Culture, The New York Public Library, Astor, Lenox, and Tilden Foundations.

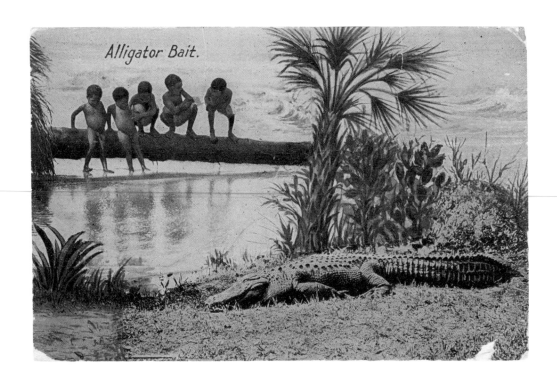

45. Unknown manufacturer, *Alligator Bait*, ca. 1907. Offset photomechanical print. Photographs and Prints Division, Schomburg Center for Research in Black Culture, The New York Public Library, Astor, Lenox, and Tilden Foundations.

46. Cochrane Co., *The Home Stretch in Florida*, ca. 1907. Offset photomechanical print. Photographs and Prints Division, Schomburg Center for Research in Black Culture, The New York Public Library, Astor, Lenox, and Tilden Foundations.

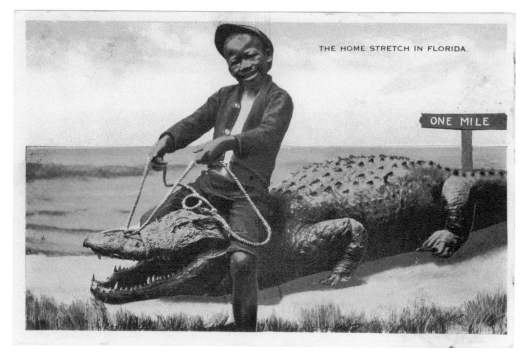

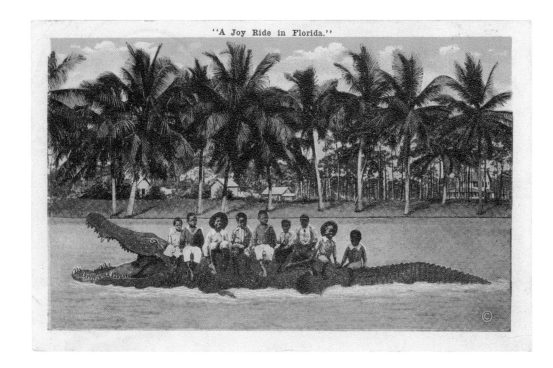

47 [a,b]. E. C. Kropp Co., *A Joy Ride in Florida*, ca. 1907. Offset photomechanical print (recto and verso). Posted from Ormond Beach, Florida, to Rochester, New York, January 23, 1917. Photographs and Prints Division, Schomburg Center for Research in Black Culture, The New York Public Library, Astor, Lenox, and Tilden Foundations.

since Baldwin published her study of postcards in 1988. As Naomi Schor explains in her influential analysis of *cartes postales* depicting Paris circa 1900, the "image face of the postcard provides visual representations" that we must carefully consider, but "the message side records the millions of exchanges between the men and women of that time, which often refer quite explicitly to the choice of image, for the sides are not sealed off from one another any more than are the signified and signifier." And so "it is in reading those communications, which range from laconic formulaic greetings to virtual letters . . . , that one is placed in the position of the voyeur, or better yet the eavesdropper on everyday life."[4]

Of course, the inscriptions found on photographic postcards that rendered African Americans objects of laughter constituted a particular kind of communication. Like all writings on early postcards, they were necessarily brief, usually confined to the white margins of the image or to the small area reserved for personal messages on a card's divided back (a format first introduced in 1907). They were generally written quickly, in an informal tone, and with reference to knowledge shared by the sender and recipient, who could be family members, neighbors, or friends. The inscriptions, moreover, interacted with the cards' iconography, almost always supporting their racial politics. As Baldwin and sociologist Wayne Martin Mellinger have shown, words and images worked together in early American postcards to maintain a socially legitimized and nationally disseminated racism. What scholars have been less attentive to, and what this chapter sets out to explore, is the crucial role that photography played in the process.[5]

In many ways, it was the photographic character of picture postcards that shaped how Americans used them as vehicles for racial humor and that enabled the cards to carry ideological messages of personal relevance. Unlike cards that reproduced hand-drawn images or popular prints, color offset prints based on photographs fueled a fantasy that the black types they depicted were based on actual, if not firsthand, observations. They were therefore treated as "true" images against which postcard senders and recipients could construct visions of themselves as white and middle-class. Produced by some of the largest postcard publishers in the United States, the photographically illustrated cards considered here attracted from their predominantly female consumers a surprisingly limited range of responses. Most common among these were comparisons between the pictured black bodies and the everyday lives of the postcard sender and her intimates. The laughter that such comparisons may have generated through a card's exchange, intended to communicate feelings of belonging and affinity across distances, shows us how important the quotidian intersection of photography, race, and humor had become for many—if not most—Americans in the first decades of the twentieth century.

Most histories of the picture postcard in the United States highlight the years 1898 and 1907: the former, when the U.S. Post Office Department allowed publishers to begin printing what were called "private mailing cards," and the latter, when it decided to divide the back of the postcard in half, allowing one side to carry a handwritten message and the other a postal address. The years in between were just as significant, however, for they witnessed the rapid development of higher-quality color photolithographic printing processes, their gradual shift from Germany to U.S.-based publishers, and a boom in American postcard production and consumption. In 1906, for instance, the trade publication *Post Card Dealer*—itself evidence of a thriving industry—reported that Germany still led the annual national consumption of postcards with a staggering 1,161,000,000, but the United States was a close second with a reported 770,500,000.[6] For the fiscal year ending June 30, 1908, the U.S. Post Office recorded a total of 667,777,798 cards mailed from and to the United States. As historian Daniel Gifford has deduced from the 1910 U.S. census records, "that would be seven postcards a year for every man, woman and child in the nation, and that does not even count postcards collected in albums and boxes and never mailed."[7] Indeed, collecting clubs had become popular in cities across the country beginning around 1905, with stationery firms and publishers producing albums designed for the collection of picture postcards. The latter sponsored collecting contests in addition to issuing cards in numbered sets or souvenir folders, assembling images related to a particular theme. There was no shortage of outlets from which to purchase these cards, with retail stores, druggists, vacation spots, and pushcart vendors all capitalizing on the craze.[8]

Among the producers of the cards discussed in this chapter were some of the nation's largest publishers in the Midwest and Northeast, including the Detroit Publishing Company (formerly the Detroit Photographic Company), E. C. Kropp Company of Milwaukee, Curt Teich Company of Chicago, and Hugh C. Leighton Company of Portland, Maine. When it came to printing photomechanical images of African Americans at the height of the postcard craze, Detroit led the way with respect to the numbers of cards it generated, the size of its distribution area, and the technical quality of its reproductions. What the company referred to as "Negro" subjects appeared in every series it issued between 1901 and 1913. The 6000 series of 1902, for example, consisted of 733 offset photomechanical prints; of those, at least seventeen titles invoked black types, many of which were presented as comic. These were *Living Easy* (6074), *Seben, Come Leben* (6075), *Bliss* (6076), *A Horseless Carriage* (6330), *Eight Little Pickaninnies Kneeling in a Row* (6397), *A Happy Family* (6470), *Sunny Jim* (6471), *Mammy Going to Market* (6472), *First Hoeing of Cotton* (6820), *Envy* (6821),

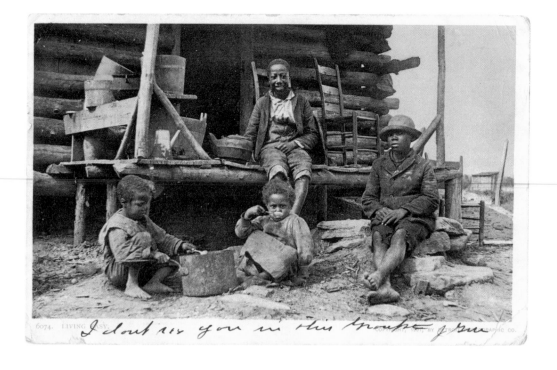

48. Detroit Photographic Company, *Living Easy*, ca. 1902. Offset photomechanical print. Private collection.

Anticipation (6822), *A Native Product* (6823) (discussed above), *Coons in a Cotton Shed* (6824), *Brotherly Love* (6825), *Discovered* (6826), *A Study in Black and White* (6827), and *I Wasn't Born to Labor* (6834). Cards with overtly racial content often appeared consecutively in a given series, encouraging the avid collector to generate from them a narrative about black life in America. From an image of African American children in ragged clothes sitting outside a dilapidated log cabin, hardly "living easy" (fig. 48), for example, the collector would move to an image of black boys crouching on the ground beside a clapboard house intent on a game of marbles (fig. 49), before encountering a photograph of two boys posed in front of the same house, one experiencing the "bliss" of sinking his teeth into a watermelon slice while another covertly grabs a slice for himself (fig. 50). Thus constructed was a story about blacks' so-called propensity for poverty, idleness, simple gratifications, and mischievousness—one that would have been familiar to the cards' middle-class consumers, just as it will be familiar to readers of this book. That these three cards in the 6000 series were surrounded by images of the Thousand Islands, New York, and views of Native Americans and Mexican types suggests that the Detroit Publishing Company saw them as belonging to the same white bourgeois worldview, one that fantasized about outdoor leisure and about racial and ethnic difference.[9]

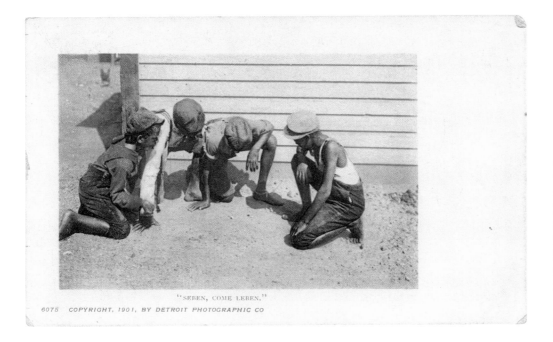

49. Detroit Photographic Company, *Seben, Come Leben*, ca. 1901. Offset photomechanical print. The Miriam and Ira D. Wallach Division of Art, Prints and Photographs: Photography Collection, The New York Public Library.

50. Detroit Photographic Company, *Bliss*, ca. 1902. Offset photomechanical print. The Miriam and Ira D. Wallach Division of Art, Prints and Photographs: Photography Collection, The New York Public Library.

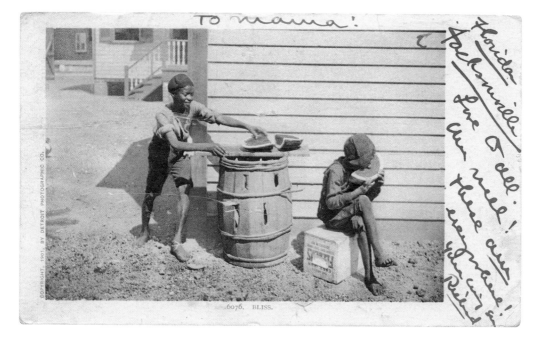

In his study of American holiday postcards, Daniel Gifford draws several conclusions about who was sending and collecting cards, and from where, in the early days of the craze. Surveying a sample of two thousand postcards listed on the auction website eBay, Gifford found that "the great majority of postcard recipients were living in rural or small-town communities (populations of less than 10,000)" located chiefly in the northern states, especially in New England. They were also predominantly women, children, and "*white* middle-class (and aspiring middle class) consumers," or those belonging to "ethnic stocks that hailed from Northern and Western Europe."[10] He speculates that America's "new" immigrants and African Americans generally did not send or receive postcards at the height of their popularity, for obvious reasons; when picture postcards with Christmas, Thanksgiving, and other holiday themes did not exclude nonwhites from their iconography, they assigned them stereotypical roles. To take pleasure in the Detroit Publishing Company's 6000 series, in other words, one had to see oneself as the kind of person for whom a vacation to the Thousand Islands would be expected and natural, and for whom images of black boys in comic scenarios would generate feelings of racial superiority.

Admittedly less quantifiable than Gifford's survey, my analysis of photographic postcards illustrated with racial stereotypes is based on material in two important institutions with publicly accessible collections—the New York Public Library and the American Antiquarian Society—along with the private collection I built over a decade through purchases from online auctions. The postcard correspondence with which this chapter began is consistent with Gifford's conclusions regarding the audiences for postcards, insofar as its sender saw herself as a white middle-class woman and its recipient a male child of the same ilk residing in New York State. But the fact that the cards were sent from Frances Mathews in Florida complicates Gifford's view that postcards were a practice associated almost exclusively with the northern industrial states. Indeed, many of the cards analyzed below were posted from the South to the North, from friends and relatives traveling or residing below the Mason-Dixon line. This indicates that early picture postcards featuring racial humor had a broad national reach, as previously noted by Brooke Baldwin.[11] It may also point to something specific about photographic stereotypes of African Americans as a postcard trope—namely, that they were deemed especially suited to communication across great distances in the United States, traversing its internal and politically charged borders. The handwritten messages on these postcards often used the illustrations on the front to emphasize difference, to distinguish an *us* from a *them*, which is consistent with a card crossing a geographic or cultural divide.

The variety of racial humor considered here further complicates Gifford's observations about the relationship between the recipient of a card and the subject of its imagery. In correlating postmarks with U.S. census records, Gifford found it "notable

how many times the image on the postcard mirrored the general description of the recipient. . . . Within the chain of capitalist consumption it is obvious that a conscious process of identification between image and recipient was taking place at the point of purchase." This observation led Gifford to propose an explanation for the apparently "hostile reaction to comic postcards" he encountered in historical writing about holiday cards. For if "children were meant to see themselves in postcard imagery," then through their encounters with humorous cards they "risked absorbing the 'wrong' messages." Such cards "had the power to twist and undermine the process of identification, acculturation, and socialization that postcards . . . were meant to achieve."[12] Twist, perhaps, if by that Gifford means compounding and enriching psychological, cultural, and social processes—but certainly not undermining or weakening those processes. As I argue here, everyday encounters with comic images of African Americans, framed by the guiding hand(writing) of a trusted adult, had the ability to fuel children's fantasies of their own whiteness and rightness, encouraging the consolidation of a discrete and desired self.

PUTTING PEN TO PAPER

The inscriptions accompanying the racial humor of early postcards were not only proscribed by social conventions; they were also directed toward particular identity-shaping processes. Exemplifying this characteristic are the busy tourist's correspondence cards that E. C. Kropp Company and other large postcard manufacturers printed in the 1920s and '30s. The front side of these cards featured a comic illustration of an African American, and beside it a series of boxes in which the sender could check off the specific characteristics of his or her message. Figure 51 depicts a black child clinging to the trunk of a palm tree as two wide-mouthed alligators anticipate his fall—a well-worn, even comfortable scene for consumers circa 1900, but one that can shock and disgust viewers today. Its caption—"'Honey, Come Down! I'm Waiting for You'—in Florida"—aligns the gators with the card sender, signaling their shared delight in consuming a black body, either for lunch or through the tourist industry. The sender dutifully, and playfully, followed the card's instructions to "avoid writer's cramp—save time—check only items desired" to produce this hackneyed message: "Dear *old thing*, How are you? I am *enjoying*. Here it's *delightful*. Here I enjoy *loafing*. People here are *interesting*. I spend evenings *at movies*. Business is *good*. *I don't fish much*. I need *you*. My next stop is *Sarasota*. Expect me home *soon*. Yours *lovingly*, A. P." The twelve categories the sender could select from a limited set of options tell us much about what Americans expected of the tourist postcard in the early twentieth century: it would be addressed to a friend or loved one, indicate the sender's current emotional state and needs, document his or her leisure activities, which were dictated in part by the

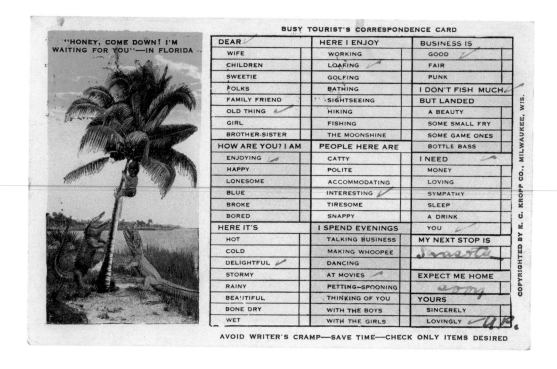

114

"HONEY, COME DOWN! I'M WAITING FOR YOU"—IN FLORIDA

DEAR	HERE I ENJOY	BUSINESS IS
WIFE	WORKING	GOOD
CHILDREN	LOAFING	FAIR
SWEETIE	GOLFING	PUNK
FOLKS	BATHING	I DON'T FISH MUCH.
FAMILY FRIEND	SIGHTSEEING	BUT LANDED
OLD THING	HIKING	A BEAUTY
GIRL	FISHING	SOME SMALL FRY
BROTHER-SISTER	THE MOONSHINE	SOME GAME ONES
HOW ARE YOU? I AM	PEOPLE HERE ARE	BOTTLE BASS
ENJOYING	CATTY	I NEED
HAPPY	POLITE	MONEY
LONESOME	ACCOMMODATING	LOVING
BLUE	INTERESTING	SYMPATHY
BROKE	TIRESOME	SLEEP
BORED	SNAPPY	A DRINK
HERE IT'S	I SPEND EVENINGS	YOU
HOT	TALKING BUSINESS	MY NEXT STOP IS
COLD	MAKING WHOOPEE	Sarasota
DELIGHTFUL	DANCING	
STORMY	AT MOVIES	EXPECT ME HOME
RAINY	PETTING—SPOONING	soon
BEAUTIFUL	THINKING OF YOU	YOURS
BONE DRY	WITH THE BOYS	SINCERELY
WET	WITH THE GIRLS	LOVINGLY

COPYRIGHTED BY E. C. KROPP CO., MILWAUKEE, WIS.

AVOID WRITER'S CRAMP—SAVE TIME—CHECK ONLY ITEMS DESIRED

51. E. C. Kropp Co., *Busy Tourist's Correspondence Card*, ca. 1920s. Offset photomechanical print. Posted from Miami, Florida, to Providence, Rhode Island, March 1, 1930. Courtesy American Antiquarian Society.

weather, and comment upon the kinds of people he or she encountered while traveling far from home. Writing from Miami, Florida, to Providence, Rhode Island, around March 1, 1930, "A. P." expressed his or her own pleasure in the card's conceit when addressing Mrs. Charles Walder on the back of the card, "Don't you love this. Labor saving device of the south." Given the great frequency with which scenes of black labor graced postcards from Florida—from harvesting cotton, citrus fruits, and sugarcane to dipping and scraping pine trees for turpentine—the irony of this statement was unlikely to have been lost on the sender. His leisure, a key signifier of white bourgeois identity, was inscribed on the backs of stereotyped African Americans.

While the busy tourist's correspondence cards typically boasted prints made after hand-drawn illustrations, the inscription practices they outlined applied just as readily to photographic postcards. What photography added to the mix was corroboration; anyone could conjure the crudely rendered scene in figure 51, but it was harder to deny the sender's perceptions of a place and its people when their representations were photographic, even though Americans knew that such images were created specifically for a booming postcard industry. In some cases, senders' inscriptions made the supposed veracity of the card's technology explicit, as in a Detroit Publishing Company card with the derogatory title *Eight Little Pickaninnies Kneeling in a Row* that was posted from Richmond, Virginia, to Miss Ruth Pike in Newburyport, Massachusetts, on March 4, 1907

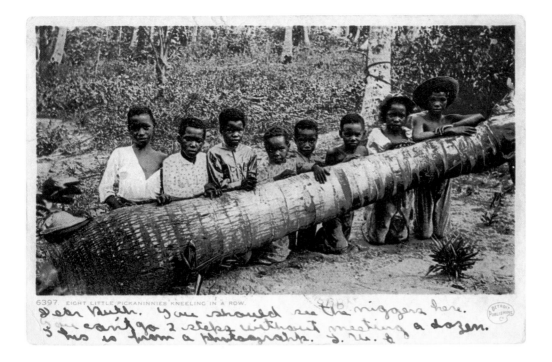

6397. EIGHT LITTLE PICKANINNIES KNEELING IN A ROW.

Dear Ruth. You should see the niggers here. You can't go 2 steps without meeting a dozen. This is from a photograph. J. W. B.

(fig. 52). Handwritten on the front of the card, alongside an image of black boys posed along a fallen tree, are the following words: "Dear Ruth, You should see the niggers here. You can't go 2 steps without meeting a dozen. This is from a photograph." Documenting *how things were* was one of the most important functions that postcards' photographic humor served, yet such documentation depended on the interaction between a predetermined commercial image and handwritten words of the sender's invention.

Cards sent from southern states in this period by white Americans traveling from other parts of the United States routinely objectified and generalized black bodies. We can see these gestures plainly in one of the many examples of *Bliss* printed by the Detroit Photographic Company (see fig. 50), now in the collection of the New York Public Library. On the front of the card, a young man scrawled this message to his mother in Berkeley, California: "Florida Jacksonville. Love to all. Am well! These are everywhere! Your loving son Richard." Insatiably curious about the African Americans pictured on photographic postcards, whites traveling in the South used them as inscrutable evidence of racial difference, proof of what *they* look like and what *they* do, despite the fact that the pictures were obviously staged and framed by comic captions. Through its title, *The Ole Mammie*, a souvenir card from Montgomery, Alabama, for instance, announced that the depicted woman in a headscarf seated in front of a dilapidated cabin was a stereotype, not the stuff of everyday life. Yet "H. J. B.," who posted

52. Detroit Publishing Company, *Eight Little Pickaninnies Kneeling in a Row*, ca. 1902. Offset photomechanical print. Posted from Richmond, Virginia, to Newburyport, Massachusetts, March 4, 1907. Private collection.

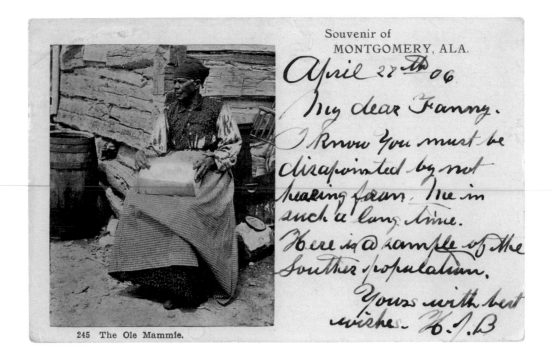

Souvenir of
MONTGOMERY, ALA.

April 28th 06
My dear Fanny.
I know you must be disappointed by not hearing from me in such a long time. Here is a sample of the Southern population.
Yours with best wishes ½.J.B

245 The Ole Mammie.

53. Unknown manufacturer, *The Ole Mammie*, ca. 1905. Offset photomechanical print. Posted from Memphis, Tennessee, to Norwich, New York, May 4, 1906. Courtesy American Antiquarian Society.

the card from Memphis, Tennessee, to "dear Fanny" in Norwich, New York, on May 4, 1906, verified the figure's existence by writing, "Here is a sample of the Southern population," as if the photograph printed on the card were extracted from the place and its people (fig. 53). Similarly, a card posted to Winchester, New Hampshire, on July 19, 1918, declared definitively of Paris Island, South Carolina: "This is the way they travel down here" (fig. 54). That the card carried the title *Rapid Transit* to describe a rickety wooden cart pulled by a single ox—a vehicle that looks anything but rapid— betrays the image's significant limitations as an ethnographic document. It reveals to the modern viewer its principal work as a medium for white fantasies of blacks as incongruous with modern technology, which previous chapters traced through other forms of photographic humor.[13]

Modes of transportation adopted by southern blacks were of special interest to senders of early postcards, in part because of their own recent travel experiences. The geographical distances postcard writers crossed in order to arrive at their destinations tended to be considerable. Cross-country trips were physically taxing in the first decades of the twentieth century, as they involved many long days of travel by train, automobile, or a combination of the two. These trips were therefore often broken up into multiple smaller excursions that resulted in frequent travel across many weeks, with cards marking each leg of the journey. It was probably with her long voyage from

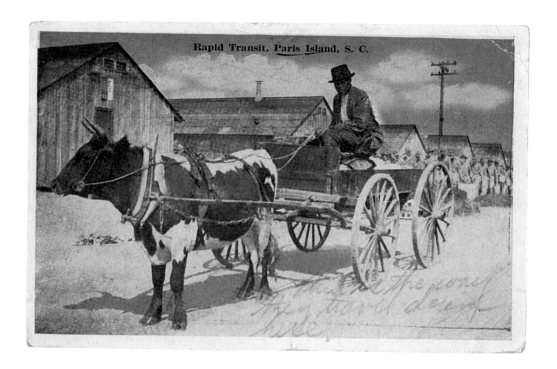

Rapid Transit. Paris Island, S. C.

the Northeast in mind that a woman named Florence sent a Detroit Photographic Company card, *Mammy Going to Market*, home to her relatives in Somerville, Massachusetts, on January 31, 1907 (fig. 55). Not only did she remark upon the ox-drawn cart driven by "Mammy" as "a common team here" in Jacksonville, Florida, but she also commented on her own travel experiences, much as the busy tourist's correspondence cards prescribed: "Arrived safely after a pleasant trip at 3.40. Have dinner here and leave in an hour for Tampa. Fresh fruits and vegetables fine." Likewise, travel appears to have been weighing heavily on the sender of *Rapid Transit* from Paris Island, South Carolina, as the proclamation of "the way they travel down here" was accompanied by a note pointing to the sender's own travels: "Have not been able to locate Arnold as yet. The men don't stay in one place very long."

The travelers who sent cards back home from places like Florida and South Carolina bought into nostalgia for an image of life in the southern states that was a thing of the past by the early twentieth century. Scholars have located nostalgia for the Old South in northern popular culture before and after the Civil War, tracing it through literature, music, and the visual arts. Its plantation imagery allowed urban northerners to momentarily "escape immediate troubles and luxuriate in memories of a less turbulent past"—to enjoy a fictive space, in other words, undisturbed by the realities of mass immigration, industrialization, and political unrest that came to define the Progressive

54. Unknown manufacturer, *Rapid Transit, Paris Island, S.C.,* ca. 1915. Offset photomechanical print. Posted from Paris Island, South Carolina, to Winchester, New Hampshire, July 19, 1918. Courtesy American Antiquarian Society.

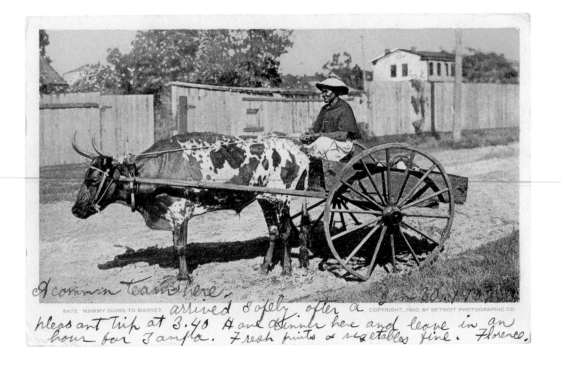

A common team here, arrived safely after a
pleasant Trip at 3.40 Have dinner here and leave in an
hour for Tampa. Fresh fruits & vegetables fine. Florence.

6472. MAMMY GOING TO MARKET. COPYRIGHT, 1902, BY DETROIT PHOTOGRAPHIC CO.

55. Detroit Photographic Company, *Mammy Going to Market*, ca. 1902. Offset photomechanical print. Posted from Jacksonville, Florida, to Somerville, Massachusetts, January 31, 1907. Courtesy American Antiquarian Society.

Era.[14] Images of African Americans laboring productively and contentedly in fields of cotton or driving teams of oxen became commodified tropes in this period, tropes that depended on northern viewers' sensing their own distance from such scenes and on their desires to project onto them fantasies of a time before the cultural anxieties of the present. Postcards like *Rapid Transit* and *Mammy Going to Market* were therefore appealing to northern travelers in part because they reassured them and their loved ones that the acceleration of transportation in American cities—a key symbol of urban life in the early twentieth century—was evidence of social progress and their own success. To observe how racial others traveled was to advocate for the properness and superiority of how white selves navigated modern life.

INSCRIBING IDENTITY AND DIFFERENCE

What becomes clear from these and countless other examples is that postcard senders who imagined themselves as white and middle class were keen to compare their own experiences with those of stereotyped southern blacks. At times, their choice of racial humor when selecting a card to post seems to have been motivated by a recognition of affinity between the caricatured blacks the card depicted and the subjects between whom it was exchanged. Such recognition could be made swiftly and casually, as in

a Detroit Photographic Company card posted from a woman visiting Denver, Colorado, to her young niece, Miss Virginia Bigelow, in Westmoreland, Kansas, on April 28, 1909. For the occasion she selected a popular card titled *Mammy's Pet*, on which she inscribed, "Would love to see you. Hope you are a good girl for Aunt Melva. Going home this morning. Lovingly, Aunt Kate" (fig. 56). Casting Virginia in the role of the "pet" and Melva (or Kate herself) in the guise of "Mammy," these words could have expressed the sender's sympathy toward the innocent-looking African American child on the card. Just as easily, they could have highlighted the differences she perceived between that child and her own niece, differences framed as so obvious that the comparison could only be comical to the pair exchanging the card. Another woman, who had recently moved to Lincoln, Nebraska, selected a card titled *Oh! Dat Ar Watermillion* to carry a message to her young relative, Miss Adele Fisher, on November 15, 1907 (fig. 57). The writer thanked Adele for her latest correspondence and expressed a desire to see the "bunch" back in St. Louis, Missouri, before warning the girl, "don't eat too much turkey [on] Thanksgiving." It is tempting to connect this warning to the overeating black children illustrated on the front of the card, especially since the sender had responded to the image with another inscription. "No thanks I don't care for something," she wrote in polite English that contrasted the caricatured black dialect of the printed caption, as if the kids were offering her a slice of their melon.[15]

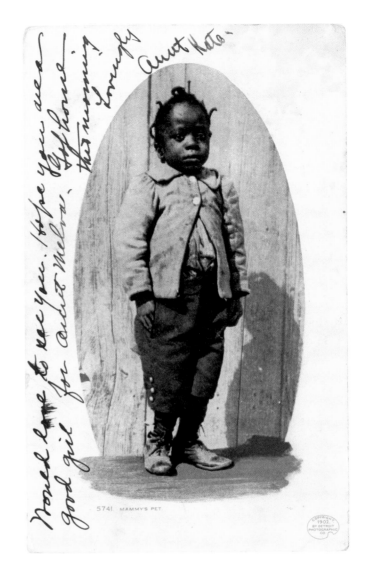

56. Detroit Photographic Company, *Mammy's Pet*, ca. 1902. Offset photomechanical print. Posted from Denver, Colorado, to Westmoreland, Kansas, April 28, 1909. Private collection.

Both of these cases belong to a particular variety of postcard humor identified by Brooke Baldwin, one in which "the jokester humorously identifies either himself or the card's white recipient as one of the Blacks pictured on the card." While the senders' implicit comparisons between themselves and stereotyped blacks may have been sparked by the recognition of affinity across racial lines, or the "universality of human relationships," the comic "tone of their messages implies that they believed those links to be tenuous at best." Baldwin therefore proposes reading the interracial comparisons in postcard inscriptions as "a gentle way of poking fun at one's own and one's friends' foibles" without challenging the "superiority and immutability of their

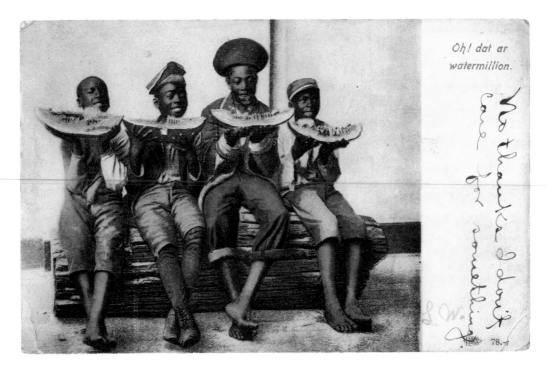

57 [a,b]. Unknown manufacturer, *Oh! Dat Ar Watermillion*, ca. 1907. Offset photomechanical print (recto and verso). Posted from Lincoln, Nebraska, to St. Louis, Missouri, November 15, 1907. Private collection.

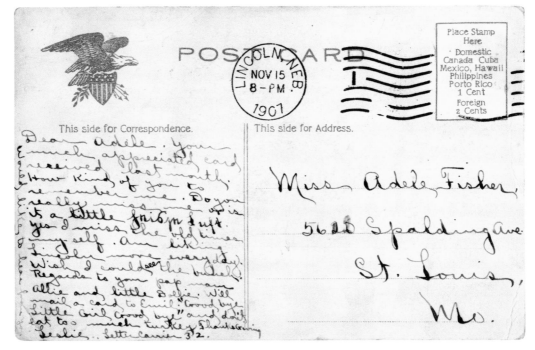

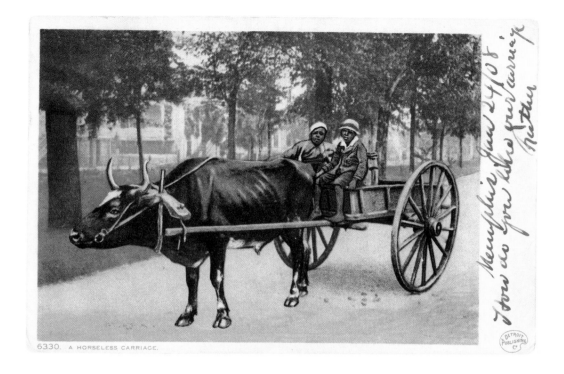

6330. A HORSELESS CARRIAGE.

racial status."[16] Indeed, the writing on postcards often underscored the strangeness of African Americans' everyday lives to their senders and recipients, particularly to city dwellers who were unaccustomed to the sights of rural black labor.

Black bodies could be co-opted into white bourgeois fantasies of the self in any number of ways, even standing in for the card's sender or recipient. An ethnographic scene of African Americans cutting sugarcane could be inscribed, "Having a fine time on my uncle's plantation," while an image of six broadly grinning black boys on an ox-drawn carriage could carry the message, "I am having the time of my life."[17] In these instances, each vacationing writer wanted to see in the postcard's photograph a depiction of true contentment—*not* an image of exploitation or, in the case of the plantation scene, back-breaking labor. The picture, in turn, became a medium through which the writer could express to her northern relatives her own feelings of happiness in the South. This projection of white feelings onto black bodies should bring to mind the history of the photographic smile presented in chapter 3.

Other postcard inscriptions directly called upon the addressee to insert him- or herself into a racial caricature. Photographs of African Americans traveling by ox and cart presented many possibilities for such identification, from "How do you like your carriage" (fig. 58) to "This is how we will ride home in the morning if we have to pay

58. Detroit Publishing Company, *A Horseless Carriage*, ca. 1902. Offset photomechanical print. Posted from Memphis, Tennessee, to Rochester, New York, January 24, 1908. Private collection.

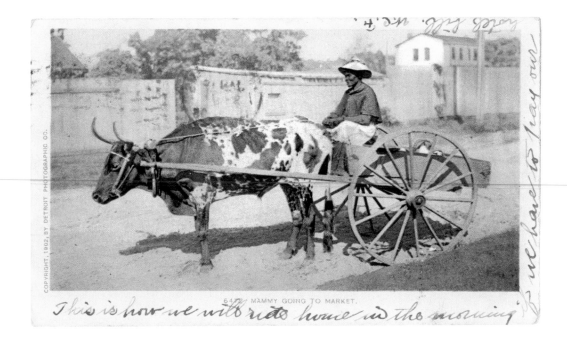

This is how we will ride home in the morning

59. Detroit Photographic
Company, *Mammy Going
to Market*, ca. 1902. Offset
photomechanical print.
Posted from North Adams,
Massachusetts, to Lee,
Massachusetts, January 18, 1905.
Private collection.

our hotel bill" (fig. 59). The postcard sender deemed these scenarios worthy of laugh-
ter and hoped the recipient would do the same, by inferring that neither would ever
experience such a rustic and obviously unsophisticated "ride." It is as if these messages
called upon their intended readers to put themselves in the shoes of the caricatured
black, only to deny that such placement could lead to genuine empathy for African
Americans. Time and again, we see the racial humor of photographic postcards pulling
white subjects into the scene, pushing them toward, but ultimately away from, black
subjects. One woman defined this gesture when she wrote on the back of *Free Lunch
in the Jungle*, "How would you like to be in this fellows [*sic*] place?" (fig. 60). Emery
Harlow of Lisbon Falls, Maine, surely had no desire to change places with the grimac-
ing black boy whose torso is engulfed by the mouth of a hungry alligator on the shore
of a Floridian swamp. The query was designed to generate within her an immediate
response expressed as a light chuckle, comic absurdity winning out over the recognition
of others' suffering, guilt, and generally bad feelings.

 Photography played a key role in jokes involving interracial identification, for it
was the photograph's iconicity—its perceived resemblance to the object that once sat
before the camera's lens—that postcard writers relied on to connect with and amuse
their friends and relatives. Many inscriptions, in fact, claimed that the comic photo-
graphs of black subjects were actually pictures of white selves. A card posted from

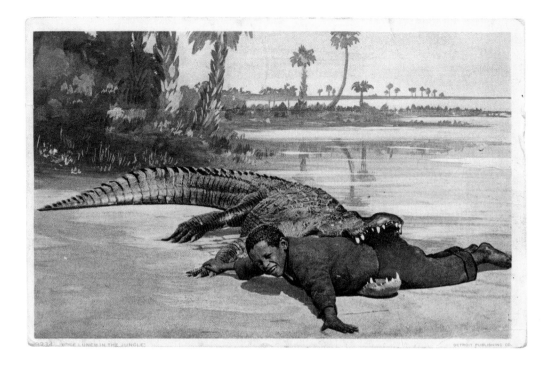

60 [a,b]. Detroit Publishing Company, *Free Lunch in the Jungle*, ca. 1905–6. Offset photomechanical print (recto and verso). Posted to Lisbon Falls, Maine, 1908. Photography Collection, The Miriam and Ira D. Wallach Division of Art, Prints and Photographs, The New York Public Library, Astor, Lenox, and Tilden Foundations.

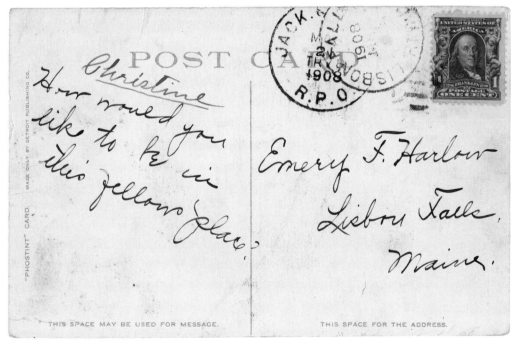

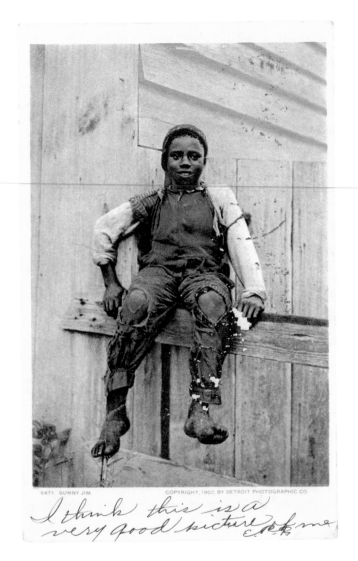

Florida to Minnie Quackenush in New Jersey in 1906, for example, contains the following note: "I think this is a very good picture of me" (fig. 61). The sender assumed, however, that Minnie would recognize a blatant incongruity between his own physical appearance and that of aging, dark-complexioned "Sunny Jim" on the front of the card, and would thus laugh at the idea that this could be a photographic representation of her correspondent. In 1903 one writer in Norfolk, Virginia, took photographic identification a step further; when posting the Detroit Photographic Company's *Waiting for the Circus* to friends in North Hatley, Canada, she assigned the names of her own family members to the black children featured on the card (fig. 62). This is the "Bunch in Virginia taken especially for their Hatley friends," she quipped, careful to select a verb, *taken*, that would name the postcard's picture as a photographic, and presumably genuine, representation of Mildred, Jessie, Elle, Bernard, and the rest of the Holmes family.

The projections of a white self into the image of a caricatured black discussed above recall the complex processes of identification that historians Eric Lott and Michael Rogin have attributed to American blackface minstrelsy. In his influential reading of early minstrel performances among urban working-class northerners, Lott presents the white subjectivity of blackface performers and audiences as "absolutely dependent upon the otherness it seeks to exclude and constantly open to transgression. . . . And if only to guarantee the harmlessness of such transgression, racist 'othering' and similar defenses must be under continual manufacture." It was through the minstrel show, Lott argues, that northerners "disrupted ideas of racial demarcation" and "precariously . . . lived their own whiteness."[18] Rogin similarly approaches minstrelsy as a social and cultural phenomenon that offers a glimpse into the racial unconscious of urban Americans. His analysis of Al Jolson's performance in the Hollywood film *The Jazz Singer* (1927) shows how blackface entertainment in the early twentieth century could help forge new American identities for immigrant populations in the midst of rampant

61. Detroit Photographic Company, *Sunny Jim*, ca. 1902. Offset photomechanical print. Posted from Daytona, Florida, to Paterson, New Jersey, April 1, 1906. Private collection.

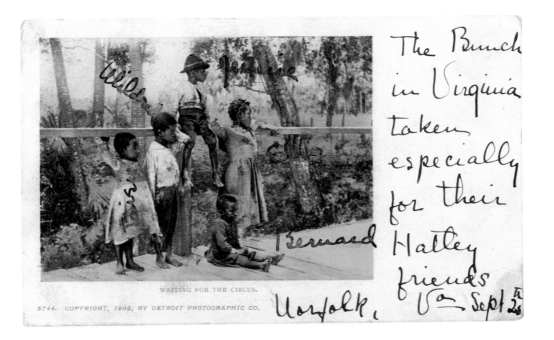

62. Detroit Photographic
Company, *Waiting for the Circus*,
ca. 1902. Offset photomechanical
print. Posted from Norfolk,
Virginia, to North Hatley,
Quebec, Canada, September 25,
1903. Private collection.

nativism. As a Jewish actor, Jolson could assert his own whiteness and work against the anti-Semitism of the period ironically by playing black, or "by putting on the mark of a group that must remain immobile, unassailable, and fixed at the bottom."[19]

While these interpretations of minstrelsy might help us understand the interracial performances on postcards shared among working-class Americans and new immigrants, they are less useful when it comes to analyzing the inscriptions of postcard senders whose income levels and family histories placed them less precariously within dominant American culture. To read their identification with black subjects, we might turn instead to the concept of racial melancholia developed by Anne Cheng. In *The Melancholy of Race* (2001), Cheng presents the "history of American national idealism" as caught in a "melancholic bind between incorporation and rejection" of the racial other. To say that "dominant white identity in America operates melancholically" is to acknowledge it "as an elaborate identificatory system based on psychical and social consumption-and-denial." Invoking a metaphor that recalls popular images of blacks and alligators, Cheng proposes that the "melancholic eats the lost subject—feeds on it, as it were," at the same time that s/he resents it.[20] For this reason, melancholy, like racism, seeks to exclude but never fully expels the racial other.

When the postcard sender who saw herself as white and middle class projected her own thoughts and feelings into stereotyped black bodies, we might say that she was participating in "an entangled network of repulsion and sympathy, fear and desire,

repudiation and identification."[21] Of this participation she would have been unconscious, insofar as any subject is unaware of the subtleties of white domination or the psychic effects of an identity performance as it is taking place. Surely women traveling within the southern states and corresponding with friends and family in the North would not have been able to articulate how or why they invested so much in the performances of racial otherness they staged on photographic postcards. Those performances simply continued, relentlessly, relying on photographs of African Americans to support the projection of a confident and contented white self.

It was rare for postcard inscriptions to work against this political message. I offer as an example a Detroit Publishing Company card titled *Washington Lincoln Napoleon Alexander Jackson* now in the collection of the New York Public Library (fig. 63). Rather than invite the card's recipient to laugh at the absurdity of the child's grand name, the inscription uses the photograph and its caption as an occasion for sentimentality. "My dear Lillie," H. M. Fellows wrote from North Carolina in 1913, "I feel as if I were addressing the little dark-eyed girl I knew so many years ago; now a faithful useful Churchwoman in the vineyard where happy years of my own youth were spent." The photograph of a black toddler in a red shirt sitting in a high-backed chair and looking intently at the viewer thus activates sympathetic feeling. This shift in the motivation for the comparison between a white self and a black subject might suggest to modern viewers that the postcard recipient was African American. The 1900 U.S. census nevertheless defines forty-year-old Lille P. Weatherby's entire household as "white"—save one "black" servant—demonstrating that earnest visual identification across the races on photographic postcards was not impossible.[22] It simply required a subject with some political imagination who could see drawing real connections across the races as a welcome opportunity, rather than as a threat to a precarious sense of self.

CONSCIOUSNESS AND CRITIQUE

The psychic and political investments associated with the inscriptions on early postcards help us understand why so few card senders acknowledged the artificiality of the African American types that became so popular during the format's golden age. For the words and images on the cards to set the stage for performances of identity, Americans had to be complicit in the illusion of veracity that the cards portrayed. Still, we can find exceptions to this trend among extant photographic postcards, such as *Two Sunny Smiles* (fig. 64), which a woman named Sue sent from Williamston, North Carolina, to Mrs. Mattie Draughon in Rocky Mount on August 19, 1937. Sue wrote on the back of the card, "Sure do miss that 'Mug' of yours 'beautiful' but I'm sending you these 'sunny smiles' or rather I'll pretend they are anyway. Have lots to tell you." She appears

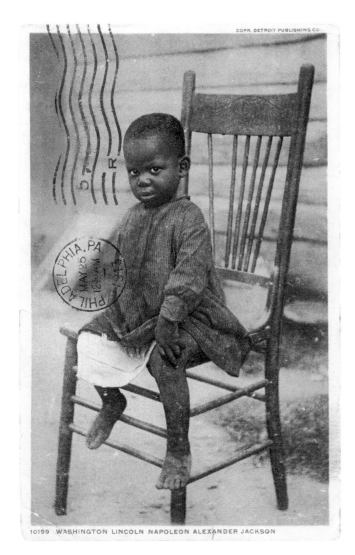

10199 WASHINGTON LINCOLN NAPOLEON ALEXANDER JACKSON

to doubt that the beaming faces of the two boys in overalls are genuine expressions of happiness, or "sunny smiles." In so doing, she reveals that the photograph functioned as a convenient fiction for her, Mrs. Draughon, and countless other postcard senders before them. Was it the late date of 1937 that provided Sue with the critical distance needed to see through the sunny smiles? Was it the fact that the postcard was exchanged between two southern women that allowed the private admission of a long-kept secret? Or was it that the photograph on the card was made by the now celebrated local female photographer, Bayard Wootten, and therefore clearly constructed as a pleasing image of North Carolina commissioned for the national postcard market? While we may never be able to answer these questions, we do know that, despite Sue's doubts, the charade

was allowed to continue, with both sender and recipient pretending that the postcards they exchanged represented things *as they were*, or at least *as they ought to be*.

In 2002, the Studio Museum in Harlem began commissioning artists to challenge directly Americans' acceptance of historical postcard imagery as true representations of black life and culture. Artists from across the United States and of diverse backgrounds have been invited to "photograph Harlem, and tur[n] their unique depictions of the neighborhood into free, limited edition postcards." Curators at the Studio Museum instructed these artists to "provide alternative, multifaceted views of Harlem, representing its complex and diverse history, and capturing the community in a critical moment of growth and change." The resulting work has been displayed in an ongoing exhibition series titled *Harlem Postcards*. "While many artists have been drawn to the visual vibrancy of Harlem . . . , others seek to reveal its surprising, less familiar corners, or focus on the histories of Harlem's different communities," the museum explained on the tenth anniversary of the series. "Aiming the camera at the sidewalk, the storefront and the sky, artists have reinvented the notion of what belongs on a postcard, and what it means to represent a neighborhood to those who do not live there."[23]

As one might expect in such a reclamation project, the tone of many of the photographs displayed in *Harlem Postcards* has been serious and celebratory, with images paying homage to Harlem's rich literary and musical history, its distinctive architecture, and its cultural landmarks. They have also acknowledged the individuals who populate the neighborhood today, working against the presentation of black bodies as racial types that once dominated the commercial postcard industry. In 2002, for example, Brooklyn-based conceptual artist Anissa Mack created for the Studio Museum's exhibition a postcard she titled *After the Fact (Rachel and Renée Collins at RiteAid on 125th St.)*.[24] While the first part of the title encourages the mind to wander—to little girls after getting their hair styled, or to the moments of silence following a spat or rebuke—the remainder situates the image in the lives of two unique subjects, who pose for a studio portrait. In this respect, the image of Rachel and Renée Collins at their local Rite Aid functions as an antidote to *Washington Lincoln Napoleon Alexander Jackson* (see fig. 63), in which a black child is stripped of his real name and projected into a white fantasy of racial otherness, grounded in neither a specific time nor a specific place. The grace with which the girls sit before Mack's camera, moreover, undermines the comic tradition of representing black bodies as unfit or unwilling subjects for the studio photographer.

For other artists living and working outside Harlem, like Zoe Crosher, the Studio Museum's commission presented an opportunity to acknowledge their perspectives as outsiders picturing people and places they do not know intimately. "As a Californian, I've learned about Harlem primarily through what I have seen, read and heard, rather than experienced," Crosher explained in 2012. "So I wanted to stay away from a more

64 [a,b]. Graycraft Card Company, *Two Sunny Smiles*, ca. 1930s. Offset photomechanical print (recto and verso). Posted from Williamston, North Carolina, to Rocky Mount, North Carolina, August 19, 1937. Private collection.

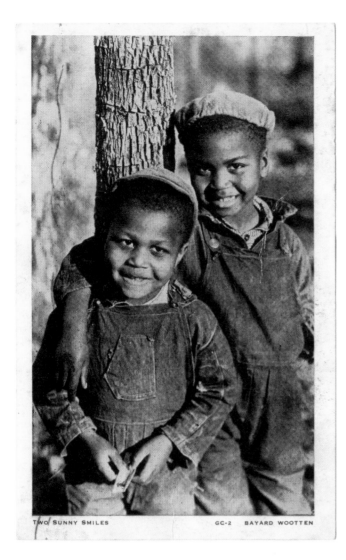

conventional approach to documenting a place I know only as an imaginary version of itself." Her solution was to photograph the "crumpled up backs of postcards" created by other artists in the *Harlem Postcards* series, which emphasized, she claimed, "the physicality of the existing postcard archive."[25] The title of the resulting artwork—*Katy, Kori & Rashid and Other Backs (Crumpled)*—points to additional interpretations of this unique choice of subject (fig. 65). By naming the cards and treating them as if they were black bodies, Crosher invokes the historical practice of writing on the backs of stereotyped African Americans. She subverts that practice, moreover, by replacing passive stereotypes with named contemporary artists who have actively worked against them at the Studio Museum: Katy Schimert, Kori Newkirk, and Rashid Johnson.

65. Zoe Crosher, *Katy, Kori & Rashid and Other Backs (Crumpled)*, 2012. Digital C-print, 11.25 × 15 in. With permission of the artist.

When racial humor has appeared in the *Harlem Postcards* series, it has been created by young artists of color treading carefully in the waters of stereotype. When New York–based conceptual and performance artist Heather Hart produced *Build-A-Brother Workshop (The Paper Doll Barbershop Poster)* in 2014 (fig. 66), she admitted readily, "It is a slippery position between exploiting the black male archetype and honoring that same black maleness." Parodying the Build-A-Bear Workshop franchise, popular among suburban American children, and the American tradition of paper dolls, Hart's postcard features the head of a young black man surrounded by eighteen different head accessories, including a variety of hairstyles and hats that Hart says were "inspired by the timeless barbershop posters I find all over Harlem." The card invites viewers to cut out these accessories and create their own "brother" by selecting the headgear that best suits the character one desires for the figure. How and what we choose to attach to the head says much about our individual conceptions of black masculinity and about our sense of self. "Through interaction, humor and material," Hart explains, "I encourage viewers to relate to my work not only through physicality, but also by opening a dialogue that depends on their perception."[26]

For more than fifteen years, *Harlem Postcards* has freely distributed this artwork to visitors, putting into circulation alternative images of the predominantly black

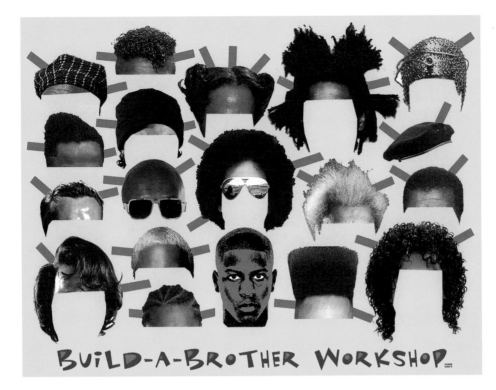

66. Heather Hart, *Build-A-Brother Workshop (The Paper Doll Barbershop Poster)*, 2014. Giclée print. With permission of the artist.

community in which the Studio Museum is embedded. In an interview with *Artsy* editor Tess Thackara in 2015, after ten years as the museum's director, Thelma Golden described the exhibition project in these terms: "I was often horrified by the way that the mainstream media, when they would want to picture Harlem, would sometimes do it with images that were over 50 years old. . . . Why is it so hard to imagine an image for this community today?"[27] Reflecting on the history of black representation in American commercial postcards, we can begin to address Golden's question. Indeed, this popular medium of photographic humor has incorporated a variety of racial jokes that this book has thus far examined—from witticisms about the racial character of the photographic negative to comedy featuring black bodies that smile too broadly, or that fail to comprehend the workings of the camera. Working against these tropes and evoking the traditions of African American vernacular photography, Golden envisions the *Harlem Postcards* project "as something of a family photo album for the neighborhood," one that documents, "Here we are today. Here we are next year. Here we are the year after." If racial humor is to enter into the work of such documentation, it is to force into contemporary consciousness the construction of racial identity and difference that once defined the comic postcard.

Chapter 5

Revival and Subversion

SNAPSHOT PERFORMANCES FROM KODAK TO KARA WALKER

In the late spring and early summer of 2014, 130,000 people visited the Domino Sugar Refinery in the Williamsburg neighborhood of Brooklyn, New York, to see an installation by the renowned artist Kara Walker. Walker inscribed the political motivation for her work into its lengthy title, *A Subtlety, or the Marvelous Sugar Baby, an Homage to the Unpaid and Overworked Artisans Who Have Refined Our Sweet Tastes from the Cane Fields to the Kitchens of the New World on the Occasion of the Demolition of the Domino Sugar Refining Plant.*[1] The focus of the installation in the defunct factory, whose chief product once fueled the transatlantic slave trade, was a colossal sugarcoated sculpture (fig. 67) that conflated a mythical creature (the sphinx) with a centuries-old American stereotype of black womanhood (the mammy). The attribution of *A Subtlety* to an exhibition featuring a seventy-five-foot-tall figure, with flaring nostrils and a gigantic vulva and outfitted only in a headscarf, was incongruous at best. Around this figure the artist placed smaller sculpted black boys holding bananas or giant baskets; these were made of resin and covered in molasses. Walker knew that the materials in which she rendered these forms would melt and collapse in Brooklyn's summer heat, just as viewers knew that the colossal sculpture would soon be cut into pieces and the once bustling sugar factory razed to make way for a finely appointed apartment complex.

Walker thus brought to life the history of American slavery and racial stereotype for her audience, only to stage its spectacular destruction.

In the two months that *A Subtlety* was on view, visitor after visitor posed for snapshots alongside the sculptures. Taking photos with mobile phones and uploading them to Facebook and Twitter were not only permitted but explicitly encouraged in written instructions posted at the entrance and exit of the exhibit. As *Colorlines* editor Jamilah King observed on the daily news site shortly after the exhibit opened, "Nearly everyone had their phone out and the Instagram hashtag #KaraWalkerDomino was filled with images of the exhibit (my own included). In that way, it was a deeply interactive exhibit, one as much about the present as the past."[2]

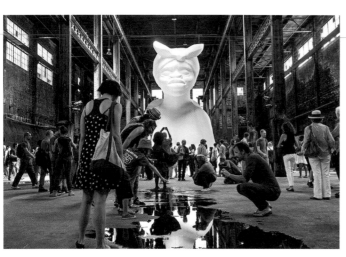

67. Installation view of Kara Walker, *A Subtlety, or the Marvelous Sugar Baby, an Homage to the Unpaid and Overworked Artisans Who Have Refined Our Sweet Tastes from the Cane Fields to the Kitchens of the New World on the Occasion of the Demolition of the Domino Sugar Refining Plant*, 2014. Domino Sugar Refinery, Brooklyn, New York. Robert Nickelsberg / Getty Images News / Getty Images.

In effect, Kara Walker constructed and displayed what she described as "a giant 10-foot vagina," and then invited a public obsessed with selfies and social media to engage with it photographically. Many of the photos taken of the exhibit were banal, simply documenting the figures on view in the factory from a variety of angles. With alarming regularity, however, the public exhibition of a colossal "mammy-sphinx" became an occasion for viewers to enact racial and sexual fantasies in which they presented themselves as dominant over a seemingly indomitable creature. In countless photos that men and women of all races posted online, people feigned shock, stuck out their tongues, or pretended to fondle the sculpture's sexually charged features, especially the breasts and buttocks. Posing with the colossal sculpture became so popular on image-sharing apps that one enterprising internet user created a website enabling anyone with a webcam to create a virtual selfie against the backdrop of Walker's work. Garnering the attention of news sites and blogs, this "selfie generator" addressed itself to people who could not make it to the Brooklyn exhibition but wanted to picture themselves as part of the media event unfolding there and to elicit the "jealousy and admiration" of their friends.[3]

Criticism of these photographic performances exploded on the internet, writers insisting that the thoughtlessness and vulgarity they frequently demonstrated reenacted the racism that Walker aimed to expose and undermine in *A Subtlety*. Critics were especially bothered by the white majority at the exhibition, some of whom treated it as little more than an occasion for irreverent photographic humor. "It was hard to avoid seeing white children laughing at the artwork, smiling and posing for photos next to the figurines," Nadia Williams wrote to *Art in America*, as she was co-organizing a

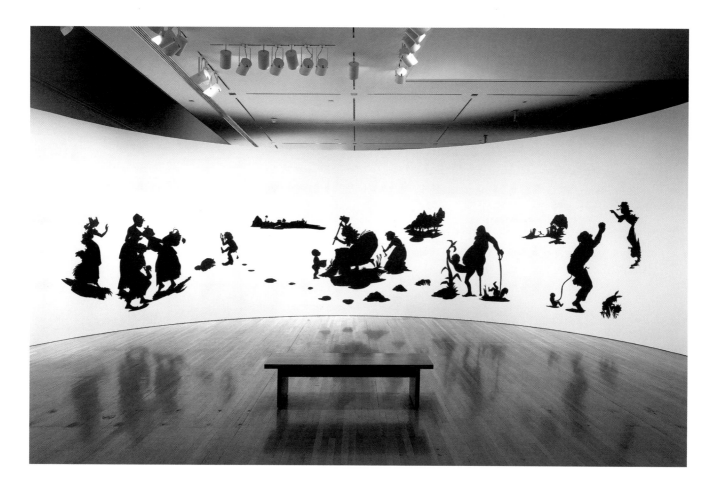

public gathering for people of color at the refinery in July 2014. "Seeing people giggle while taking photos of the sphinx's vagina—mostly white males—disgusted me."[4]

Walker herself had been accused of creating offensive images in the past, most famously by African American artists Betye Saar and Howardena Pindell. In 1997, Saar spearheaded a national letter-writing campaign that called Walker's award-winning cut-paper silhouettes "revolting." She was responding to silhouette installations like *The End of "Uncle Tom" and the Grand Allegorical Tableau of Eva in Heaven*, in which characters from Harriet Beecher Stowe's *Uncle Tom's Cabin* defecate, engage in lewd sexual acts, and prepare to murder or maim one another (fig. 68). Saar's letters to artists, curators, and community leaders urged them to think carefully about these artworks. "Are African-Americans being betrayed under the guise of art?" she asked. "Are we being degraded by plantation mentalities?"[5]

The criticism surrounding *A Subtlety*, however, was directed not so much at Walker as at the white snapshooters who flocked to the site in great numbers. It was their

68. Kara Walker, *The End of "Uncle Tom" and the Grand Allegorical Tableau of Eva in Heaven*, 1995. Cut paper on wall, approx. 396.2 × 1066.8 cm. Installation view: *Kara Walker: My Complement, My Enemy, My Oppressor, My Love*, Hammer Museum, Los Angeles, 2008. Artwork © Kara Walker, courtesy of Sikkema Jenkins & Co., New York.

69 [a,b,c].　Snapshots of unidentified subjects with watermelons, ca. 1910s. Gelatin silver prints. Private collection.

laughter, gestures, and antics in front of the sugar sphinx that appeared to miss the point of the project altogether. Or did they? And what about the many black men and women who were snapping away in front of the colossal sculpture? How are we to understand the photographic humor that Walker's exhibition occasioned for them? This chapter uses the snapshots stimulated by *A Subtlety* and their widespread dissemination to explore how vernacular photographs have relied on humor to conjure old ideas about race and engage with them in the present. Doing so requires that we look back to the history of the snapshot in the United States and consider how this form of amateur photography relied on comic tropes to both publicly degrade and empower African Americans—well before the advent of the camera phone and the now ubiquitous selfie.

SNAPSHOT MINSTRELSY

The photos taken at the Domino Sugar Refinery that solicited public criticism bring to mind a wildly popular trope in early American snapshots in which white men, women, and children smiled broadly for the camera with gigantic slices of melon in hand. These pictures were taken mostly outdoors and their subjects were often engaged in a bourgeois ritual such as a family picnic, a summer camp or romp, or simply relaxing at home (fig. 69). In the extraordinary number of photographs that adopt this convention, the presence of the watermelon stimulates the photographed subjects to perform a racial stereotype. In a photograph of four white male teenagers with watermelon slices—on which someone has inscribed the word "Coons"—the political work of the subjects' actions is hard to ignore, for the inscription suggests that their melon-induced smiles were seen at one time as comic appropriations of a degrading black stereotype by the photographer, the teenagers themselves, and/or a subsequent viewer of the photograph. (We cannot, after all, be certain about when the inscription was added to the photograph; what matters is that it is there at all.)

Legible as a modern form of amateur minstrelsy, the act of parting one's lips in the presence of a gigantic slice of melon served adolescent male desires to act foolishly and whites' long-standing fascination with and invasion of "uncivilized" black culture. Taking possession of an object associated with racial otherness—stealing it back, as it were, for the watermelon has always embodied a white fantasy of blackness—the subjects in the photograph could test the boundaries between racial identities in ways that had been imagined for decades.[6] Kodak made it possible to collapse this work into an exceedingly brief and permanently recorded instant, ultimately affirming the power of whiteness. In highlighting this example, I do not mean to suggest that most white children and their parents were consciously thinking about mimicking a racist

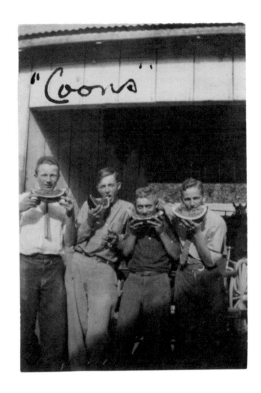

stereotype when they held melons to their lips, opened their mouths wide, and snapped the shutter. They did not need a critical view of their self-presentation for the camera, in other words, in order for the latter to be framed by assumptions about race and class.

Manuals consumed by amateur photographers at the turn of the twentieth century taught readers how to play with racial caricature in their snapshots and to look at black bodies as comic elements in their compositions. This work was most often performed through captioned illustrations rather than through direct textual instruction. Consider a pair of photographs illustrated in F. Dundas Todd's *First Step in Photography*, a practical manual aimed at early Kodakers. In a chapter on how to print and tone your photographs, without any obvious connection to the technical discussion at hand, the book presents two toddlers before and after a sizeable snack (fig. 70). The incongruity of these pictures would not have been lost on readers, who were fed plentifully on a diet of racial humor; these blond children were *not* the subjects they expected to find partaking most gleefully in a watermelon feast. It was precisely this incongruity that would have stimulated laughter among a class of amateurs who could identify readily with the children's absent parents. Humorous, too, was the ambiguity presented by the "after" photograph. Were the broad smiles of the toddlers replaced by expressions of displeasure and anguish because the feast came to an end and they wanted even more of the fruit? Or was it the feast itself that made them so unhappy—melon-colic, as period humor was fond of saying? They had indulged, after all, in a pleasure constructed specifically for *others*—a trope introduced in chapter 3.

However readers interpreted this joke, they would have learned by example that authorities on amateur photography saw the appearance of fun as serious business. Here is what one such authority, W. I. Lincoln Adams, had to say in 1906 about the "value" of the pictures that Kodak trained Americans to make at home:

> Snapshots are often carelessly made, in the spirit of frolic . . . , of a group of friends, a family party, or some young children at their play. But the uncertainty of life, causing, perhaps, the disappearance of one of the bright young faces from the happy group, may give that particular little snapshot value far beyond the measure of mere dollars and cents; as it may contain the best or only portrait of the lost child or friend. . . . An album filled with snap-shots of a family of young children, taken at different ages and at their various sports and pastimes, in summer and winter, grows in interest and value with the passage of years until it, too, becomes a priceless possession.[7]

This passage makes several important assumptions. First, friends, family, and children made the best subjects of amateur photographs. Second, these pictures were responses

70 [a,b]. *Before the Feast* and *After the Feast.* In F. Dundas Todd, *First Step in Photography: A Book for Beginners in the Art* (1897; Chicago: Chicago Photo-Beacon Co., 1899), 40–41. Courtesy Harvard University Library.

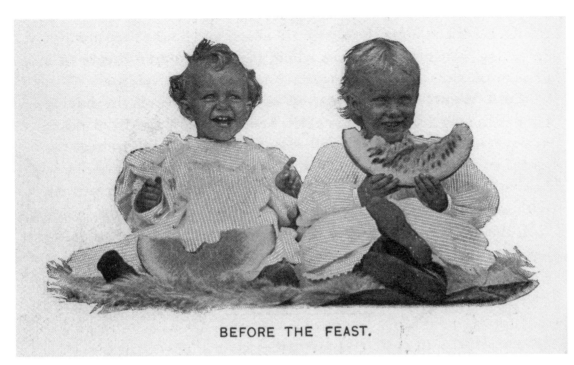

BEFORE THE FEAST.

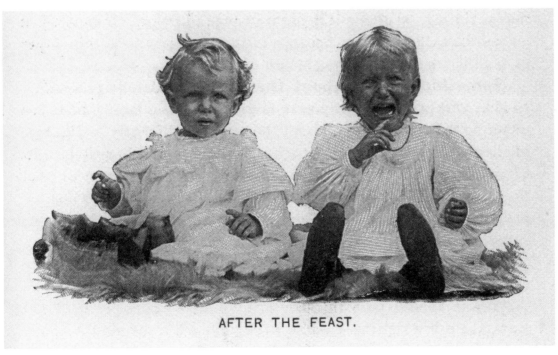

AFTER THE FEAST.

to perceived threats to the white bourgeois family, among them high child mortality rates. Finally, the snapshot had a life of its own that exceeded that of its subjects, especially for the viewers of a photographic album, where these pictures were most often encountered. The literature on amateur photography in the Progressive-Era United States, in other words, conceived of this popular practice as pushing back against a fantasy of racial death. And so when we see racial humor in early snapshots, we must remember the high stakes with which joy was staged for the amateur camera, and how much whiteness mattered.

STAGING THE PAGE

As hybrid media, early snapshot albums included a variety of photographic formats, sometimes cut and arranged into patterns, many captioned. Alongside photographs one can also find newspaper clippings, certificates of achievement, souvenirs from travel, pressed plants, pieces of cloth—anything, really, that signaled a memory and conveyed a desired identity to the album maker's friends and family. Enlivened by conversations inspired by the album pages, these juxtapositions of images, texts, and histories were meant to tell a story in creative and personal ways, even though they almost always adopted dominant social conventions. To read the snapshots in figure 69 outside the vernacular photographic albums in which they were once pasted, therefore, is to leave out an exceedingly rich context that, in the case of most vintage snapshots that survive today, can never be reconstructed. It is highly likely that the photograph of the melon-eating teenagers was not the only snapshot in figure 69 associated with an inscription that invoked a racist stereotype. Indeed, album makers were taught by magazines like *Kodakery* to inscribe on the page the time and place an image was made and to conjure "bright, clever captions." Such captions were especially appropriate for pictures that aimed "to snare the smile and lure the laugh"; they might even be created first, stimulating the production of a snapshot.[8]

Snapshot albums created by white Americans in the late 1890s and the early twentieth century reveal that racial humor ran through this popular genre.[9] From New England to California, a broad spectrum of middle-class Americans performed black caricatures for the camera through theatrical poses, wardrobe, and even the application of burnt cork. While these images are jarring to twenty-first-century viewers, white album makers were fond of pasting in self-portraits or pictures of friends grinning broadly in blackface. Such images show how mundane black caricature had become in American life and how unselfconscious most Americans were about the racism that underlies their performances for the camera. Often, it was not the image alone that constituted a racial joke but the image in conversation with a witty handwritten caption.

These titles reframed a seemingly innocent image—of a black subject the snapshooter casually encountered or a member of his social circle—in a manner that usually asserted the amateur photographer's social and economic superiority. Essentially, any social activity or life event could occasion such humor in a snapshot album, from a family vacation or Christmas celebration to the daily experiences of high school or college.

Take, for instance, an album documenting a trip in July 1896 that the unidentified photographer made to the U.S. Capitol, the national monuments, the Corcoran Art Gallery, Mount Vernon, and neighborhoods in which he observed black Washingtonians at home, work, and play. Among the thirty-five snapshots affixed to the album's thick gray pages are those in figure 71. In the upper left of figure 71a, a black man in work clothes pushes items on a cart along a dirt road. The caption "Change of Abode" suggests that a single hand-pushed cart could contain all of this man's possessions; alternatively, the cart itself might constitute his home. Below this photograph another snapshot depicts a black man and woman sitting idly in front of a rundown brick house presented to the viewer as a "Typical 'Colored' Block." The amateur photographer demonstrates through that phrase how little he thought of the economic vitality of African Americans in the capital city of the United States and of their contributions to the national labor force. Making light of the poor social conditions he observed in Washington, D.C., he generalized them to describe the condition of an entire race and encapsulated that view in a single image. Another album page applies caricatured dialect to a similar scene containing three black figures in front of a dilapidated row house (fig. 71b). "What You Two Pussons Doin?" the album-maker imagines the figures asking him and a companion. An inscription imagines their response—"Bet You're in Dat Camera"—recalling the popular jokes about black sitters and their presumed ignorance of photographic technology, discussed in chapter 2. Opposite, schoolboys are shown standing "Ready to Catch a Doug[h]nut" and then "Scra[m]bling for 'Pinnies.'" In both snapshots, black boys stand apart from the rest of the mixed-race group, signaling their difference, perhaps at the instruction of the photographer. More touristic photos taken in or near the city follow, along with pictures of fine brownstone exteriors titled "where we ate" and "where we slept." The latter images reinforce the apparent differences between the white bourgeois tourist and the black people he chose to photograph and label on his trip.

There are many ways in which we might draw connections, while recognizing important differences, between these once album-bound photographic performances and the digital snaps that white Americans equipped with camera phones produce today in staggering numbers. As media studies scholar Lisa Gye has argued, contemporary mobile camera practices have much in common with the image production of historical snapshooters, as both result in "photographs that help to construct personal

71 [a,b]. [OVERLEAF] Pages from a snapshot album documenting a trip to Washington, D.C., July 5–15, 1896. Randolph Linsly Simpson African-American Collection, Beinecke Library, Yale University.

CHANGE OF
ABODE

TYPICAL
"COLORED"
BLOCK

3 GENERATIONS
DARKIE STORE HOME

9 x 12

"WHAT YOU TWO PUSSONS DOIN?" TOO
"BET YOU'RE IN DAT CAMERA" LATE

READY
TO CATCH
A
DOUGNUT

SCRABLING
FOR
"PINNIES"

and group memories, that maintain and develop social relationships and that allow their users to express and present themselves to the world."[10] Of course, the "world" that experienced an early snapshot album was tiny compared to the ever-expanding audiences of social media platforms today. By default, all photos posted to a Facebook or Instagram account are public, visible to anyone registered to use the application; even when users opt to make their accounts private, their app "friends" can disseminate their photos with anyone they choose. As Instagram understands it, this ability to take and share photographs is one that enhances, rather than works against, older snapshot and communication practices, such as the telegram. Some scholars have described the instantaneous photo sharing the app enables as creating an "intimate, visual co-presence" specific to the camera phone.[11] But did not early snapshot albums create opportunities for photographic subjects to experience a kind of co-presence as they sat beside one another, reminiscing together while turning the pages of an album? Certainly, it was not the same thing as snapping a photo with friends in the Domino Sugar Refinery and in a matter of seconds posting that image to online social media; nor are the tools we now have to annotate camera-phone pictures on Facebook and Instagram equivalent to the inscribed captions or oral culture of snapshot albums. And yet to say that they constitute wholly different modes of communication fails to grasp the significant ways in which digital image-sharing practices remediate the conventions of historical snapshots.[12]

For these reasons it is productive to see the act of posting to social media an image of a white self virtually licking or fondling Kara Walker's "mammy-sphinx" as akin to the racially charged album humor of early white Kodakers. Both practices upheld an image of blackness as always-already available for white consumption and as the object of white happiness. Like the Americans who posed with watermelons for their family snaps in the early twentieth century, many visitors to *A Subtlety* used Walker's colossal caricature to enact a playful yet powerful white self. With mobile phones at the ready before Walker's larger-than-life sculpture, these subjects all too easily inserted themselves into a long history of crudely reducing black women to possessions and playthings. Their pictures therefore did more than say "look at me" and "I am here," attracting attention to an individual in a public domain; they framed their subjects as invulnerable to a degrading stereotype's commanding physical presence in the refinery, and as capable of mastering a figment of the American cultural imagination that has long outlived the abolition of slavery in the United States.

CREATING *An Audience*

In an interview with the *Los Angeles Times* in October 2014, Kara Walker was asked to comment on the snapshots that people had taken in front of *A Subtlety*, specifically

those that seemed to take pleasure in the mammy as a racist stereotype. She admitted, "It's not unexpected. . . . Human behavior is so mucky and violent and messed-up and inappropriate. And I think my work draws on that. . . . It comes from responding to situations like that, and it pulls it out of an audience." Art historian Mark Reinhardt later reflected on *A Subtlety* in similar terms, observing that "part of Walker's gambit has always been to engage certain aspects of the racial unconscious, to bring them into the open, and . . . photography here becomes another—and singular—means of doing the work."[13] As noted, the artist and her team recognized the potential of the mobile photograph and actively encouraged visitors to snap away. What was not revealed publicly until the *Los Angeles Times* interview was that Walker had captured their behavior on video. As she put it, "I was spying." Her footage was revealed to the world in an exhibition at a Chelsea gallery in New York that opened in November 2014. In addition to displaying preliminary sketches for *A Subtlety* and a severed hand of the "mammy-sphinx," Walker showed a twenty-seven-minute video titled *An Audience*, shot an hour before the Brooklyn exhibition closed on July 6, 2014.[14]

Beginning with its opening shots of people walking toward the refinery, Walker's video focuses on black viewers, an audience critics observed was far outnumbered by whites during the life of the Brooklyn exhibition. We follow one presumably African American family—a mother and two young children—entering the exhibition and passing a sign inviting them to "share pictures on social media." The video camera then focuses on the initial reactions of a few black visitors to the colossal sculpture. One woman shakes her head, reacting to a surge of emotion at the sight of the "mammy-sphinx," while other visitors train their cameras on Walker's sculptures with predominantly solemn, concentrated expressions. Around seven minutes into *An Audience*, Walker follows the family that escorted us into the exhibition, bringing the viewer close up to the body of the sculpture. While viewing its backside, we begin to hear laughter erupting from the audience and we witness, for the first time, the posing of a comical snapshot, as two black women stick out their buttocks in an effort to imitate the exaggerated rear end of the figure. At around nine minutes, we see a smiling black man reaching his arms in the air so that they might appear, in a photograph, as touching that same rear end. A black woman wearing a headscarf makes a similar gesture moments later, pretending to place two fingers on the oversized vulva.

Occasionally, Walker depicts white visitors attempting a virtual pinch or fondle of the "mammy-sphinx," but their actions are decidedly in the minority. Selfies also initially appear less frequently in *An Audience* than other photographic experiences, perhaps because they can be too easily critiqued as unreflective, narcissistic images. For much of the video, then, Walker zeroes in on black children and families as well as some intraracial and interracial couples engaged in collaborative self-representation

near the sculpture's front paws. They use its sugarcoated chest and face as a backdrop for their photographs, their gestures generally lacking the vulgarity of the controversial snaps posted to the exhibit's Instagram feed. In the carefully edited video, we therefore see precisely what Walker wants us to see—a predominantly African American, middle-class audience picturing themselves for one another as content and proud in the presence of a gigantic racial caricature.

That it takes some time for Walker's audience to set up their photographs demonstrates the thoughtfulness with which they approach the act of posing before the massive happy object the artist constructed in the refinery. Particularly for the young women in the video, selecting just the right way to arrange their bodies proves challenging, causing them to feel slightly nervous and often resulting in sober expressions or strained smiles charged with unspoken meaning. Their photographic performances resonate with some of the serious selfies that people of color posted to Instagram on the final day of the exhibition. In one of those posts, a young woman who describes herself on Instagram as an artist, dreamer, and fashionista from New York City shared a selfie in which she looks steadily into her camera, capturing her head and shoulders in the foreground and Walker's sculpture surrounded by viewers in the background. Quoting an article in *Allure* magazine on the challenges women face when aging, she reframed its message as one of black female empowerment. "Your reflection in the mirror is a record of resistance and acceptance, history and identity, loss and hope," she wrote. "And, ultimately, a tribute to the people who came before you."[15] Another, posted by a male dancer and choreographer from the city, paired his selfie with a call for responsible self-education and empathy: "I was moved today by what I experienced, walking through the #KaraWalkerDomino exhibit. Ask questions, do your research, learn your history and the history of others."[16]

The summer of 2014 was an especially important moment for this message to be disseminated, for it was in August that public demonstrations across the United States responded to the shooting of an eighteen-year-old black man (Michael Brown) by a white police officer in Ferguson, Missouri. The previous year, moreover, saw the birth on social media of the Black Lives Matter movement, after the acquittal of a white neighborhood watch volunteer who shot and killed seventeen-year-old Trayvon Martin. In both cases, it has been argued that racial stereotyping and a decided lack of empathy resulted in the death of a black teenager.

Despite—or, perhaps, because of—the grim state of U.S. race relations in 2014, many of the poses captured in *An Audience* also embrace a sense of humor. Humor clearly runs through a segment in the video, beginning around minute sixteen, when a young woman confidently instructs her photographer friend to position the camera close to the ground, orchestrating a view of herself as towering before the camera's

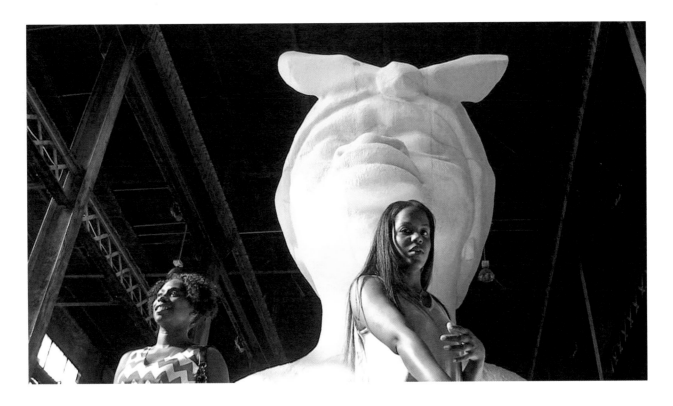

lens, as if trying to compete with the stature of the "mammy-sphinx" (fig. 72). Standing with her purse casually slung across her arm, she sticks out her tongue just as casually, then bursts into laughter, apparently sharing a joke with her companion. She poses for several more shots, first offering a peace sign before extending a thumb toward the sculpture behind her. Throughout the scene, the young woman appears confident, in control, and contented by sharing her encounter with Walker's artwork. Comically cloaked in the language of irreverence and degradation, hers are gestures of affirmation and uplift.

72. Kara Walker, still from *An Audience*, 2014. Digital video with sound, 27:18 minutes. Artwork © Kara Walker, courtesy of Sikkema Jenkins & Co., New York.

SPREADING JOY

To contextualize the photographic performances of black subjects captured in *An Audience*, I offer as comparison an early snapshot album now in the collection of the Schomburg Center for Research in Black Culture at the New York Public Library. Unlike the albums discussed thus far, this one was the creation of a young African American man: George Brashear. Shared only with those closest to him, the album could have been seen by his peers on the football and track teams or in his military training class at the Tuskegee Institute, the center for black education founded by

Booker T. Washington from which Brashear graduated in 1917.[17] It could have sparked conversations with the young women he met at school, some potential girlfriends, the siblings and cousins with whom he grew up, and other family members back home who inspired his affection. He refers to almost all of these relations by first name, and everyone appears happy to pose for a friendly camera.

Most of the pictures in the album date to between 1915 and 1920, and so encompass World War I and the mass migration of African Americans from the southern states to the urban Northeast and Midwest. On one page (fig. 73a) we see Brashear himself in a hand-cut snapshot in the upper right, holding a hat in his hand and standing with a woman named Viola on his arm. Both figures smile for the photographer, who is surely someone they know well. Around a newspaper clipping on the history of football we find more snaps of Brashear's family and friends. They include one picture of young women eating watermelon outdoors, "enjoying a visit to Addie's home." Another page takes us to Tuskegee, where some students pose with rifles in self-consciously manly positions (fig. 73b). These pictures are accompanied by a snapshot of two named women at top center, and by an outdoor group picture in the lower right. The latter contains the serious and smiling faces of three women and two men as they partake of a watermelon feast, performing the work of the caption, "Spreading Joy." And another page: this one contains a wartime poem titled "Keep the Home Fires Burning" (fig. 73c). Around the clipping we see people doing precisely that, in some form or other. "Betty almost fell out of the tree. She grabbed the nearest 'thing' to her," one inscription on the page explains. Next to her, a little girl in a white dress smiles at the camera, while Teddy, Manuel, and Leon go for a playful swim. Below them, two men shake hands "just before a spin" in a fashionable car. Again, at lower left, Brashear offers an image of "Happy Days," as four people pose with giant slices of melon on a sunny afternoon.

As the album unfolds, we find more pictures of sports teams, cut-out faces of loved ones, and outdoor snapshots depicting fun with good friends. The swimming boys return, along with a "happy bunch" (at bottom) and news of a football victory that describes the album maker as a "colored wonder" (fig. 73d). On a subsequent page we see a cropped studio portrait of Brashear's teacher from Carbondale, Illinois, surrounded by several lighthearted snaps whose captions suggest they were taken in St. Louis, Missouri (fig. 73e). Our narrator appears to have gone on a trip and taken his camera with him. He poses for us with friends at Forest Park, one of the sites of the 1904 Olympics, where an African American competitor medaled for the first time in the history of the games. The Tuskegee athlete flirts with a young woman taking his picture: "She made me laugh," he wrote. Perhaps it is "she" who is "posing" on the right, returning a smile of her own. Later, we encounter yet more friends, more fun, and another woman who gave him a big smile (fig. 73f). This woman in the center

HISTORY OF FOOTBALL
I. THE FIRST RULES.

This coming week will mark the forty-eighth anniversary of the beginning of inter-collegiate football on this side of the Atlantic. The first gridiron contest ever staged in America between college teams was played at New Brunswick, N. J., on the 6th day of November, 1869. The opposing teams represented Princeton and Rutgers, although the former institution was then known as Nassau Hall, and was far from being the great university it now is.

Rutgers college is at New Brunswick, only about twenty miles from Old Nassau, and the proximity of the two institutions naturally led to an intense athletic rivalry. Rutgers was the first to take up football, and organized an eleven with W. J. Legget as captain. The Princetonians were challenged to a gridiron battle, and Nassau immediately accepted the defi. W. S. Gummere, who had made a reputation on the diamond, was chosen as the leader of the team that was to bear the colors of Old Nassau in a contest at the new sport with the hated rival.

Gummere and Legget aranged a meeting to formulate a set of rules to govern the first intercollegiate gridiron combats.

This pioneer set of regulations is a remarkable code, and bears practically no resemblance to the rules governing any form of present-day football.

Some of the provisions were as follows:

The players on each side shall number twenty-five.

Four judges and two referees shall officiate at each game.

There shall be no throwing or running with the ball, either constituting a foul, when the ball must be thrown perpendicularly in the air by the offending side.

There shall be no tripping or holding of players, and holding the ball and free kicks are not allowed.

In case a ball passes out of bounds, it shall be kicked on horizontally by the side which kicked it out.

Maybird — Louise

Enjoying a visit at Addie's Home

Viola + Me

Lillian + friend

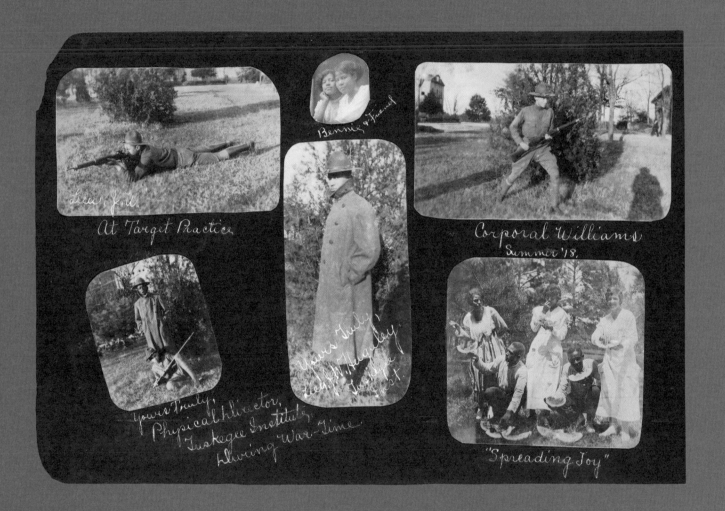

Bennie & Friend

At Target Practice

Corporal Williams
Summer '18.

Yours Truly,
Physical Director,
Tuskegee Institute,
Hluring War-Time.

Yours Truly,
Corp. W. Hugeley,
Tuskegee Inst.

"Spreading Joy"

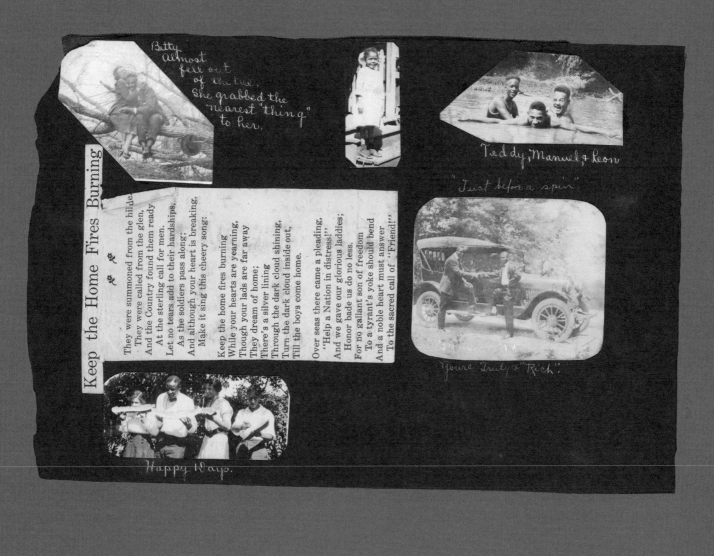

Betty
almost
fell out
of the tree.
She grabbed the
"nearest" "thing"
to her.

Teddy, Manuel & Leon

"Just before a spin"

Keep the Home Fires Burning

They were summoned from the hillside,
They were called from the glen,
And the Country found them ready
At the sterling call for men.
Let no tears add to their hardships,
As the soldiers pass along;
And although your heart is breaking,
Make it sing this cheery song:

Keep the home fires burning
While your hearts are yearning,
Though your lads are far away
They dream of home;
There's a silver lining
Through the dark cloud shining,
Turn the dark cloud inside out,
Till the boys come home.

Over seas there came a pleading,
"Help a Nation in distress!"
And we gave our glorious laddies;
Honor bade us do no less.
For no gallant son of freedom
To a tyrant's yoke should bend
And a noble heart must answer
To the sacred call of "Friend!"

Yours Truly & "Rich".

Happy Ways.

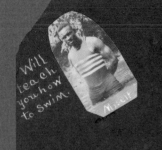

Will teach you how to swim.

Maxie

Teddy, Manuel, & Leon.

Betty

More Hope.

Open.

FORWARD PASS GETS VICTORY.

OPEN STUFF BEWILDERS THE VISITORS.

Knighten, Brashear and Paschal, Three Colored Wonders, Prove to be Nearly the Whole State School Team—Brashear Makes Sixty-yard Pass.

One of the most open American football games seen in the south for many a moon was pulled off yesterday afternoon on the Manual field when the fast Whittier State team romped through the Santa Barbara High team by a 46-to-0 score. Every one of the scores was the direct work of either Knighten, Brashear or Paschal, the three star Whittier players.

OPEN STUFF.

One of the interesting factors of the game was the fact that the Whittier team only tried line-bucking twice throughout the game. Every one of the gains came from forward passes, of which eleven tries were successful in nine instances, and speedy end runs.

The work of the three colored marvels of the Whittier team, Knighten, Paschal and Brashear, was spectacular in the extreme and sent thrills of terror chasing up and down the spines of their helpless opponents.

A HEAVER.

Brashear, playing left half, pulled off some of the classiest forward passes seen in a long time. Most of his passes were good for forty yards' gain, while on one occasion he sent the ball through the air for over sixty yards, which was successfully completed.

Santa Barbara got the kick-off at the start, but Knighten received the ball and dashed down the field for a thirty-five-yard gain. Following immediately upon this run were two by Knighten and the first touchdown. Knighten kicked the goal, making the score 7 to 0. The second score of the quarter was made by two forward passes, Knighten to Brashear, which netted seventy yards and the touchdown. Knighten failed to kick the goal. The quarter ended 13 to 0.

SOME RUN.

The second quarter was spectacularly ushered in by a sixty-five-yard run to touchdown by Knighted on an intercepted forward pass only thirty seconds after the whistle blew. Brashear kicked the goal. The heart was taken completely out of the Santa Barbara team when Knighten again scored on an end run from the middle of the field. The half ended with Whittler far in the lead, 26 to 0.

The third quarter was featured by an end run by Knighten, which gained the Whittler team seventy yards. After he had passed the whole field, Knighten tripped and fell, which robbed him of a ninety-yard run and touchdown. However, he was instrumental in the two touchdowns that Whittier put over that quarter.

SLAUGHTER.

In the first, Brashear scored on a forward pass from Knighten and in the second Knighten took the ball over on a short end run. Time up for the quarter stopped further slaughter at 39 to 0.

The final score came in the last quarter after a fifty-yard pass, Knighten to Trassec, Whittier's 120-pound full-back.

The winning squad averaged 155 pounds in weight, and had two ten-second-flat men for the 100-yard dash. The Santa Barbara team wasn't able to tip the scales over 140, while their only player to distinguish himself was Ferguson, their quarter-back.

The line-up:

Santa Barbara High.		Whittier State School.
Thomas	R. G. L.	Crump, Watters
Gates	R. T. L.	Nelson
Welch	R. E. L.	Simmons
J. Twitchell	C.	Vanlara, Costa
R. Twitchell	L. T. R.	Green
Richardson	L. E. R.	Paschal
Ferguson	Q.	Larks
Brooks	R. H. L.	Brashear
Harris	L. H. R.	Knighten
Parma	F.	Trassec

A happy Bunch

Forest Park
She
Made
Me
Laugh.

Forest Park
Just
Posing.

Minnie H. Gerhardt
Teacher
Carbondale, Ill.

Two on One

Van, Rosie, Me

St. Louis, Mo.

The
Gerhardt
Sisters

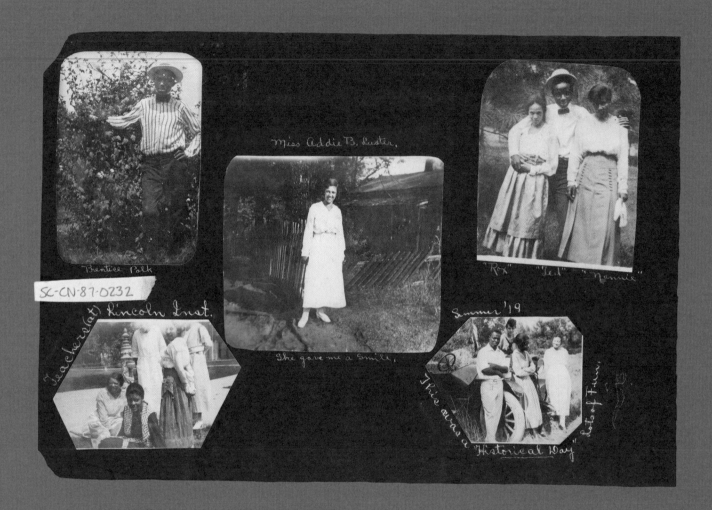

Miss Addie B. Luster.

Prentice Polk

"Rx" "Ted" "Nannie"

Teachers(at) Lincoln Inst.

She gave me a Smile.

Summer '19

This was a "Historical Day" lots of fun.

of the composition is probably the same Addie who hosted the summer picnic at her home, pages before.

We may never know what made the moments represented in the album especially memorable for Brashear, nor can we say very much about the many relationships the snapshots portray. As previously noted, we simply do not have access to the oral culture that once gave the album its life, as we are excluded from the conversations between Brashear, his friends, and his family. But we can reasonably assert that the relationships constructed here were intimate and that the playfulness with which the photos were snapped and captioned contributed to their representation as such. We see in this elaborately constructed object, as in so many other early African American photo albums, an exposition of what critic bell hooks has described as the unique power of snapshots in black life. It was through seemingly banal photographs, these so-called true-to-life images, that people could work against the "degrading images of blackness . . . in the dominant culture" and thus "empower ourselves through representation." Snapshots, hooks explains, "offered us a way to contain memories, to overcome loss, to keep history."[18] This was especially important work within the context of the New Negro movement, which emerged around 1895 and flourished in the 1920s. The trope of the New Negro, embraced in African American literature and the arts, associated blackness with education, refinement, progress, and race consciousness; it constituted a radical reconstruction of white images of the black that carried the names Zip Coon, Sambo, and Mammy.[19]

hooks admits that there is space for "fun" in the creation of a "counter-hegemonic world of images." Yet within this form of "visual resistance," she finds no place for the racial stereotypes that continue to proliferate in popular visual culture.[20] No doubt we can see the appeal of this position, which has become a hallmark of scholarship on African American vernacular photography. To celebrate the camera as an instrument of self-representation, as a political tool that allowed African Americans to see how they looked through their own eyes, it would seem necessary to imagine everyday black photographers as operating outside racist ways of picturing black life, entirely on their own terms. While this understanding of African American photography has been a valuable one, it enacts some erasure of its own. What gets left out is the idea that white fantasies of blackness can be absent *and* present within black vernacular photography, as in George Brashear's album.

BLACK LAUGHTER

The critical humor that I am attributing to Brashear and to the black subjects whom Walker features in *An Audience* can be perplexing, as it depends upon the resuscitation

and inhabitation of demeaning stereotypes. It is easy to imagine viewers reacting negatively to early African American snapshot albums in which subjects willingly, even joyfully, bare their teeth for the camera with melons in hand, framed on the page by an apparently racist caption. They could judge Brashear for pandering to white conceptions of blackness, choosing to see in his album stereotypes from the plantation tradition that fuel the racist imagination.[21] Under the veneer of racial stereotype, however, we might choose to uncover something else: highly sympathetic images of romantic love and friendship emerging from a multidimensional affective space. Like the black subjects featured in Kara Walker's *An Audience*, everyone in Brashear's album appears finely dressed, self-assured, collegial, and wholly familiar with the pleasures of bourgeois leisure. Clippings and captions, moreover, speak of success, self-consciousness, and authenticity. Brashear thus makes obvious an incongruity between the stereotypical watermelon-eating "Negro" and the highly sympathetic self-image laid out in his album. He resuscitates and inhabits a public, shameful image of the black, in other words, only to redeploy it as an instrument of self-empowerment among close friends and family.

In his classic cultural history of Harlem in the 1920s, Nathan Irvin Huggins attempted to explain the politics and psychology of such racial humor, which revives in order to subvert. He did so by considering African Americans' participation in blackface minstrelsy. Beginning in the late nineteenth century, Huggins argued, black actors like Bert Williams and George Walker wore black masks with a degree of self-consciousness unmatched by their white peers. On the minstrel stage, "they were not portraying themselves or any other Negroes they knew. Rather, they were intending to give style and comic dignity to a fiction that white men had created and fostered and with which black men (on and off stage) conspired, being one of the few public selves that they were permitted." Exaggeration became an important feature of these performances because it insinuated a distance between the "theatrical grotesques" the black actors adopted and the embodied identities of African Americans. That such distance is exceedingly difficult to maintain accounts for the psychological complexity that Huggins associates with racial humor performed by someone who identifies him- or herself as belonging to that racial group. He defines it as a "kind of self-masochism which converts self-hatred—through its indulgence—into gratification and the pleasure of self-esteem. But the rub is that the contempt for self and race on which such humor turns must be ever-present to make it work." Huggins sees the work of Williams and Walker as "laughing to keep from crying" and warns of a possible "corrosion of the self in this pretense, and surely a rending of integrity."[22]

Scholars have complicated this view of blacks laughing at other blacks by pointing to economic and regional identification as important factors. According to historian

Lawrence Levine, black humor in the context of the Great Migration helped people come to terms with the history of American slavery and racism in the twentieth century, as much as it allowed them to laugh at their own contemporary circumstances, including "the idiosyncrasies of behavior often produced by mobility and the transitions between South and North."[23] In an essay titled "An Extravagance of Laughter," Ralph Ellison presented in these terms his own experiences as a student at the Tuskegee Institute in the 1930s, reading laughter among his class-conscious peers as a mechanism for coping with life in a small Alabama city. He recalled what happened after one Tuskegee student, whose last name was "Whyte," was harassed by local white policemen:

> Back on campus we were compelled to buffer the pain and negate the humiliation by making grotesque comedy out of the extremes to which whites would go to keep us in what they considered to be our "place." Once safe at Tuskegee, we'd become fairly hysterical as we recounted our adventures and laughed as much at ourselves as at the cops. We mocked their modes of speech and styles of intimidation, and teased one another as we parodied our various modes of feigning fear when telling them who we were and where we were headed. It was a wild, he-man, schoolboy silliness but the only way we knew for dealing with the inescapable conjunction of laughter and pain.[24]

Students at Tuskegee in the 1930s, who aspired to the urban middle class and who were encouraged to see themselves as fortunate to be among the mobile and the knowledgeable, also used laughter to deal with the shame they associated with the "immediate southern rural past."[25] Writer Zora Neale Hurston famously described this class-motivated racial humor in 1933, proclaiming that "self-despisement lies in a middle class who scorns to do or be anything Negro," while "the Negro 'farthest down' is too busy 'spreading his junk' in his own way to see or care."[26] A study conducted twenty-five years later by sociologists Russell Middleton and John Moland, and cited by Huggins, lent hard data to Hurston's assertion.[27] The investigation involved two groups of largely middle-class university students in a southern city: one exclusively black, the other white. The researchers found something they had not expected; the black students told more "anti-Negro" jokes than the white students did. They speculated that the black students who incorporated degrading black stereotypes into peer-to-peer humor were not laughing at themselves or at the black race in general but rather at "lower class Negroes" with whom they did not want to be associated. Jokes that reproduced white Americans' assumptions about blacks—from their "pronounced sexuality" to a "tendency to fight with knives and razors, dishonesty, stinginess, verbal

difficulties, and so on"—could be funny to the study subjects principally because they were jokes about *others*.[28]

In recent decades, the field of African American studies has had much to say about black humor and its redeployment of racial stereotype. Building upon Henry Louis Gates Jr.'s exploration of the signifying tradition,[29] Glenda Carpio has studied African American literature and art that operates through complex forms of parody and caricature. Her book *Laughing Fit to Kill* poses a crucial question, the same one that led Betye Saar to launch her letter-writing campaign in 1997: "Can stereotypes be used to critique racism without solely fueling the racist imagination?" Carpio's case studies, which include contemporary visual artists Robert Colescott and Kara Walker, point to an affirmative response. They "use the complicated dynamics of race and humor to set the denigrating history of antebellum stereotypes against their own humorous appropriation of those images." They summon stereotypes "through formally innovating means that incorporate aspects of popular culture (images produced by television or by advertisement, for example), of other art forms (modern art, film and comic strips, for instance), and postmodern techniques." Their work thus "give[s] life . . . to the most taboo aspects of race and sexuality in America, ultimately seeking to effect a liberating sabotage of the past's hold on the present."[30]

But like the black stars of the minstrel stage, Colescott and Walker are in the business of making *public* performances of racial stereotypes. As a result, they may be able to tell us very little about *private* reactions to or reenactments of those stereotypes in the everyday lives of African Americans. Along the same lines, Mel Watkins has called for scholars to recognize the "rift between blacks' public and private reactions to black stage humor," which might enable a Tuskegee student to condemn a racial caricature in the presence of strangers but to laugh at its assumptions about blackness at home or in a close circle of friends. Watkins laments that "documentation of the *private* humor of blacks during any period before the mid-twentieth century is scant, particularly from the Civil War to the 1920s," which underscores the significance of vernacular objects like George Brashear's album.[31]

The Brashear album reminds us that you do not have to be a high-profile artist to deploy humor as critique; nor is complexity incompatible with the spontaneity and so-called ordinariness of the snapshot. What we see in Brashear's photographs are witty commentaries on white constructions of black happiness and affirmations of Tuskegee's mission to uplift through education. For this young man at Tuskegee, and for so many other middle-class African American Kodakers in the early twentieth century, grinning broadly (and playing other racial stereotypes for the camera) was as pleasurable as it was political.

In the contemporary selfie culture on display in *A Subtlety* and captured in *An Audience*, the racial humor of early Kodakers breathed new life. Counting on all who visited *A Subtlety* to turn to their cameras as well as to their sense of humor, Walker orchestrated for her visitors one of two historical subject positions. On the one hand, she offered the position of the snapshooter who saw the "mammy-sphinx" as an opportunity to bring to life stereotypes of black womanhood, to reenact the gendered power relations that once defined the institution of slavery, and to thus reaffirm their whiteness. On the other hand, Walker presented her audience with an occasion to deny a centuries-old racial caricature the power to define black female bodies as grotesque and subservient. While criticism of the exhibition highlighted the former position, *An Audience* documented the eagerness and pleasure with which many black visitors took up the latter, unknowingly keeping alive the photographic tradition represented by Brashear's album.

Of course, the performance of any subject position is a messy affair that can involve unease, half measures, and various degrees of consciousness. Were we privy to the conversations that took place among Brashear and his friends when they posed for their snaps, as we are to their counterparts in *An Audience*, we might witness some of this messiness and the discomfort that racial humor presents to many Americans today, regardless of the racial group with which they identify. Having attended the exhibition, I can attest to having seen viewers of all races responding tentatively to the sculptures with their own eyes and using their cameras to mediate the memories, fears, desires, and complex emotions that the artworks summoned in them. As a mother who self-identities as white, I can also speak to the guilt and embarrassment I experienced when my light-complexioned, blond-haired son begged me to take selfies with him as he grinned broadly alongside the figures in the exhibition. More than anything, I did not want to be seen as resurrecting old ideas about photography, race, and emotion, or to treat the black bodies constructed by Kara Walker as my own happy objects. As a white woman, how could my performance for the camera look like anything other than simple collusion with the racism that gave rise to the "mammy" stereotype? Could my laughter before the camera ever subvert?

Like many other contemporary reenactments of slavery and its history, Walker's exhibition recognizes that any encounter with a racist trope is messy at best, and no one walks away unmarked by the experience.[32] Walker does this in *An Audience* by documenting visitors' (usually children's) strong reactions to the stench of burnt sugar in the refinery and their awkward negotiations of the sticky floor, which clung to their shoes. About twenty minutes into the video, a toddler has a close encounter with one

of the melting figurines, leaving his hands dripping with resin. The adult women with the boy urge him to "say cheese" for the camera, remarking that he "got a part of the artwork," but the child looks confused about what has just occurred and unsure of his next move. Walker then cuts to a shot of the child beginning to lick his fingers, generally pleased by their sweetness; the women shriek at him to stop, clearly amused but also troubled by his desire to ingest Walker's concoction—to take it all in.

There may have been something inherently funny about George Brashear posing with his friends and watermelons at Tuskegee, just as there was about Walker using a seventy-five-foot racist stereotype to stimulate anything other than racism. But theirs was a subtle humor that relied on a sympathetic audience to think and act critically, and to laugh for all the right reasons. Only by picking up a watermelon or coming face to face with the "mammy-sphinx" could they demonstrate that these objects have always been simply that—materializations of a ridiculous idea. *An Audience* therefore ends with visitors to *A Subtlety* laying their hands on the colossal sculpture—something they were invited to do only at the closing of the exhibition—and fully grasping the constructedness and brittleness of the stereotype before them.

As Walker's oeuvre and its critical reception have vividly demonstrated, restaging racist images can generate pain, revulsion, guilt, and anguish—and it can disrupt, educate, empower, and gratify. Debates around these two sets of feelings and actions were heated both when George Brashear compiled his album and in the early twenty-first century, with the resurgence of postracial discourse in the United States. Is destabilizing the perverse logic of the racial jokes that have saturated popular photographic culture since 1839 worth the psychic suffering triggered by watermelon smiles and other racist visual tropes? Is it up to the contemporary black artist to determine that worth for viewers? What about the white scholar and her audiences? Writing a book like *Study in Black and White* requires trust in the positive transformative potential of critical analysis. Readers will have to decide whether they can share this view, and that is something with which I hope they will continue to grapple. If racial humor can be wrested from laughter—or, as Brashear and Walker posit, subjected to a different sort of laughter—can it engender new ways of seeing blackness and whiteness? I would renew the recommendation made by artist and historian Michael Harris in 1997, the same year that Betye Saar launched her protest of Walker's silhouettes. "The important thing is not that people take a particular position," offered Harris, "but that people think about it and talk about it before they come to their conclusions."[33]

Notes

INTRODUCTION

1. On the meanings of the black/white binary in Anglo-American culture, see Theresa H. Pfeifer, "Deconstructing Cartesian Dualisms of Western Racialized Systems: A Study in the Colors Black and White," *Journal of Black Studies* 39, no. 4 (2009): 528–47; Kim F. Hall, *Things of Darkness: Economies of Race and Gender in Early Modern England* (Ithaca: Cornell University Press, 1995); and Winthrop D. Jordan, *White over Black: American Attitudes Toward the Negro, 1550–1812* (Chapel Hill: University of North Carolina Press, 1968).

2. Surveys of photographic humor include Rolf H. Krauss, *Die Fotografie in der Karikatur* (Seebruck am Chiemsee: Heering, 1978); Bill Jay, *Cyanide and Spirits: An Inside-Out View of Early Photography* (Munich: Nazraeli Press, 1991) and *Some Rollicking Bull: Light Verse, and Worse, on Victorian Photography* (Munich: Nazraeli Press, 1996); and Heinz K. Henisch and Bridget A. Henisch, *Positive Pleasures: Early Photography and Humor* (University Park: Pennsylvania State University Press, 1998). Two recent, richly illustrated books speak to a renewed scholarly interest in the genre: Louis Kaplan, *Photography and Humour* (London: Reaktion Books, 2017); and Rolf H. Krauss, *Laughter and the Camera: A Different History of Photography* (Bielefeld: Kerber Verlag, 2016).

3. On approaches to humor in American art history and visual studies, see Wendy Wick Reaves, "The Art in Humor, the Humor in Art," *American Art* 15, no. 2 (2001): 2–9.

4. Nancy A. Walker, *What's So Funny? Humor in American Culture* (Wilmington, Del.: Scholarly Resources, 1998), 5.

5. Daniel Wickberg, *The Senses of Humor: Self and Laughter in Modern America* (Ithaca: Cornell University Press, 1998), 124.

6. Henri Bergson, *Laughter: An Essay on the Meaning of the Comic*, trans. Cloudesley Brereton and Fred Rothwell (New York: Macmillan, 1914), 7–8.

7. Joseph Boskin and Joseph Dorinson, "Ethnic Humor: Subversion and Survival," *American Quarterly* 37, no. 1 (1985): 81–82.

8. Lawrence W. Levine, *Black Culture and Black Consciousness: Afro-American Folk Thought from Slavery to Freedom* (Oxford: Oxford University Press, 1977), chapter 5.

9. Boskin and Dorinson, "Ethnic Humor," 93.

10. See Eric Lott, *Love and Theft: Blackface Minstrelsy and the American Working Class* (New York: Oxford University Press, 1993).

11. See especially Anne Anlin Cheng, *The Melancholy of Race: Psychoanalysis, Assimilation, and Hidden Grief* (New York: Oxford University Press, 2001); and Sara Ahmed, *The Promise of Happiness* (Durham: Duke University Press, 2010).

12. For more on minstrelsy in transnational contexts, see chapter 2.

13. See Thomas Bender, ed., *Rethinking American History in a Global Age* (Berkeley: University of California Press, 2002); and Winfried Fluck, Donald E. Pease, and John Carlos Rowe, eds., *Re-Framing the Transnational Turn in American Studies* (Hanover: Dartmouth College Press, 2011).

14. See Richard Eves, "'Black and White, a Significant Contrast': Race, Humanism, and Missionary Photography in the Pacific," *Ethnic and Racial Studies* 29, no. 4 (2006): 725–48.

CHAPTER 1

1. Herschel Papers, February 14, 1839, Harry Ransom Center, University of Texas at Austin, quoted in Deborah Willis and Carla Williams, *The Black Female Body: A Photographic History* (Philadelphia: Temple University Press, 2002), 1. Reproduced with permission, parts of this chapter were first published in my article "Comical Conflations: Racial Identity and the Science of Photography," *Photography and Culture* 4, no. 2 (2011): 133–56.

2. "Photogenic Drawings," *Foreign Quarterly Review* 23 (April 1839): 213–18.

3. "Salad for the Photographer," *Philadelphia Photographer* 3, no. 26 (1866): 62.

4. See Bill Jay, "Photographic Pleasures, Popularly Portrayed with Pen and Pencil, 1855," *British Journal of Photography* 133, no.

2 (1986): 37–39; Bridget A. Henisch and Heinz K. Henisch, *The Photographic World and Humour of Cuthbert Bede* (Lewiston: Edwin Mellen Press, 2002) and "Cuthbert Bede and the Photographic Scene in the 1850s," *History of Photography* 28, no. 4 (2004): 348–56.

5. "Country Scenes," *Saturday Evening Post*, July 9, 1853, back cover. This cartoon was first published, with the caption "Portrait of a Distinguished Photographer Who Has Just Succeeded in Focussing a View to His Complete Satisfaction," in *Punch*, May 21, 1853, 208.

6. Hazel Waters, *Racism on the Victorian Stage: Representation of Slavery and the Black Character* (Cambridge: Cambridge University Press, 2007), 98.

7. Marcus Wood, "The American South and English Print Satire, 1760–1865," in *Britain and the American South: From Colonialism to Rock and Roll*, ed. Joseph P. Ward (Jackson: University Press of Mississippi, 2003), 107–40. See also Michael A. Chaney, *Fugitive Vision: Slave Image and Black Identity in Antebellum Narrative* (Bloomington: Indiana University Press, 2008) and "Heartfelt Thanks to *Punch* for the Picture: Frederick Douglass and the Transnational Jokework of Slave Caricature," *American Literature* 82, no. 1 (2010): 57–90.

8. [Thomas Carlyle], "Occasional Discourse on the Negro Question," *Fraser's Magazine for Town and Country*, December 1849, 678. Carlyle's critics found a different reason to be anxious about Brother Jonathan (the United States), fearing that his argument for compelling blacks to work would bolster proslavery sentiments in the American South. This fear was articulated by John Stuart Mill and the many African American leaders who crossed the ocean to weigh in on the "Negro question." See [John Stuart Mill], "The Negro Question," *Fraser's Magazine for Town and Country*, January 1850, 25–31; Audrey A. Fisch, "'Negrophilism'

and British Nationalism: The Spectacle of the Black American Abolitionist," *Victorian Review* 19, no. 2 (1993): 20–47, and *American Slaves in Victorian England: Abolitionist Politics in Popular Literature and Culture* (Cambridge: Cambridge University Press, 2000); and Marcus Wood, *Slavery, Empathy, and Pornography* (Oxford: Oxford University Press, 2002).

9. On the transatlantic history of Stowe's novel, see Douglas A. Lorimer, *Colour, Class, and the Victorians: English Attitudes to the Negro in the Mid-Nineteenth Century* (Leicester: Leicester University Press, 1978); Thomas F. Gossett, *"Uncle Tom's Cabin" and American Culture* (Dallas: Southern Methodist University Press, 1985); Fisch, *American Slaves in Victorian England*; Marcus Wood, *Blind Memory: Visual Representations of Slavery in England and America, 1780–1865* (New York: Routledge, 2000); Sarah Meer, *Uncle Tom Mania: Slavery, Minstrelsy, and Transatlantic Culture in the 1850s* (Athens: University of Georgia Press, 2005); and Jo-Ann Morgan, *"Uncle Tom's Cabin" as Visual Culture* (Columbia: University of Missouri Press, 2007).

10. Wood, *Blind Memory*, 143.

11. On the racial connotations of "Day & Martin," see Waters, *Racism on the Victorian Stage*, 61.

12. On the origins of blackface minstrelsy in the United States, see Robert C. Toll, *Blacking Up: The Minstrel Show in Nineteenth-Century America* (New York: Oxford University Press, 1974); and Eric Lott, *Love and Theft: Blackface Minstrelsy and the American Working Class* (New York: Oxford University Press, 1993).

13. Derek B. Scott, *Sounds of the Metropolis: The Nineteenth-Century Popular Music Revolution in London, New York, Paris, and Vienna* (Oxford: Oxford University Press, 2008), 147.

14. Douglas A. Lorimer, "Bibles, Banjoes, and Bones: Images of the Negro in the Popular Culture of Victorian England," in *In Search of the Visible Past: History Lectures at Wilfrid Laurier University, 1973–1974*, ed. Barry M. Gough (Waterloo: Wilfred Laurier University Press, 1975), 31–50; J. S. Bratton, "English Ethiopians: British Audiences and Black-Face Acts, 1835–1865," *Yearbook of English Studies* 11 (1981): 127–42; Michael Pickering, "Mock Blacks and Racial Mockery: The 'Nigger' Minstrel and British Imperialism," in J. S. Bratton et al., *Acts of Supremacy: The British Empire and the Stage, 1790–1930* (Manchester: Manchester University Press, 1991), 179–236; Waters, *Racism on the Victorian Stage*; and Scott, *Sounds of the Metropolis*.

15. See Meer, *Uncle Tom Mania*.

16. William Ragan Stanton, *The Leopard's Spots: Scientific Attitudes Toward Race in America, 1815–1859* (Chicago: University of Chicago Press, 1960); Winthrop D. Jordan, *White over Black: American Attitudes Toward the Negro, 1550–1812* (Chapel Hill: University of North Carolina Press, 1968); and Nancy Stepan, *The Idea of Race in Science: Great Britain, 1800–1960* (London: Macmillan, 1982).

17. See Karen Newman, "'And Wash the Ethiop White': Femininity and the Monstrous in *Othello*," in *Shakespeare Reproduced*, ed. Jean Howard and Marion O'Connor (London: Methuen, 1987), 141–62; Kim F. Hall, *Things of Darkness: Economies of Race and Gender in Early Modern England* (Ithaca: Cornell University Press, 1995); Anne McClintock, *Imperial Leather: Race, Gender, and Sexuality in the Colonial Contest* (New York: Routledge, 1995), chapter 5; and Anandi Ramamurthy, *Imperial Persuaders: Images of Africa and Asia in British Advertising* (Manchester: Manchester University Press, 2003), chapter 2.

18. Cuthbert Bede, *Photographic Pleasures, Popularly Portrayed in Pen and Pencil* (London: T. McLean, 1855), 66–67.

19. Bede, 51. A slightly different version of this illustration was first published with the

caption "A Photographic Positive" in *Punch*, July 30, 1853, 48.

20. The apparently true basis of Bede's story is noted in Henisch and Henisch, *Photographic World*, 65–66; and Jay, "Photographic Pleasures." Bede identified the young lady as Miss Hussey Pache, the niece of photographer J. M. Heathcote.

21. Heinrich Hoffman, *The English Struwwelpeter, or Pretty Stories and Funny Pictures from the German* (London: Dean and Son, ca. 1860). The stories in this collection were published in the United States shortly after their English translation. "The Girl Who Inked Herself and Her Books" appeared, for instance, in *Little Miss Consequence* (New York: McLoughlin Bros., ca. 1859–62).

22. H. Cholmondeley-Pennell, "Perils of the Fine Arts," in *Puck on Pegasus* (London: John Camden Hotten, 1868), 127–29. Bill Jay notes in "The Black Art" (manuscript, ca. 1985) that the earliest publication of this poem was 1861.

23. Bede, *Photographic Pleasures*, ix.

24. This view of female amateurs contrasts with that of the 1880s and '90s, when photography became a "socially acceptable recreational activity for women" in Britain and the United States, offering them new social opportunities. See Madelyn Moeller, "Ladies of Leisure: Domestic Photography in the Nineteenth Century," in *Hard at Play: Leisure in America, 1840–1940*, ed. Kathryn Grover (Amherst: University of Massachusetts Press, 1992), 139–60. On the gentlemanly character of British amateur photography at midcentury, see Grace Seiberling, *Amateurs, Photography, and the Mid-Victorian Imagination* (Chicago: University of Chicago Press, 1986).

25. See Wood, *Blind Memory*; and Meer, *Uncle Tom Mania*. Bede's criticism of female amateurs and abolitionists also came in the wake of the controversy surrounding the World Anti-Slavery Convention held in London in 1840, when the American female delegates were denied their seats. At the time, only men could serve as officers and committee members in the British and Foreign Anti-Slavery Society, and few English women challenged this convention. See Kathryn Kish Sklar, "'Women Who Speak for an Entire Nation': American and British Women at the World Anti-Slavery Convention, London, 1840," in *The Abolitionist Sisterhood: Women's Political Culture in Antebellum America*, ed. Jean Fagan Yellin and John C. Van Horne (Ithaca: Cornell University Press, 1994), 301–33.

26. Joyce Green MacDonald, "Acting Black: *Othello*, *Othello* Burlesques, and the Performance of Blackness," *Theatre Journal* 46, no. 2 (1994): 231–49; and Kris Collins, "White-Washing the Black-a-Moor: *Othello*, Negro Minstrelsy, and Parodies of Blackness," *Journal of American Culture* 19, no. 3 (1996): 87–101.

27. Collins, "White-Washing the Black-a-Moor," 98.

28. In 1997, the Shakespeare Theatre Company in Washington, D.C., performed what director Jude Kelly called a "photonegative" *Othello*, in which "white" actors played "black" characters, and vice versa, while the dialogue remained unchanged. My reading of Bede's racial humor is conversant with criticism of that controversial performance in observing the ways in which photography can operate as metaphor and thus engage "assumptions about identity, race relations, sexual politics, [and] class mobility." Sujata Iyengar, "White Faces, Blackface: The Production of 'Race' in *Othello*," in *Othello: New Critical Essays*, ed. Philip C. Kolin (New York: Routledge, 2002), 105. See also Denise Albanese, "Black and White, and Dread All Over: The Shakespeare Theater's 'Photonegative' *Othello* and the Body of Desdemona," in *A Feminist Companion to Shakespeare*, ed. Dympna Callaghan (Malden, Mass.: Blackwell, 2000), 226–47.

29. Oliver Wendell Holmes, "The Stereoscope and the Stereograph," in *Soundings from the*

Atlantic (Boston: Ticknor and Fields, 1864), 134–35. Holmes's essay first appeared in the *Atlantic Monthly*, June 1859, 738–48.

30. Holmes, 136–37.

31. "Photography," *Household Words*, March 19, 1853, 61.

32. Julia F. Munro, "'Drawn Towards the Lens': Representations and Receptions of Photography in Britain, 1839 to 1853" (PhD diss., University of Waterloo, 2008), 124. See also, by Munro, "'The Optical Stranger': Photographic Anxieties in British Periodical Literature of the 1840s and Early 1850s," *Early Popular Visual Culture* 7, no. 2 (2009): 167–83.

33. *Uncle Tom in England: The London Times on Uncle Tom's Cabin; A Review from the London Times of Friday, September 30, 1852* (New York: Bunce & Brother, 1852), 4–5.

34. Waters, *Racism on the Victorian Stage*, 166–67.

35. Samuel Stanhope Smith, *An Essay on the Causes of the Variety of Complexion and Figure in Human Species* (Philadelphia: Robert Aitken, 1787); Stanton, *Leopard's Spots*; and Jordan, *White over Black*, 517.

36. James Cowles Prichard, *Researches into the Physical History of Man* (London: J. and A. Arch, 1813); Stepan, *Idea of Race in Science*, 38–39; and Hannah Franziska Augstein, *James Cowles Prichard's Anthropology: Remaking the Science of Man in Early Nineteenth-Century Britain* (Amsterdam: Rodopi, 1999). Prichard's *Researches* went through several editions between 1813 and the 1850s, ensuring that the idea of man's black origins remained in transatlantic circulation.

37. [Mill], "Negro Question," 30.

38. "Photography," *Household Words*, 61.

39. Although humor sections appeared in American almanacs in the seventeenth century, the cheap publications known as "comic almanacs" did not became popular in the United States until the 1830s. Early examples of this genre include Charles Ellms's *American Comic Almanac*, first published in Boston in 1831, and Frank Leslie's *Comic Almanac*, published annually between the 1870s and 1890s.

40. Elbert Anderson, *Elbert Anderson's Photo-Comic Allmynack* (Philadelphia: Benerman and Wilson, 1873), 35.

41. For period discussions of photographic lighting as tailored to complexion, see R. J. Chute, "Hints Under the Skylight: The Light and the Subject," *Philadelphia Photographer* 11, no. 130 (1874): 313–14; and T. R. Williams, "Portraiture—Hints on Lighting," *Photographic Mosaics* 3 (1868): 123. On the ways in which photographic technologies have privileged white skin since their invention, see Brian Winston, "A Whole Technology of Dyeing: A Note on Ideology and the Apparatus of the Chromatic Moving Image," *Daedalus* 114, no. 4 (1985): 105–23; Richard Dyer, *White* (London: Routledge, 1997); and Tanya Sheehan, *Doctored: The Medicine of Photography in Nineteenth-Century America* (University Park: Pennsylvania State University Press, 2011), chapter 3.

42. H. J. Rodgers, *Twenty-Three Years Under a Sky-Light, or Life and Experiences of a Photographer* (Hartford: H. J. Rodgers, 1872), 175–76.

43. See Fred Wilson and Lisa Corrin, *Mining the Museum: An Installation*, exhibition catalogue (New York: W. W. Norton, 1994).

44. Fred Wilson, *X*, from the portfolio "Tantra," 2005, digital color chromogenic print on Duratrans © sheet: 53 × 55.7 cm (20 7/8 × 21 15/16 inches), Gift of Exit Art 2012.133.6.6, RISD Museum of Art. Readers may view a reproduction of this artwork at http://risdmuseum.org/art_design/objects/6867_x?context=72&type=exhibitions, accessed January 9, 2018. I was unable to obtain permission from the artist to reproduce *X* in this chapter.

45. Marion S. Trikosko, *Malcolm X Waits at Martin Luther King Press Conference*, head-and-shoulders portrait, March 26, 1964, film negative, U.S. News & World

Report Magazine Photograph Collection, Library of Congress Prints and Photographs Division, accessed January 9, 2018, https://www.loc.gov/item/2003688131; and John Singer Sargent, *Madame X (Madame Pierre Gautreau)*, 1883–84, oil on canvas, 82 1/8 in. × 43 1/4 in., Arthur Hoppock Hearn Fund, 1916, Metropolitan Museum of Art, accessed January 9, 2018, http://www.metmuseum.org/art/collection/search/12127.

46. Susan Sidlauskas, "Painting Skin: John Singer Sargent's *Madame X*," *American Art* 15, no. 3 (2001): 8–33.

47. Susan Gubar, *Racechanges: White Skin, Black Face in American Culture* (New York: Oxford University Press, 1997), 5–6, 10.

CHAPTER 2

1. On the genre mixing and racial politics of *The Octoroon*, see Daphne A. Brooks, *Bodies in Dissent: Spectacular Performances of Race and Freedom, 1850–1910* (Durham: Duke University Press, 2006), chapter 1. Zoe Peyton takes poison and dies in the American version of *The Octoroon*. London audiences were reportedly displeased with this ending, however, so Boucicault wrote an alternative conclusion that brought Zoe and her beloved George Peyton together.

2. On the role of photography in *The Octoroon*, see Harley Erdman, "Caught in the Eye of the Eternal: Justice, Race, and the Camera; From *The Octoroon* to Rodney King," *Theatre Journal* 45, no. 3 (1993): 333–48; and Adam Sonstegard, "Performing Remediation: The Minstrel, the Camera, and *The Octoroon*," *Criticism* 48, no. 3 (2006): 375–95.

3. Dion Boucicault, *The Octoroon: A Play in Four Acts* (1859; reprint, London: John Dicks; New York: De Witt Publishing, n.d.), 8, 10, 16.

4. See Robert Dingley, "The Unreliable Camera: Photography as Evidence in Mid-Victorian Fiction," *Victorian Review* 27, no. 2 (2001): 42–55; and Jennifer Tucker, *Nature Exposed: Photography as Eyewitness in Victorian Science* (Baltimore: Johns Hopkins University Press, 2006).

5. "Theatrical Photography—*The Octoroon*," *Photographic Journal* 116 (December 16, 1861): 339–40.

6. John Lowe, "Theories of Ethnic Humor: How to Enter, Laughing," *American Quarterly* 38, no. 3 (1986): 439–60.

7. While critical of its racist language, this chapter uses the phrase *darkey photographer* (without quotation marks) to acknowledge its frequent use and to encompass its many variations in the period.

8. Joseph Roach, *Cities of the Dead: Circum-Atlantic Performance* (New York: Columbia University Press, 1996), 180, 181.

9. Katy Chiles, "Blackened Irish and Brown-Faced Amerindians: Constructions of American Whiteness in Dion Boucicault's *The Octoroon*," *Nineteenth-Century Theatre and Film* 31 (2004): 28–50. Other models for seeing theatrical performances as incorporating local and transnational mappings of race include Shannon Steen, *Racial Geometries of the Black Atlantic, Asian Pacific, and American Theatre* (New York: Palgrave Macmillan, 2010); and Brooks, *Bodies in Dissent*.

10. H. G. T. Thayer, "Log of the H. S. Bark Brazileira," 1862–63, Miscellaneous Manuscripts Collection, Library of Congress, Washington, D.C., 5, 7.

11. Michael J. Bennett, "'Frictions': Shipboard Relations Between White and Contraband Sailors," *Civil War History* 47, no. 2 (2001): 140.

12. Thayer, "Log of the H. S. Bark Brazileira," 7.

13. See Frank E. Moran, "Libby's Bright Side," in *Footfalls of Loyalty*, ed. Mary W. Westcott (Lincoln, Neb.: Journal Company, State Printer, 1886), 172–89; and Charles Warrington Earle, "In and Out of Libby

Prison," in *Military Order of the Loyal Legion of the United States, Commandery of the State of Illinois, Military Essays and Recollections*, vol. 1 (Chicago: A. C. McClurg, 1891), 247–92.

14. Earle, "In and Out of Libby Prison," 259–60.

15. Without access to all of the original scripts, we can only speculate that similar lines and actions appeared in *Scenes in the Studio*, *The Nigger in the Daguerreotype Saloon*, and *Countryman in a Photograph Gallery*.

16. The script was published in Charles White, *Scenes in the Studio* (French's acting edition) (New York, ca. 1865), 56–65; and *Darkey Drama, Part I* (New York: Samuel French, ca. 1865), 56–65. The San Francisco Minstrels also performed the farce in New York under the title *Scenes at Gurney's* in 1874.

17. In the title of the sketch, the word was spelled "darkey," "darkie," or "darky." British newspapers include similar titles for the same script, including *The Negro Photographer* (1874), *The Nigger Photographer* (1874), and *The Darkey Photographers* (1920).

18. *The Darkey Photographer*, in *Spencer's Book of Comic Speeches and Humorous Recitations*, ed. Albert J. Spencer (New York: Dick and Fitzgerald, 1867), 89–97 (hereafter *DP*). The same script appeared in Abel Heywood, *Heywood's Stump Speeches and Nigger Jokes, Etc.* (Manchester: A. Heywood & Son, 1886), 92–99; William De Vere, *De Vere's Negro Sketches, End-Men's Gags, and Conundrums: Adapted to the Use of Amateurs or Professionals* (New York: Excelsior, 1889), 18–24; and *Wehman's Minstrel Sketches, Conundrums, and Jokes* (New York: Henry J. Wehman, 1890), 17–22.

19. *DP*, 89.

20. "Daguerrian Gallery of the West," *Gleason's Pictorial Drawing-Room Companion* 6, no. 13 (April 1, 1854): 208.

21. Margaret Rose Vendryes, "Race Identity/Identifying Race: Robert S. Duncanson and Nineteenth-Century American Painting," *Art Institute of Chicago Museum Studies* 27, no. 1 (2001): 99, 83. Of Duncanson, Vendryes notes that he only rarely painted subjects with overtly "black" themes, as in the commissioned *Uncle Tom and Little Eva* (1853), suggesting to scholars that race was "superficial to his story" (84).

22. *DP*, 89 (emphasis added).

23. "Polygraphic Hall," *Examiner* (London), June 10, 1865, 360.

24. Announcements for the show appeared in the *Sydney Morning Herald*, February 23, 1865, 1; *Empire* (Sydney), February 24, 1865, 4; *Argus* (Melbourne), March 27, 1865, 8; and *South Australian Register* (Adelaide), June 6, 1865, 2. William Henry Caster, an amateur photographer and member of the American Christy Minstrels, performed *The Photographic Studio* with a minstrel troupe in Sydney in 1865; see https://www.daao .org.au/bio/william-henry-caster, accessed January 9, 2018.

25. "Mohawk Minstrels," *Weekly News*, January 14, 1888, included in a collection of newspaper clippings from the British press mounted in a scrapbook, making a history of these performers from January 1886 to October 1889, Harvard Theatre Collection, Houghton Library.

26. On the place of "God Save the Queen" in minstrel shows in the British colonies, see Chinua Thelwell, "'The Young Men Must Blacken Their Faces': The Blackface Minstrel Show in Preindustrial South Africa," *TDR/The Drama Review* 57, no. 2 (2013): 66–85. See also Rachel Cowgill and Julian Rushton, eds., *Europe, Empire, and Spectacle in Nineteenth-Century British Music* (Aldershot: Ashgate, 2006); and Jeffrey Richards, *Imperialism and Music: Britain, 1876–1953* (Manchester: Manchester University Press, 2001).

27. Susan Smulyan, *Popular Ideologies: Mass Culture at Mid-Century* (Philadelphia: University of Pennsylvania Press, 2007), 28. On the cultural work of amateur minstrelsy in early twentieth-century America, see also

Leslie Paris, *Children's Nature: The Rise of the American Summer Camp* (New York: New York University Press, 2008), chapter 6.

28. Frank Dumont, *The Witmark Amateur Minstrel Guide and Burnt Cork Encyclopedia* (Chicago: M. Witmark & Sons, 1899), 8. *The Darkey Photographer* was translated into a dialect-free script for amateurs and published as *The Photographer* in Frank Honywell Fenno, *The Speaker's Favorite, or Best Things for Entertainments, for Home, Church, and School* (Philadelphia: J. E. Potter, 1893), 169–76.

29. While Jeremiah Gurney is believed to be the first American to whom Samuel F. B. Morse taught the daguerreotype process, and one of the first to open a daguerreotype studio in New York City, the Tait brothers (John and Alexander) set up several studios in New Zealand, including one in Reefton that opened around 1881, the same year that *Tait's Photographic Studio* was performed there.

30. Richard Waterhouse, *From Minstrel Show to Vaudeville: The Australian Popular Stage, 1788–1914* (Kensington: University of New South Wales Press, 1990). Studies of the American influences on Australasian blackface minstrelsy include Matthew W. Wittmann, "Empire of Culture: U.S. Entertainers and the Making of the Pacific Circuit, 1850–1890" (PhD diss., University of Michigan, 2010); Melissa Bellanta, "Leary Kin: Australian Larrikins and the Blackface Minstrel Dandy," *Journal of Social History* 42, no. 3 (2009): 677–95, and "The Larrikin's Hop: Larrikinism and Late Colonial Popular Theatre," *Australasian Drama Studies* 52 (April 2008): 131–47; Lynn Abbott and Doug Seroff, *Out of Sight: The Rise of African American Popular Music, 1889–1895* (Jackson: University Press of Mississippi, 2002), chapter 1; and Bob Carlin, *The Birth of the Banjo: Joel Walker Sweeney and Early Minstrelsy* (Jefferson, N.C.: McFarland, 2007). According to these sources, the first troupe of African American performers to arrive in

Sydney, on December 6, 1876, was Corbyn's Georgia Minstrels. They performed *The Octoroon* at the Bijou Theater in Melbourne in June 1877. Charles B. Hicks's Georgia Minstrels followed shortly thereafter.

31. Helen Gilbert and Jacqueline Lo, *Performance and Cosmopolitics: Cross-Cultural Transactions in Australasia* (New York: Palgrave Macmillan, 2008), 26–27. One offshoot of this adaptation process was playing Aboriginal characters in blackface and modeling them on the "stage Negro."

32. Richard Waterhouse, "Popular Culture," in *Americanization and Australia*, ed. Philip Bell and Roger Bell (Sydney: University of New South Wales Press, 1998), 50. For other examples of American images migrating into popular Australasian culture, see Ann McGrath, "Playing Colonial: Cowgirls, Cowboys, and Indians in Australia and North America," *Journal of Colonialism and Colonial History* 2, no. 1 (2001), https://muse.jhu.edu/article/7364; Neville K. Meaney, ed., *Under New Heavens: Cultural Transmission and the Making of Australia* (Port Melbourne, Victoria: Heinemann Educational, 1989); and Geoffrey Lealand, *A Foreign Egg in Our Nest? American Popular Culture in New Zealand* (Wellington: Victoria University Press, 1988).

33. Waterhouse, *From Minstrel Show to Vaudeville*, 106–8. See also Richard White, *Inventing Australia: Images and Identity, 1688–1980* (Sydney: George Allen and Unwin, 1981); and Herbert I. London, *Non-White Immigration and the "White" Australia Policy* (New York: New York University Press, 1970).

34. On American studio photographers' efforts to present themselves as skilled operators, see Tanya Sheehan, *Doctored: The Medicine of Photography in Nineteenth-Century America* (University Park: Pennsylvania State University Press, 2011).

35. Paul Gilmore, *The Genuine Article: Race, Mass Culture, and American Literary Manhood* (Durham: Duke University Press, 2001), 191.

36. *DP*, 92.

37. *DP*, 90.

38. *DP*, 90.

39. *DP*, 95.

40. *DP*, 92.

41. *DP*, 91–92.

42. *DP*, 95–96.

43. Edward Long, *The History of Jamaica, or General Survey of the Ancient and Modern State of That Island, with Reflections on Its Situation, Settlements, Inhabitants, Climate, Etc.*, vol. 2 (London: T. Lowndes, 1774), 354–55, quoted in Michael Adas, *Machines as the Measure of Men: Science, Technology, and Ideologies of Western Dominance* (Ithaca: Cornell University Press, 1989), 14–15.

44. Nancy Stepan, *The Idea of Race in Science: Great Britain, 1800–1960* (London: Macmillan, 1982).

45. Bruce Sinclair, ed., *Technology and the African-American Experience: Needs and Opportunities for Study* (Cambridge: MIT Press, 2004), 4; see also Ronald T. Takaki, *Iron Cages: Race and Culture in Nineteenth-Century America* (New York: Knopf, 1979).

46. See Steven Hoelscher, "Viewing Indians: Native Encounters with Power, Tourism, and the Camera in the Wisconsin Dells, 1866–1907," *American Indian Culture and Research Journal* 27, no. 4 (2003): 1–51; Martha A. Sandweiss, *Print the Legend: Photography and the American West* (New Haven: Yale University Press, 2002); Nigel Holman, "Photography as Social and Economic Exchange: Understanding the Challenges Posed by Photography of Zuni Religious Ceremonies," *American Indian Culture and Research Journal* 20, no. 3 (1996): 93–110; James Farris, *Navajo and Photography: A Critical History of the Representation of an American People* (Albuquerque: University of New Mexico Press, 1996); and Margaret B. Blackman, "Copying People: Northwest Coast Native Responses to Early Photography," *BC Studies* 52 (Winter 1981–82): 86–108.

47. For examples, see *Brisbane Courier*, March 15, 1867, 2; and "The Natives of Central Australia," *Register* (Adelaide), June 8, 1904, 5. See also Janet Hoskins, "The Camera as Global Vampire: The Distorted Mirror of Photography in Remote Indonesia and Elsewhere," in *The Framed World: Tourism, Tourists, and Photography*, ed. Mike Robinson and David Picard (Surrey: Ashgate, 2009), 151–68; and Max Quanchi, *Photographing Papua: Representation, Colonial Encounters, and Imaging in the Public Domain* (Cambridge: Cambridge Scholars Publishing, 2007).

48. Alfred Burton, "Through the King Country with the Camera: A Photographer's Diary," entry dated May 17 at Tawhata, in *The Maori at Home: A Catalogue of a Series of Photographs Illustrative of the Scenery and of Native Life in the Centre of the North Island of New Zealand* (Dunedin: Burton Brothers, 1886), 14. Burton's account was also published in the *Otago Daily Times* on July 25, 1885, and in the *Illustrated London News* on September 3, 1887.

49. Edward Payton, an artist who joined Burton on his trip in 1885, confirmed his peer's observations about the Maori and photography. With a hint of disappointment, he noted that the natives were fixated on Burton's "camera with all its mechanical arrangements" and less taken by his sketches. See Payton, *Round About New Zealand: Being Notes from a Journal of Three Years Wandering in the Antipodes* (London: Chapman and Hall, 1888), 259.

50. See Leonard Bell, *Colonial Constructs: European Images of Maori, 1840–1914* (Auckland: Auckland University Press, 1992); and Anne Maxwell, *Colonial Photography and Exhibitions* (London: Leicester University Press, 1999). Maori comparisons of the camera to *taipo* were based on their view that circulating an image diminished a subject's life force; see Michael King, *Maori: A Photographic and Social History* (Auckland: Heinemann, 1983).

51. Adas, *Machines as the Measure*, 159.

| 171

52. Arthur Radclyffe Dugmore, *Camera Adventures in the African Wilds . . .* (New York: Doubleday, Page, 1910), 125–26.

53. "Not a Favorable Occasion," *Puck*, May 24, 1893, 218. For another example, featuring a European trader in the South Pacific, see "The March of Civilization," *Puck*, February 8, 1888, 380.

54. See "The March of Civilization," *Puck*, June 11, 1890, 247; and "Likely to Happen Under the Coming Administration," *Puck*, January 27, 1897, 8–9.

55. *Puck*'s illustrations helped fuel that fantasy by staging introductions of newly designed Western devices into stereotyped African villages, including Edison's "talking doll" and phonograph. See "Christmas at Bolobo," *Puck*, December 24, 1890, 305; and "The Little African and the Too Versatile Phonograph," *Puck*, January 10, 1900, 2.

56. Gretchen Murphy, *Shadowing the White Man's Burden: U.S. Imperialism and the Problem of the Color Line* (New York: New York University Press, 2010), 35. See also Paul Lyons, *American Pacificism: Oceania in the U.S. Imagination* (New York: Routledge, 2006). These studies show that perceptions of indigenous peoples dovetailed with popular ideas about African Americans, making the demarcation of color lines around 1900 a transnational process.

57. *DP*, 94.

58. Turner belonged to Wilson's Minstrels and Turner & Mack's Party in the 1860s. That only he appears in blackface in figs. 17 and 18 was probably an aesthetic choice that clearly differentiated between the two men in the small frame of the carte de visite.

59. Charles White, *Daguerreotypes, or The Picture Gallery* (New York: R. W. DeWitt, 1874), 5.

60. See T. S. Arthur, "American Characteristics No. V.—The Daguerreotypist," *Godey's Lady's Book*, May 1849, 352–55; Ralph Parr, *Havin' Ther Photographs Takken* (Manchester: Abel Heywood & Son, ca. 1890); and "Down from Croajinger-goalong [sic]," *Melbourne Punch Almanac* (1884): 16. An excellent example of the international circulation and longevity of humor concerning naïve studio sitters is an article titled "My First Pose: How It Feels to Be Photographed for the First Time." When published in the *Broadford Courier* on August 26, 1892, its original source was identified as *Peck's Sun*, a popular weekly newspaper published in Milwaukee, Wisconsin. The same article was reprinted in dozens of Australian and New Zealand newspapers.

61. For an early example of this trope, see "Foolish Folks—All Fools' Day Sketches," *Harper's New Monthly Magazine*, April 1856, 717. The same image was popular in Australasia, as we can see in stories such as "Interesting but Not Satisfactory," *Kilmore Free Press* (New Zealand), April 9, 1896, 4.

62. Erdman, "Caught in the Eye," 37.

63. White, *Daguerreotypes, or The Picture Gallery*, 5–6.

64. *DP*, 96.

65. This fantasy played out just after African American emancipation in a story about a "faithful old darkey" named "Uncle Zeb" that was published in America's leading photographic trade journal, the *Philadelphia Photographer* (see vol. 1, no. 3 [1864]: 47). In the story, Zeb obeys the operator's instructions so well that he continues to stare steadily at the camera until there are "great tears rolling down his cheeks." When the operator asks if he has been sitting before the lens for twenty minutes, Zeb replies, "Yes! Massa! Neber moved wunst!"

66. *DP*, 96.

67. W. I. Scandlin, "Professional Versus Amateur Photographs," *American Amateur Photographer* 21 (1907): 45–47. Scandlin edited *Anthony's Photographic Bulletin* and co-edited the sixth edition of *How to Make Photographs: A Manual for Amateurs* (New York: E. & H. T. Anthony & Co., 1898).

68. Arthur Hewitt, "Amateurs and Their Failures: Certain Maxims Not in Text Books," *American Annual of Photography* 17 (1903): 173–75.

69. A. S. Daggy, "An Amateur," *Harper's Young People*, August 27, 1889, 741.

70. "Zip Coon" was a stock character in American minstrelsy and the title of a popular minstrel song first performed by George Dixon in 1834. This caricature of an urban black man exhibited airs unsuited to his lowly status, dressed as a dandy, and mangled standard English. A "coon song" by Williams and Walker, "Snap Shot Sal" (New York: Feist & Frankenthaler, 1897), similarly ridiculed the pretensions of a black lady amateur. The sheet music cover pictures a stylishly dressed African American woman carrying a camera identified as Sal Van Astor Gould. Audiences would have been amused by her zealousness in taking snapshots, the comical appearance of her black subjects, and her opinion that she was "too dignified to sell 'em [the snaps]."

71. C. H. Gallup (Poughkeepsie, New York), *The Amateur*, cabinet card, ca. 1890, Beinecke Library, Yale University.

72. Melissa Miles, "Out of the Shadows: On Light, Darkness, and Race in Australian Photography," *History of Photography* 36, no. 3 (2012): 337–52. Miles also discusses "The Best of Friends," *Australasian Photo Review* 12, no. 12 (December 21, 1905): 445, and two photographs by the amateur photographer Veda R. Coghlan depicting an Aboriginal boy with a Kodak 3A folding pocket camera. The first is titled *Photography in the "Never Never"—His First Lesson* (June 22, 1914, 294) and the second *Off for the Holidays* (December 22, 1913, 665).

73. For more on the racial humor that appeared in the *Auckland Weekly News*, see King, *Maori*, 2–3.

74. Henry Louis Gates Jr., "The Trope of a New Negro and the Reconstruction of the Image of the Black," *Representations* 24 (Autumn 1988): 132–33.

75. Deborah Willis, *Reflections in Black: A History of Black Photographers, 1840–1999*, exhibition catalogue (New York: W. W. Norton, 2000), xvii. See also Deborah Willis, *Let Your Motto Be Resistance: African American Portraits*, exhibition catalogue (Washington, D.C.: Smithsonian Books, 2007), and *VanDerZee: Photographer, 1886–1993*, exhibition catalogue (New York: Harry N. Abrams, 1993); and Deborah Willis-Thomas, ed., *Picturing Us: African American Identity in Photography* (New York: New Press, 1994).

76. Shawn Michelle Smith, "Unfixing the Frame(-up): A. P. Bedou," in *Pictures and Progress: Early Photography and the Making of African American Identity*, ed. Maurice O. Wallace and Shawn Michelle Smith (Durham: Duke University Press, 2012), 271.

77. Wallace and Smith, "Introduction: Pictures and Progress," in *Pictures and Progress*, 4.

78. See Marcy J. Dinius, *The Camera and the Press: American Visual and Print Culture in the Age of the Daguerreotype* (Philadelphia: University of Pennsylvania Press, 2012), chapter 6; and John Stauffer, Zoe Trodd, and Celeste-Marie Bernier, eds., *Picturing Frederick Douglass: An Illustrated Biography of the Nineteenth Century's Most Photographed American* (New York: Liveright, 2015).

79. Wallace and Smith, "Introduction: Pictures and Progress," 6, 7.

80. Quanchi, *Photographing Papua*, 38–39.

81. Quanchi, 61.

82. Jane Lydon, *Eye Contact: Photographing Indigenous Australians* (Durham: Duke University Press, 2005); and Roslyn Poignant, *Professional Savages: Captive Lives and Western Spectacle* (New Haven: Yale University Press, 2004), 159. Similar arguments have been made about indigenous Americans and photography. According to Martha Sandweiss, "to imagine every photograph of an indigenous person represents an act of cultural imperialism is to deny the ambitions of the sitter, the capacity

CHAPTER 3

1. This question motivates two studies of the photographic smile: Fred E. H. Schroeder, "Say Cheese! The Revolution in the Aesthetics of Smiles," *Journal of Popular Culture* 32, no. 2 (1998): 103–45; and Christina Kotchemidova, "Why We Say 'Cheese': Producing the Smile in Snapshot Photography," *Critical Studies in Media Communication* 22, no. 1 (2005): 2–25.

2. On popular associations between photographers' use of the posing apparatus, surgical operations, and disciplinary practices, see Tanya Sheehan, *Doctored: The Medicine of Photography in Nineteenth-Century America* (University Park: Pennsylvania State University Press, 2011), chapter 2.

3. Sara Ahmed, "The Happiness Turn," *New Formations* 63 (Winter 2007–8): 11. Ahmed expands upon these ideas in *The Promise of Happiness* (Durham: Duke University Press, 2010).

4. Marcus Aurelius Root, *The Camera and the Pencil, or The Heliographic Art* (1864; reprint, Pawlet, Vt.: Helios, 1971), 143.

5. Rev. A. A. Taylor, "Expression," *Philadelphia Photographer* 2, no. 14 (1865): 23.

6. For a discussion of the etiquette manual as a popular form of social discipline in nineteenth-century America, see John F. Kasson, *Rudeness and Civility: Manners in Nineteenth-Century Urban America* (New York: Hill and Wang, 1990).

7. Root, *Camera and the Pencil*, 85–86.

8. On the restraints placed on expressions of "excessive" emotion, see Kasson, *Rudeness and Civility*, chapter 5.

9. On the toothy smile as an expression of low social, moral, and mental character in

the fine arts, see Schroeder, "Say Cheese," 108–16; and Angus Trumble, *A Brief History of the Smile* (New York: Basic Books, 2004). Alan Trachtenberg has also approached the smile in early American photography as a theatrical gesture, noting the importance of Le Brun's studies to both fine artists and actors. See his "Reading Lessons: Stories of a Daguerreotype," *Nineteenth-Century Contexts: An Interdisciplinary Journal* 22, no. 4 (2001): 537–57, and "Lincoln's Smile: Ambiguities of the Face in Photography," *Social Research* 67, no. 1 (2000): 1–23.

10. Quoted in Charles Darwin, *The Expression of the Emotions in Man and Animals* (London: John Murray, 1872; reprint, New York: Oxford University Press, 1998), 202.

11. Darwin, 195–96, 20.

12. See Phillip Prodger, *Darwin's Camera: Art and Photography in the Theory of Evolution* (Oxford: Oxford University Press, 2009), chapter 7. Prodger first observed the connection between Darwin and Landy in "Rejlander, Darwin, and the Evolution of 'Ginx's Baby,'" *History of Photography* 23, no. 3 (1999): 260–68.

13. For references to Landy's *Expressive Pets* in American photographic journals, see "Editor's Table," *Philadelphia Photographer* 9, no. 107 (1872): 400; "Editor's Table," *Photographic World* 2, no. 18 (1872): 192; "Landy's Expressive Pets," *Photographic Times* 2, no. 19 (1872): 104; "Our Picture," *Philadelphia Photographer* 9, no. 104 (1872): 300; "American Novelties," *Photographic Times* 4, no. 44 (1874): 127; "Buy Landy's Expressive Pets," *Anthony's Photographic Bulletin* 5, no. 6 (1874): 226; and "James Landy," *Wilson's Photographic Magazine* 34, no. 492 (1897): 556–58.

14. Sara Ahmed, "Sociable Happiness," *Emotion, Space, and Society* 1, no. 1 (2008): 11.

15. "Our Picture," *Philadelphia Photographer*, 300.

16. On the relationship between baby pictures and anxieties about race and class in modern America, see Shawn Michelle Smith,

American Archives: Gender, Race, and Class in Visual Culture (Princeton: Princeton University Press, 1999), 113–35; and Sheehan, Doctored, chapter 3.

17. Root, Camera and the Pencil, 46–47.

18. For discussion of how interiors of commercial portrait studios encouraged performances of gentility in nineteenth-century America, see Shirley Teresa Wajda, "The Commercial Photographic Parlor, 1839–1889," Perspectives in Vernacular Architecture 6 (1997): 216–30; and Katherine C. Grier, Culture and Comfort: Parlor Making and Middle-Class Identity, 1850–1930 (Washington, D.C.: Smithsonian Institution Press, 1997).

19. See, for example, "Trying, Very," Harper's Weekly, March 19, 1859, 192; and "Strategy II," Puck, May 3, 1893, 173.

20. "Great Scheme of Mr. Cabnitts," Puck, November 13, 1895, 196.

21. In thinking through the relationship between social "others" and excessive happiness, I am indebted to ideas about "affective excess" theorized by José Esteban Muñoz in relation to contemporary Latino/a culture and adopted by Elspeth Brown in her reading of American fashion photography. Both authors read "over-the-top" performances of affect as markers of social difference for nonnormative groups. See Muñoz, "Feeling Brown: Ethnicity and Affect in Ricardo Bracho's The Sweetest Hangover (and Other STDs)," Theatre Journal 52, no. 1 (2000): 67–79; and Brown, "De Meyer at Vogue: Commercializing Queer Affect in First World War–Era Fashion Photography," Photography and Culture 2, no. 3 (2009): 253–74.

22. Born in 1853, Gallup came from a well-respected family with deep roots in the Hudson River valley. At the age of thirteen he moved with his family to Poughkeepsie and tried his hand at a number of skilled trades, from making spring beds to apprenticing at a machinist's shop and working for the local fire department. It was not until 1885, after an extended trip to Cuba, where he oversaw a small plantation, that Gallup decided to make photography his profession and purchased an established studio at 292–94 Main Street. What became known as C. H. Gallup & Co. greatly expanded in size and output in the decades that followed, becoming a massive commercial success, until Gallup's death in 1917. On the history of photography in Poughkeepsie and Gallup's place in it, see Helen Wilkinson Reynolds, "Daguerreotypes and Photographs," Dutchess County Historical Society Year Book 16 (1931): 34–38; and "Charles H. Gallup," in Commemorative Biographical Record of Dutchess County, New York (Chicago: J. H. Beers & Co., 1897), 249–50.

23. Advertisement for C. H. Gallup & Co., ca. 1880s, Historic Huguenot Street.

24. The Poughkeepsie Daily Eagle frequently commented on the "baby show" that Gallup conducted at the Dutchess County Fair in the late 1890s and early 1900s.

25. Around the time that Gallup's advertising campaign began, he took on his Cuban brother-in-law (Jose Manuel Godinez) as a business partner and opened branch studios in Connecticut, Massachusetts, and other areas of New York State. The owner of a Cuban plantation and a graduate of Eastman Business College in Poughkeepsie, Godinez knew how to manage a large operation and market its products. See "Jose Manuel Godinez," in Biographical Record of Dutchess County, 215–16.

26. To date I have identified eight different advertising cards by Gallup in public and private collections and have found references to several more in Poughkeepsie newspapers and the American photographic press. The six cards not addressed in this chapter are The Amateur (Beinecke Library, Yale University), a print version of which I discuss in chapter 2; a portrait of John King, an itinerant African American chimney sweep (Schomburg Center for Research in Black Culture, New York Public Library);

a picture of Gallup's prize Angora cat, Foxy (private collection); *The Fish Story* (private collection), which depicts Gallup himself recounting a tall tale to a male companion; a card featuring young boys as Italian bootblacks titled *Scene from Real Life* (private collection); and *The Twins* (unlocated), a remarkable card that transforms two little girls into old women through liberal retouching. As reported by the *Poughkeepsie Daily Eagle*, Gallup enlarged these cards when he publicly displayed them; a fragment of *The Melon Story* in its enlarged form has been preserved in the collection of the Schomburg Center.

27. *Anticipation and Reality* is one of the many studies of facial expression Gallup is known to have made. According to the *Photographic Times and American Photographer* 20, no. 459 (1890): 326, he claimed to have printed more than ten thousand cabinet cards showing "the different expressions of two little girls of four years. . . . Another shows twenty-four different facial expressions of one man."

28. On early efforts to achieve and market "instantaneous photography," see Phillip Prodger, *Time Stands Still: Muybridge and the Instantaneous Photography Movement*, exhibition catalogue (New York: Oxford University Press, 2003).

29. See C. H. Gallup & Co., *The Fish Story*, ca. 1890, cabinet card, private collection.

30. In conceiving *The Melon Story*, Gallup probably had in mind the poems of Eugene Fields, from which he also quoted in *The Fish Story*, and specifically Fields's meditations on watermelon, published in popular periodicals. See, for example, Eugene Fields, "Meloncholic," *Puck*, October 8, 1879, 496, and "To a Watermelon," *Puck*, September 1, 1880, 460.

31. On ideas about blackness, primitiveness, and childhood, see Gail Bederman, *Manliness and Civilization: A Cultural History of Gender and Race in the United States,* *1880–1917* (Chicago: University of Chicago Press, 1995).

32. Mel Watkins, *On the Real Side: A History of African American Comedy from Slavery to Chris Rock* (Chicago: Lawrence Hill Books, 1999), 100.

33. See Saidiya V. Hartman, *Scenes of Subjection: Terror, Slavery, and Self-Making in Nineteenth-Century America* (New York: Oxford University Press, 1997); and Joseph Boskin, *Sambo: The Rise and Demise of an American Jester* (New York: Oxford University Press, 1986). George Boulukos discusses the trope of the "grateful slave" in similar terms in *The Grateful Slave: The Emergence of Race in Eighteenth-Century British and American Culture* (Cambridge: Cambridge University Press, 2008).

34. Much has been written about the African American presence in the Hudson River valley, which boasted the largest number of slaves in the North until the late eighteenth century. Waves of black migration from the South occurred after slavery was abolished in New York State in 1827, although the black population in Poughkeepsie increased only marginally, from 440 in 1860 (less than 3 percent of the population) to 500 in 1870. That population was concentrated on relatively few streets, including Mansion, Jay, Mechanic, Church, Union, Prospect, and Main, where Gallup's studio was located. See Clyde Griffen and Sally Griffen, *Natives and Newcomers: The Ordering of Opportunity in Mid-Nineteenth-Century Poughkeepsie* (Cambridge: Harvard University Press, 1978); Joshua Gordon Hinerfeld, "The Fading Veneer of Equality: The Afro-American Experience in Poughkeepsie Between 1840 and 1860," *Dutchess County Historical Society Year Book* 68 (1983): 83–100; Lawrence H. Mamiya and Lorraine M. Roberts, "Invisible People, Untold Stories: A Historical Overview of the Black Community in Poughkeepsie," *Dutchess County Historical Society Yearbook* 72 (1987): 76–104; Michael

Edward Groth, "Forging Freedom in the Mid-Hudson Valley: The End of Slavery and the Formation of a Free African-American Community in Dutchess County, NY, 1770–1850" (PhD diss., SUNY Binghamton, 1994); Albert J. Williams-Myers, *Long Hammering: Essays on the Forging of an African-American Presence in the Hudson River Valley to the Early Twentieth Century* (Trenton: Africa World Press, 1994); and Myra B. Young Armstead, ed., *Mighty Change, Tall Within: Black Identity in the Hudson Valley* (Albany: SUNY Press, 2003).

35. See the advertisements for Scovill & Adams's Dixie Vignetter in *Photographic Times* 32, no. 7 (1900): xiv; *American Annual of Photography* 14 (1900): xi; and *American Annual of Photography* 15 (1901): 12–13.

36. Minstrel troupes visited Poughkeepsie almost monthly during and after the Civil War, among them Sharpe's Minstrels, Campbell's Minstrels, Newcomb's Minstrels, Tony Pastor's Minstrels, and Dupree and Green's Minstrels. Their performances were announced in the *Poughkeepsie Daily Eagle*; see Mamiya and Roberts, "Invisible People, Untold Stories," 81.

37. Hartman, *Scenes of Subjection*, 21.

38. My reading of blackface minstrelsy is indebted to Eric Lott, *Love and Theft: Blackface Minstrelsy and the American Working Class* (New York: Oxford University Press, 1993); Susan Gubar, *Racechanges: White Skin, Black Face in American Culture* (New York: Oxford University Press, 1997); and Susan Smulyan, *Popular Ideologies: Mass Culture at Mid-Century* (Philadelphia: University of Pennsylvania Press, 2007), 16–40. For more on minstrelsy and photographic humor, see chapter 2.

39. For discussion of this comic series, see Shirley Teresa Wajda, "A Room with a Viewer: The Parlor Stereoscope, Comic Stereographs, and the Psychic Role of Play in Victorian America," in *Hard at Play: Leisure in America, 1840–1940*, ed. Kathryn

Grover (Amherst: University of Massachusetts Press; Rochester, N.Y.: Strong Museum, 1992), 112–38.

40. Although studio portraits of white subjects posing with watermelons were not uncommon in nineteenth-century America, they rarely appear in published histories. One notable exception is a tinted carte de visite by T. M. McMakan of Danville, Pennsylvania, depicting seven unidentified female sitters, ca. 1860s–70s, published in Heinz K. Henisch and Bridget A. Henisch, *The Photographic Experience: Exhibition to Celebrate the 150th Anniversary of the Invention of Photography*, exhibition catalogue (University Park: Palmer Museum of Art, Pennsylvania State University, 1988), 122.

41. Trachtenberg expounds upon this way of reading photographs in *Lincoln's Smile and Other Enigmas* (New York: Farrar, Straus and Giroux, 2007). I am grateful for a conversation I had with him in November 2008 about this portrait of melon-eating sitters, in which he reminded me of the importance of reading the gesture of inclusion in the picture.

42. Warren I. Susman describes the culture of personality that emerged in the twentieth century in *Culture as History: The Transformation of American Society in the Twentieth Century* (New York: Pantheon Books, 1973).

43. See Bederman, *Manliness and Civilization*; and John Pettegrew, *Brutes in Suits: Male Sensibility in America, 1890–1920* (Baltimore: Johns Hopkins University Press, 2007).

CHAPTER 4

1. The Laney-Hoeing Family Papers (1842–1972) are in the Department of Rare Books, Special Collections and Preservation at the University of Rochester Library. Frederick Hoeing (1907–1962) was the only child of a prominent family in Rochester, New York. His parents were Augusta (Laney)

Hoeing (1883–1972) and Charles Hoeing (1871–1938). Frances (Walbridge) Mathews (1845–1918) was the sister of his maternal grandmother, Georgena (Walbridge) Laney. Frances married W. Henry Mathews (1838–1932). The couple was well traveled; in addition to spending winters in Florida, they are known to have taken a trip to the Mediterranean in 1913.

2. Kyla Wazana Tompkins, *Racial Indigestion: Eating Bodies in the Nineteenth Century* (New York: New York University Press, 2012), 1. On the popular depiction of black children and alligators, see also Tanya Sheehan and Henry Louis Gates Jr., "Marketing Racism: Popular Imagery in the United States and Europe," in *The Image of the Black in Western Art*, vol. 5, *The Twentieth Century, Part I*, ed. David Bindman (Cambridge: Harvard University Press, 2014), 31.

3. Brooke Baldwin, "On the Verso: Postcard Messages as a Key to Popular Prejudices," *Journal of Popular Culture* 22, no. 3 (1988): 15, 17.

4. Naomi Schor, "*Cartes Postales*: Representing Paris 1900," in *Postcards: Ephemeral Histories of Modernity*, ed. David Prochaska and Jordana Mendelson (University Park: Pennsylvania State University Press, 2010), 21. Schor's essay was first published in *Critical Inquiry* in 1992.

5. See Wayne Martin Mellinger, "Postcards from the Edge of the Color Line: Images of African Americans in Popular Culture, 1893–1917," *Symbolic Interaction* 15, no. 4 (1992): 413–33, and "Representing Blackness in the White Imagination: Images of 'Happy Darkies' in Popular Culture, 1893–1917," *Visual Sociology* 7, no. 2 (1992): 3–21; and Wayne Martin Mellinger and Rodney Beaulieu, "White Fantasies, Black Bodies: Racial Power, Disgust, and Desire in Popular Media Culture," *Visual Anthropology* 9, no. 2 (1996): 117–47. These articles on African American stereotypes in early commercial postcards examine nonphotographic illustrations.

6. Dorothy B. Ryan and George Miller, *Picture Postcards in the United States, 1893–1918*, updated ed. (New York: C. N. Potter, 1982), 22.

7. Daniel Gifford, *American Holiday Postcards, 1905–1915: Imagery and Context* (Jefferson, N.C.: McFarland, 2013), 4.

8. Ryan and Miller, *Picture Postcards*, 23.

9. For information on the 6000 series, see Jefferson R. Burdick, *The Handbook of Detroit Publishing Co. Postcards* (Essington, Pa.: Hobby Publications, 1954).

10. Gifford, *American Holiday Postcards*, 21, 25, 32–34, 51.

11. Baldwin writes of her case studies: "Postmarks of postcard senders and addresses of recipients reveal the nationwide grasp that racial stereotypes held on the popular imagination." "On the Verso," 15.

12. Gifford, *American Holiday Postcards*, 61–62.

13. See especially chapter 2.

14. Lee Glazer and Susan Key, "Carry Me Back: Nostalgia for the Old South in Nineteenth-Century Popular Culture," *Journal of American Studies* 30, no. 1 (1996): 3.

15. For more on watermelons in racial humor, see chapter 3.

16. Baldwin, "On the Verso," 22–23.

17. See *Cutting Sugar Cane*, offset photomechanical print, posted from New Orleans, Louisiana, to Worcester, Massachusetts, March 11, 1907, American Antiquarian Society; and Detroit Photographic Company, *Happy Mitchell and His Boys*, ca. 1902, posted from Hephzibah, Georgia, to Philadelphia, Pennsylvania, January 29, 1904, the Miriam and Ira D. Wallach Division of Art, Prints and Photographs: Photograph Collection, New York Public Library.

18. Eric Lott, "Love and Theft: The Racial Unconscious of Blackface Minstrelsy," *Representations* 39 (Summer 1992): 36–37, 23–24.

19. Michael Rogin, *Blackface, White Noise: Jewish Immigrants in the Hollywood Melting Pot* (Berkeley: University of California Press, 1996), 92.

20. Anne Anlin Cheng, *The Melancholy of Race: Psychoanalysis, Assimilation, and Hidden Grief* (New York: Oxford University Press, 2001), 11, 8.

21. Cheng, 12.

22. U.S. Census figures for 1900, Camden County, New Jersey, Camden City, p. 7, dwelling 134, family 142, Lillie P. Weatherby, digital image, ancestry.com, accessed August 17, 2016, http://www.ancestry.com. Of course, the listing of the Weatherbys as "white" in census records does not preclude other racial identifications among members of the family.

23. Studio Museum in Harlem, *Harlem Postcards: Tenth Anniversary*, accessed January 9, 2018, http://www.studiomuseum.org/exhibition/harlem-postcards-tenth-anniversary.

24. The artist was unable to grant permission for the artwork's reproduction. Readers may view a digital scan of it on the website of the International Center of Photography, accessed January 9, 2018, https://www.icp.org/browse/archive/objects/after-the-fact-rachel-and-ren%C3%A9e-collins-at-riteaid-on-125th-st.

25. Zoe Crosher, artist statement, *Harlem Postcards Summer 2012*, accessed August 19, 2016, http://www.studiomuseum.org/exhibition/harlem-postcards-summer-2012-yasmine-braithwaite-zoe-crosher-moyra-davey-lauren-halsey.

26. Heather Hart, artist statement, *Harlem Postcards Summer 2014*, accessed August 19, 2016, http://www.studiomuseum.org/exhibition/harlem-postcards-summer-2014-kelvin-de-leon-delphine-diallo-heather-hart-albert-vecerka. Hart has named among her primary influences conceptual artists David Hammons and Adrian Piper, both of whom have incorporated racial humor into their work (see my discussion of Piper in the introduction). In 2005, Hart began inviting people of color to participate in what she calls "Black Lunch Table" sessions, discussions of art, race, and politics that subvert the stereotype of the all-black lunch table in U.S. high schools. See Olivia Jene-Fagon and Ellen Yoshi Tani, "Welcome to the Black Lunch Table: Jina Valentine and Heather Hart on Creating Space for Communities of Color in the Art World," *Artsy*, January 17, 2016, https://www.artsy.net/article/the-art-genome-project-why-are-all-the-black-artists-sitting-together-in-the-cafeteria.

27. Quoted in Tess Thackara, "Thelma Golden Reflects on 10 Years at the Helm of the Studio Museum, and Harlem's Changing Face," *Artsy*, December 8, 2015, https://www.artsy.net/article/artsy-editorial-thelma-golden-reflects-on-10-years-at-the-helm-of-the-studio-museum-and-harlem-s-changing-face.

CHAPTER 5

1. Organized by Creative Time, *A Subtlety* was on view from May 10 through July 6, 2014. See http://creativetime.org/projects/karawalker, accessed January 9, 2018.

2. Jamilah King, "The Overwhelming Whiteness of Black Art," *Colorlines*, May 21, 2014, http://www.colorlines.com/articles/overwhelming-whiteness-black-art.

3. The selfie generator was posted online during the exhibition at http://SugarSelfie.us, accessed July 1, 2014.

4. Williams quoted in Matthew Shen Goodman, "'We Are Here': People of Color Gather at Kara Walker Show," *Art in America*, June 20, 2014, http://www.artinamericamagazine.com/news-features/previews/we-are-here-people-of-color-gather-at-kara-walker-show-. For similar criticism, see Nicholas Powers, "Why I Yelled at the Kara Walker Exhibit," *Indypendent*, June 30, 2014, https://indypendent.org/2014/06/30/why-i-yelled-kara-walker-exhibit; Alyssa Rosenberg, "Selfie Culture and Kara Walker's 'A Subtlety,'" *Washington*

Post, June 30, 2014, http://www.washington
post.com/news/act-four/wp/2014/06/30
/selfie-culture-and-kara-walkers-a-subtlety;
Stephanye Watts, "The Audacity of No
Chill: Kara Walker in the Instagram Capi-
tal," *Gawker*, June 4, 2014, http://gawker
.com/the-audacity-of-no-chill-kara-walk
er-in-the-instagram-1585944103; and
Cait Munro, "Kara Walker's Sugar Sphinx
Spawns Offensive Instagram Photos,"
Artnet, May 30, 2014, http://news.artnet
.com/art-world/kara-walkers-sugar
-sphinx-spawns-offensive-instagram
-photos-29989.

5. On Saar's and others' negative criticism of
Walker's cut-paper silhouettes, see Hilton
Als, "The Shadow Act: Kara Walker's
Vision," *New Yorker*, October 8, 2007, 70–79;
and Gwendolyn Du Bois Shaw, *Seeing
the Unspeakable: The Art of Kara Walker*
(Durham: Duke University Press, 2004).

6. There are parallels between this practice
of "taking back" the watermelon and the
history of the cakewalk, which African
Americans performed before and after
emancipation as a caricature of white bour-
geois culture. At the turn of the twentieth
century, white Americans took control of
the dance and redirected its racial satire at
black culture. See David Krasner, *Resistance,
Parody, and Double Consciousness in African
American Theatre, 1895–1910* (New York:
Palgrave Macmillan, 1997), chapter 4; and
Brooke Baldwin, "The Cakewalk: A Study
in Stereotype and Reality," *Journal of Social
History* 15, no. 2 (1981): 205–18.

7. W. I. Lincoln Adams, "The Value of 'Snap-
Shots,'" *American Annual of Photography* 20
(1906): 77–78. A practicing photographer,
Adams served as editor of the *Photographic
Times* and wrote several important textbooks
for professionals and amateurs.

8. Q. E. D., "Like a Crab—Backwards," *Koda-
kery* 5, no. 8 (June 1918): 22.

9. Research for this chapter involved viewing
photo album collections at the International

Center of Photography, the George
Eastman Museum, Beinecke Library at
Yale University, and the New York Public
Library.

10. Lisa Gye, "Picture This: The Impact of
Mobile Cameras on Personal Photographic
Practices," *Continuum* 21, no. 2 (2007): 282.

11. Mizuko Ito, "Intimate Visual Co-Presence,"
paper delivered at the Seventh International
Conference on Ubiquitous Computing,
Tokyo, September 11–14, 2005, quoted in
Gye, 285.

12. See Karin Wagner, "Moblogging, Remedia-
tion, and the New Vernacular," *Photographies*
4, no. 2 (2011): 209–28.

13. Caroline A. Miranda, "Kara Walker
on the Bit of Sugar Sphinx She Saved,
Video She's Making," *Los Angeles Times*,
October 13, 2014, http://www.latimes
.com/entertainment/arts/miranda/la-et
-cam-kara-walker-on-her-sugar-sphinx
-the-piece-she-saved-video-shes-making
-20141013-column.html; and Mark Rein-
hardt, "Vision's Unseen: On Sovereignty,
Race, and the Optical Unconscious," *Theory
and Event* 18, no. 4 (2015), https://muse.jhu
.edu/article/595837/summary.

14. The Chelsea gallery Sikkema Jenkins
& Co. presented Walker's video in an
exhibition titled *Afterword*, held November
21, 2014–January 17, 2015. The gallery
has openly distributed a five-minute trailer
for *An Audience*, which splices together high-
lights from the longer video; see https://
vimeo.com/112396045, accessed January 9,
2018.

15. unebelleame_, Instagram post, July 6,
2014, https://www.instagram.com/p/qI9ky
4LPh5/?taken-by=unebelleame_.

16. Gabe Serrano, Instagram post, July 6,
2014, https://www.instagram.com/p/qIe4
nIEpDC/?taken-by=go_off_gabe.

17. Brashear went on to become a jazz
trombonist who played with Louis Arm-
strong, Fletcher Henderson, and other top
musicians.

18. bell hooks, "In Our Glory: Photography and Black Life," in *Picturing Us: African American Identity in Photography*, ed. Deborah Willis (New York: New Press, 1994), 48–49.

19. For an introduction to this movement and its impact on visual culture, see Henry Louis Gates Jr., "The Trope of a New Negro and the Reconstruction of the Image of the Black," *Representations* 24 (Autumn 1988): 129–55.

20. hooks, "In Our Glory," 49, 46.

21. In *Colored Pictures: Race and Visual Representation* (Chapel Hill: University of North Carolina Press, 2003), Michael D. Harris describes some of the prohibitions that African Americans placed on their own behavior in the early twentieth century, including not baring their teeth in public. He notes, for instance, that his mother-in-law and her siblings "were not allowed to eat watermelon on the steps of their home. It would be too easy for whites to see these dark children eating fruit as something else, something from their own imaginations" (14). For them, Brashear's album antics would presumably have been unthinkable.

22. Nathan Irvin Huggins, *Harlem Renaissance* (New York: Oxford University Press, 1971), 258, 259–60, 262. David Krasner defines the strategies of African American blackface performers as reinscription and reversal in *Resistance, Parody, and Double Consciousness*.

23. Lawrence W. Levine, *Black Culture and Black Consciousness: Afro-American Folk Thought from Slavery to Freedom* (New York: Oxford University Press, 1977), 323.

24. Ralph Ellison, "An Extravagance of Laughter," in *Going to the Territory* (1986; reprint, New York: Vintage, 1995), 172.

25. Levine, *Black Culture and Black Consciousness*, 322.

26. Zora Neale Hurston, "Characteristics of Negro Expression" (1933), quoted in Mel Watkins, *On the Real Side: A History of African American Comedy from Slavery to Chris Rock* (Chicago: Lawrence Hill Books, 1999), 36.

27. See Huggins, *Harlem Renaissance*, 339.

28. Russell Middleton and John Moland, "Humor in Negro and White Subcultures: A Study of Jokes Among University Students," *American Sociological Review* 24, no. 1 (1959): 66.

29. According to Gates, signifying entails trickery, indirection, and purposeful negotiation between black and white linguistic worlds. See his influential study *The Signifying Monkey: A Theory of African-American Literary Criticism* (New York: Oxford University Press, 1988).

30. Glenda R. Carpio, *Laughing Fit to Kill: Black Humor in the Fictions of Slavery* (Oxford: Oxford University Press, 2008), 15. On the critical work of African American humor, see also William W. Cook, "Change the Joke and Slip the Yoke: Traditions of Afro-American Satire," *Journal of Ethnic Studies* 13, no. 1 (1985): 109–34; Granville Ganter, "'He Made Us Laugh Some': Frederick Douglass's Humor," *African American Review* 37, no. 4 (2003): 535–52; and Karen C. C. Dalton, Michael Harris, and Lowery Sims, "The Past Is Prologue but Is Parody and Pastiche Progress? A Conversation," *International Review of African American Art* 14, no. 3 (1997): 17–29.

31. Watkins, *On the Real Side*, 129.

32. On reenactments of American slavery, see Lisa Woolfork, *Embodying American Slavery in Contemporary Culture* (Urbana: University of Illinois Press, 2009).

33. Dalton, Harris, and Sims, "Past Is Prologue," 29.

Selected Bibliography

This bibliography contains a selection of secondary scholarly sources cited. It excludes web pages and other internet media.

Abbott, Lynn, and Doug Seroff. *Out of Sight: The Rise of African American Popular Music, 1889–1895*. Jackson: University Press of Mississippi, 2002.

Adas, Michael. *Machines as the Measure of Men: Science, Technology, and Ideologies of Western Dominance*. Ithaca: Cornell University Press, 1989.

Ahmed, Sara. "The Happiness Turn." *New Formations* 63 (Winter 2007–8): 1–14.

———. *The Promise of Happiness*. Durham: Duke University Press, 2010.

———. "Sociable Happiness." *Emotion, Space, and Society* 1, no. 1 (2008): 10–13.

Albanese, Denise. "Black and White, and Dread All Over: The Shakespeare Theater's 'Photonegative' *Othello* and the Body of Desdemona." In *A Feminist Companion to Shakespeare*, edited by Dympna Callaghan, 226–47. Malden, Mass.: Blackwell, 2000.

Als, Hilton. "The Shadow Act." *New Yorker*, October 8, 2007, 70–79.

Armstead, Myra B. Young, ed. *Mighty Change, Tall Within: Black Identity in the Hudson Valley*. Albany: SUNY Press, 2003.

Augstein, Hannah Franziska. *James Cowles Prichard's Anthropology: Remaking the Science of Man in Early Nineteenth-Century Britain*. Amsterdam: Rodopi, 1999.

Baldwin, Brooke. "The Cakewalk: A Study in Stereotype and Reality." *Journal of Social History* 15, no. 2 (1981): 205–18.

———. "On the Verso: Postcard Messages as a Key to Popular Prejudices." *Journal of Popular Culture* 22, no. 3 (1988): 15–28.

Bederman, Gail. *Manliness and Civilization: A Cultural History of Gender and Race in the United States, 1880–1917*. Chicago: University of Chicago Press, 1995.

Bell, Leonard. *Colonial Constructs: European Images of Maori, 1840–1914*. Auckland: Auckland University Press, 1992.

Bellanta, Melissa. "The Larrikin's Hop: Larrikinism and Late Colonial Popular Theatre." *Australasian Drama Studies* 52 (April 2008): 131–47.

———. "Leary Kin: Australian Larrikins and the Blackface Minstrel Dandy." *Journal of Social History* 42, no. 3 (2009): 677–95.

Bender, Thomas, ed. *Rethinking American History in a Global Age*. Berkeley: University of California Press, 2002.

Bennett, Michael J. "'Frictions': Shipboard Relations Between White and

Contraband Sailors." *Civil War History* 47, no. 2 (2001): 118–45.

Bergson, Henri. *Laughter: An Essay on the Meaning of the Comic*. Translated by Cloudesley Brereton and Fred Rothwell. New York: Macmillan, 1914.

Blackman, Margaret B. "Copying People: Northwest Coast Native Responses to Early Photography." *BC Studies* 52 (Winter 1981–82): 86–108.

Boskin, Joseph. *Sambo: The Rise and Demise of an American Jester*. New York: Oxford University Press, 1986.

Boskin, Joseph, and Joseph Dorinson. "Ethnic Humor: Subversion and Survival." *American Quarterly* 37, no. 1 (1985): 81–97.

Boulukos, George. *The Grateful Slave: The Emergence of Race in Eighteenth-Century British and American Culture*. Cambridge: Cambridge University Press, 2008.

Bratton, J. S. "English Ethiopians: British Audiences and Black-Face Acts, 1835–1865." *Yearbook of English Studies* 11 (1981): 127–42.

Brooks, Daphne A. *Bodies in Dissent: Spectacular Performances of Race and Freedom, 1850–1910*. Durham: Duke University Press, 2006.

Brown, Elspeth H. "De Meyer at *Vogue*: Commercializing Queer Affect in First World War–Era Fashion Photography." *Photography and Culture* 2, no. 3 (2009): 253–74.

Burdick, Jefferson R. *The Handbook of Detroit Publishing Co. Postcards*. Essington, Pa.: Hobby Publications, 1954.

Carlin, Bob. *The Birth of the Banjo: Joel Walker Sweeney and Early Minstrelsy*. Jefferson, N.C.: McFarland, 2007.

Carpio, Glenda R. *Laughing Fit to Kill: Black Humor in the Fictions of Slavery*. Oxford: Oxford University Press, 2008.

Chaney, Michael A. *Fugitive Vision: Slave Image and Black Identity in Antebellum Narrative*. Bloomington: Indiana University Press, 2008.

———. "Heartfelt Thanks to *Punch* for the Picture: Frederick Douglass and the Transnational Jokework of Slave Caricature." *American Literature* 82, no. 1 (2010): 57–90.

Cheng, Anne Anlin. *The Melancholy of Race: Psychoanalysis, Assimilation, and Hidden Grief*. New York: Oxford University Press, 2001.

Chiles, Katy. "Blackened Irish and Brown-Faced Amerindians: Constructions of American Whiteness in Dion Boucicault's *The Octoroon*." *Nineteenth-Century Theatre and Film* 31 (2004): 28–50.

Collins, Kris. "White-Washing the Black-a-Moor: *Othello*, Negro Minstrelsy, and Parodies of Blackness." *Journal of American Culture* 19, no. 3 (1996): 87–101.

Cook, William W. "Change the Joke and Slip the Yoke: Traditions of Afro-American Satire." *Journal of Ethnic Studies* 13, no. 1 (1985): 109–34.

Cowgill, Rachel, and Julian Rushton, eds. *Europe, Empire, and Spectacle in Nineteenth-Century British Music*. Aldershot: Ashgate, 2006.

Dalton, Karen C. C., Michael Harris, and Lowery Sims. "The Past Is Prologue but Is Parody and Pastiche Progress? A Conversation." *International Review of African American Art* 14, no. 3 (1997): 17–29.

Dingley, Robert. "The Unreliable Camera: Photography as Evidence in Mid-Victorian Fiction." *Victorian Review* 27, no. 2 (2001): 42–55.

Dinius, Marcy J. *The Camera and the Press: American Visual and Print Culture in the Age of the Daguerreotype*. Philadelphia: University of Pennsylvania Press, 2012.

Dyer, Richard. *White*. London: Routledge, 1997.

Ellison, Ralph. "An Extravagance of Laughter." In *Going to the Territory*, 145–97. 1986. Reprint, New York: Vintage, 1995.

Erdman, Harley. "Caught in the Eye of the Eternal: Justice, Race, and the Camera; From *The Octoroon* to Rodney King." *Theatre Journal* 45, no. 3 (1993): 333–48.

Eves, Richard. "'Black and White, a Significant Contrast': Race, Humanism, and Missionary Photography in the Pacific." *Ethnic and Racial Studies* 29, no. 4 (2006): 725–48.

Farris, James. *Navajo and Photography: A Critical History of the Representation of an American People*. Albuquerque: University of New Mexico Press, 1996.

Fisch, Audrey A. *American Slaves in Victorian England: Abolitionist Politics in Popular Literature and Culture*. Cambridge: Cambridge University Press, 2000.

———. "'Negrophilism' and British Nationalism: The Spectacle of the Black American Abolitionist." *Victorian Review* 19, no. 2 (1993): 20–47.

Fluck, Winfried, Donald E. Pease, and John Carlos Rowe, eds. *Re-Framing the Transnational Turn in American Studies*. Hanover: Dartmouth College Press, 2011.

Ganter, Granville. "'He Made Us Laugh Some': Frederick Douglass's Humor." *African American Review* 37, no. 4 (2003): 535–52.

Gates, Henry Louis, Jr. *The Signifying Monkey: A Theory of African-American Literary Criticism*. New York: Oxford University Press, 1988.

———. "The Trope of a New Negro and the Reconstruction of the Image of the Black." *Representations* 24 (Autumn 1988): 129–55.

Gifford, Daniel. *American Holiday Postcards, 1905–1915: Imagery and Context*. Jefferson, N.C.: McFarland, 2013.

Gilbert, Helen, and Jacqueline Lo. *Performance and Cosmopolitics: Cross-Cultural Transactions in Australasia*. New York: Palgrave Macmillan, 2008.

Gilmore, Paul. *The Genuine Article: Race, Mass Culture, and American Literary Manhood*. Durham: Duke University Press, 2001.

Glazer, Lee, and Susan Key. "Carry Me Back: Nostalgia for the Old South in Nineteenth-Century Popular Culture." *Journal of American Studies* 30, no. 1 (1996): 1–24.

Gossett, Thomas F. *"Uncle Tom's Cabin" and American Culture*. Dallas: Southern Methodist University Press, 1985.

Grier, Katherine C. *Culture and Comfort: Parlor Making and Middle-Class Identity, 1850–1930*. Washington, D.C.: Smithsonian Institution Press, 1997.

Griffen, Clyde, and Sally Griffen. *Natives and Newcomers: The Ordering of Opportunity in Mid-Nineteenth-Century Poughkeepsie*. Cambridge: Harvard University Press, 1978.

Groth, Michael Edward. "Forging Freedom in the Mid-Hudson Valley: The End of Slavery and the Formation of a Free African-American Community in Dutchess County, NY, 1770–1850." Ph.D. diss., SUNY Binghamton, 1994.

Gubar, Susan. *Racechanges: White Skin, Black Face in American Culture*. New York: Oxford University Press, 1997.

Gye, Lisa. "Picture This: The Impact of Mobile Cameras on Personal Photographic Practices." *Continuum* 21, no. 2 (2007): 279–88.

Hall, Kim F. *Things of Darkness: Economies of Race and Gender in Early Modern England*. Ithaca: Cornell University Press, 1995.

Harris, Michael D. *Colored Pictures: Race and Visual Representation*. Chapel Hill: University of North Carolina Press, 2003.

Hartman, Saidiya V. *Scenes of Subjection: Terror, Slavery, and Self-Making in*

184

Nineteenth-Century America. New York: Oxford University Press, 1997.

Henisch, Bridget A., and Heinz K. Henisch. "Cuthbert Bede and the Photographic Scene in the 1850s." *History of Photography* 28, no. 4 (2004): 348–56.

———. *The Photographic World and Humour of Cuthbert Bede*. Lewiston: Edwin Mellen Press, 2002.

Henisch, Heinz K., and Bridget A. Henisch. *The Photographic Experience: Exhibition to Celebrate the 150th Anniversary of the Invention of Photography*. University Park: Palmer Museum of Art, Pennsylvania State University, 1988. Exhibition catalogue.

———. *Positive Pleasures: Early Photography and Humor*. University Park: Pennsylvania State University Press, 1998.

Hinerfeld, Joshua Gordon. "The Fading Veneer of Equality: The Afro-American Experience in Poughkeepsie Between 1840 and 1860." *Dutchess County Historical Society Year Book* 68 (1983): 83–100.

Hoelscher, Steven. "Viewing Indians: Native Encounters with Power, Tourism, and the Camera in the Wisconsin Dells, 1866–1907." *American Indian Culture and Research Journal* 27, no. 4 (2003): 1–51.

Holman, Nigel. "Photography as Social and Economic Exchange: Understanding the Challenges Posed by Photography of Zuni Religious Ceremonies." *American Indian Culture and Research Journal* 20, no. 3 (1996): 93–110.

hooks, bell. "In Our Glory: Photography and Black Life." In *Picturing Us: African American Identity in Photography*, edited by Deborah Willis, 43–54. New York: New Press, 1994.

Hoskins, Janet. "The Camera as Global Vampire: The Distorted Mirror of Photography in Remote Indonesia and Elsewhere." In *The Framed World: Tourism, Tourists, and Photography*, edited

by Mike Robinson and David Picard, 151–68. Surrey: Ashgate, 2009.

Huggins, Nathan Irvin. *Harlem Renaissance*. New York: Oxford University Press, 1971.

Iyengar, Sujata. "White Faces, Blackface: The Production of 'Race' in *Othello*." In *Othello: New Critical Essays*, edited by Philip C. Kolin, 103–32. New York: Routledge, 2002.

Jay, Bill. *Cyanide and Spirits: An Inside-Out View of Early Photography*. Munich: Nazraeli Press, 1991.

———. "Photographic Pleasures, Popularly Portrayed with Pen and Pencil, 1855." *British Journal of Photography* 133, no. 2 (1986): 37–39.

———. *Some Rollicking Bull: Light Verse, and Worse, on Victorian Photography*. Munich: Nazraeli Press, 1996.

Jordan, Winthrop D. *White over Black: American Attitudes Toward the Negro, 1550–1812*. Chapel Hill: University of North Carolina Press, 1968.

Kaplan, Louis. *Photography and Humour*. London: Reaktion Books, 2017.

Kasson, John F. *Rudeness and Civility: Manners in Nineteenth-Century Urban America*. New York: Hill and Wang, 1990.

King, Michael. *Maori: A Photographic and Social History*. Auckland: Heinemann, 1983.

Kotchemidova, Christina. "Why We Say 'Cheese': Producing the Smile in Snapshot Photography." *Critical Studies in Media Communication* 22, no. 1 (2005): 2–25.

Krasner, David. *Resistance, Parody, and Double Consciousness in African American Theatre, 1895–1910*. New York: Palgrave Macmillan, 1997.

Krauss, Rolf H. *Die Fotografie in der Karikatur*. Seebruck am Chiemsee: Heering, 1978.

———. *Laughter and the Camera: A Different History of Photography*. Bielefeld: Kerber Verlag, 2016.

Lealand, Geoffrey. *A Foreign Egg in Our Nest? American Popular Culture in New Zealand.* Wellington: Victoria University Press, 1988.

Levine, Lawrence W. *Black Culture and Black Consciousness: Afro-American Folk Thought from Slavery to Freedom.* Oxford: Oxford University Press, 1977.

London, Herbert I. *Non-White Immigration and the "White" Australia Policy.* New York: New York University Press, 1970.

Lorimer, Douglas A. "Bibles, Banjoes, and Bones: Images of the Negro in the Popular Culture of Victorian England." In *In Search of the Visible Past: History Lectures at Wilfrid Laurier University, 1973–1974,* edited by Barry M. Gough, 31–50. Waterloo: Wilfred Laurier University Press, 1975.

———. *Colour, Class, and the Victorians: English Attitudes to the Negro in the Mid-Nineteenth Century.* Leicester: Leicester University Press, 1978.

Lott, Eric *Love and Theft: Blackface Minstrelsy and the American Working Class.* New York: Oxford University Press, 1993.

———. "Love and Theft: The Racial Unconscious of Blackface Minstrelsy." *Representations* 39 (Summer 1992): 23–50.

Lowe, John. "Theories of Ethnic Humor: How to Enter, Laughing." *American Quarterly* 38, no. 3 (1986): 439–60.

Lydon, Jane. *Eye Contact: Photographing Indigenous Australians.* Durham: Duke University Press, 2005.

Lyons, Paul. *American Pacificism: Oceania in the U.S. Imagination.* New York: Routledge, 2006.

MacDonald, Joyce Green. "Acting Black: *Othello, Othello* Burlesques, and the Performance of Blackness." *Theatre Journal* 46, no. 2 (1994): 231–49.

Mamiya, Lawrence H., and Lorraine M. Roberts. "Invisible People, Untold Stories: A Historical Overview of the Black Community in Poughkeepsie." *Dutchess County Historical Society Yearbook* 72 (1987): 76–104.

Maxwell, Anne. *Colonial Photography and Exhibitions.* London: Leicester University Press, 1999.

McClintock, Anne. *Imperial Leather: Race, Gender, and Sexuality in the Colonial Contest.* New York: Routledge, 1995.

McGrath, Ann. "Playing Colonial: Cowgirls, Cowboys, and Indians in Australia and North America." *Journal of Colonialism and Colonial History* 2, no. 1 (2001). https://muse.jhu.edu/article/7364.

Meaney, Neville K., ed. *Under New Heavens: Cultural Transmission and the Making of Australia.* Port Melbourne, Victoria: Heinemann Educational, 1989.

Meer, Sarah. *Uncle Tom Mania: Slavery, Minstrelsy, and Transatlantic Culture in the 1850s.* Athens: University of Georgia Press, 2005.

Mellinger, Wayne Martin. "Postcards from the Edge of the Color Line: Images of African Americans in Popular Culture, 1893–1917." *Symbolic Interaction* 15, no. 4 (1992): 413–33.

———. "Representing Blackness in the White Imagination: Images of 'Happy Darkies' in Popular Culture, 1893–1917." *Visual Sociology* 7, no. 2 (1992): 3–21.

Mellinger, Wayne Martin, and Rodney Beaulieu. "White Fantasies, Black Bodies: Racial Power, Disgust, and Desire in Popular Media Culture." *Visual Anthropology* 9, no. 2 (1996): 117–47.

Middleton, Russell, and John Moland. "Humor in Negro and White Subcultures: A Study of Jokes Among University Students." *American Sociological Review* 24, no. 1 (1959): 61–69.

Miles, Melissa. "Out of the Shadows: On Light, Darkness, and Race in Australian Photography." *History of Photography* 36, no. 3 (2012): 337–52.

Moeller, Madelyn. "Ladies of Leisure: Domestic Photography in the Nineteenth Century." In *Hard at Play: Leisure in America, 1840–1940*, edited by Kathryn Grover, 139–60. Amherst: University of Massachusetts Press, 1992.

Morgan, Jo-Ann. *"Uncle Tom's Cabin" as Visual Culture*. Columbia: University of Missouri Press, 2007.

Muñoz, José Esteban. "Feeling Brown: Ethnicity and Affect in Ricardo Bracho's *The Sweetest Hangover (and Other STDs)*." *Theatre Journal* 52, no. 1 (2000): 67–79.

Munro, Julia F. "'Drawn Towards the Lens': Representations and Receptions of Photography in Britain, 1839 to 1853." Ph.D. diss., University of Waterloo, 2008.

———. "'The Optical Stranger': Photographic Anxieties in British Periodical Literature of the 1840s and Early 1850s." *Early Popular Visual Culture* 7, no. 2 (2009): 167–83.

Murphy, Gretchen. *Shadowing the White Man's Burden: U.S. Imperialism and the Problem of the Color Line*. New York: New York University Press, 2010.

Newman, Karen. "'And Wash the Ethiop White': Femininity and the Monstrous in *Othello*." In *Shakespeare Reproduced*, edited by Jean Howard and Marion O'Connor, 141–62. London: Methuen, 1987.

Paris, Leslie. *Children's Nature: The Rise of the American Summer Camp*. New York: New York University Press, 2008.

Pettegrew, John. *Brutes in Suits: Male Sensibility in America, 1890–1920*. Baltimore: Johns Hopkins University Press, 2007.

Pfeifer, Theresa H. "Deconstructing Cartesian Dualisms of Western Racialized Systems: A Study in the Colors Black and White." *Journal of Black Studies* 39, no. 4 (2009): 528–47.

Pickering, Michael. "Mock Blacks and Racial Mockery: The 'Nigger' Minstrel and British Imperialism." In J. S. Bratton, Richard Allen Cave, Breandan Gregory, Heidi J. Holder, and Michael Pickering, *Acts of Supremacy: The British Empire and the Stage, 1790–1930*, 179–236. Manchester: Manchester University Press, 1991.

Poignant, Roslyn. *Professional Savages: Captive Lives and Western Spectacle*. New Haven: Yale University Press, 2004.

Prodger, Phillip. *Darwin's Camera: Art and Photography in the Theory of Evolution*. Oxford: Oxford University Press, 2009.

———. "Rejlander, Darwin, and the Evolution of 'Ginx's Baby.'" *History of Photography* 23, no. 3 (1999): 260–68.

———. *Time Stands Still: Muybridge and the Instantaneous Photography Movement*. New York: Oxford University Press, 2003. Exhibition catalogue.

Quanchi, Max. *Photographing Papua: Representation, Colonial Encounters, and Imaging in the Public Domain*. Cambridge: Cambridge Scholars Publishing, 2007.

Ramamurthy, Anandi. *Imperial Persuaders: Images of Africa and Asia in British Advertising*. Manchester: Manchester University Press, 2003.

Reaves, Wendy Wick. "The Art in Humor, the Humor in Art." *American Art* 15, no. 2 (2001): 2–9.

Reinhardt, Mark. "Vision's Unseen: On Sovereignty, Race, and the Optical Unconscious." *Theory and Event* 18, no. 4 (2015). https://muse.jhu.edu/article/595837/summary.

Richards, Jeffrey. *Imperialism and Music: Britain, 1876–1953*. Manchester: Manchester University Press, 2001.

Roach, Joseph. *Cities of the Dead: Circum-Atlantic Performance*. New York: Columbia University Press, 1996.

Rogin, Michael. *Blackface, White Noise: Jewish Immigrants in the Hollywood Melting Pot*. Berkeley: University of California Press, 1996.

Ryan, Dorothy B., and George Miller. *Picture Postcards in the United States, 1893–1918*. Updated ed. New York: C. N. Potter, 1982.

Sandweiss, Martha A. *Print the Legend: Photography and the American West*. New Haven: Yale University Press, 2002.

Schor, Naomi. "*Cartes Postales*: Representing Paris 1900." In *Postcards: Ephemeral Histories of Modernity*, edited by David Prochaska and Jordana Mendelson, 1–23. University Park: Pennsylvania State University Press, 2010.

Schroeder, Fred E. H. "Say Cheese! The Revolution in the Aesthetics of Smiles." *Journal of Popular Culture* 32, no. 2 (1998): 103–45.

Scott, Derek B. *Sounds of the Metropolis: The Nineteenth-Century Popular Music Revolution in London, New York, Paris, and Vienna*. Oxford: Oxford University Press, 2008.

Seiberling, Grace. *Amateurs, Photography, and the Mid-Victorian Imagination*. Chicago: University of Chicago Press, 1986.

Shaw, Gwendolyn Du Bois. *Seeing the Unspeakable: The Art of Kara Walker*. Durham: Duke University Press, 2004.

Sheehan, Tanya. "Comical Conflations: Racial Identity and the Science of Photography." *Photography and Culture* 4, no. 2 (2011): 133–56.

———. *Doctored: The Medicine of Photography in Nineteenth-Century America*. University Park: Pennsylvania State University Press, 2011.

Sheehan, Tanya, and Henry Louis Gates Jr. "Marketing Racism: Popular Imagery in the United States and Europe." In *The Image of the Black in Western Art*, vol. 5, *The Twentieth Century, Part I*, edited by David Bindman, 29–42. Cambridge: Harvard University Press, 2014.

Sidlauskas, Susan. "Painting Skin: John Singer Sargent's *Madame X*." *American Art* 15, no. 3 (2001): 8–33.

Sinclair, Bruce, ed. *Technology and the African-American Experience: Needs and Opportunities for Study*. Cambridge: MIT Press, 2004.

Sklar, Kathryn Kish. "'Women Who Speak for an Entire Nation': American and British Women at the World Anti-Slavery Convention, London, 1840." In *The Abolitionist Sisterhood: Women's Political Culture in Antebellum America*, edited by Jean Fagan Yellin and John C. Van Horne, 301–33. Ithaca: Cornell University Press, 1994.

Smith, Shawn Michelle. *American Archives: Gender, Race, and Class in Visual Culture*. Princeton: Princeton University Press, 1999.

Smulyan, Susan. *Popular Ideologies: Mass Culture at Mid-Century*. Philadelphia: University of Pennsylvania Press, 2007.

Sonstegard, Adam. "Performing Remediation: The Minstrel, the Camera, and *The Octoroon*." *Criticism* 48, no. 3 (2006): 375–95.

Stanton, William Ragan. *The Leopard's Spots: Scientific Attitudes Toward Race in America, 1815–1859*. Chicago: University of Chicago Press, 1960.

Stauffer, John, Zoe Trodd, and Celeste-Marie Bernier, eds. *Picturing Frederick Douglass: An Illustrated Biography of the Nineteenth Century's Most Photographed American*. New York: Liveright, 2015.

Steen, Shannon. *Racial Geometries of the Black Atlantic, Asian Pacific, and American Theatre*. New York: Palgrave Macmillan, 2010.

Stepan, Nancy. *The Idea of Race in Science: Great Britain, 1800–1960*. London: Macmillan, 1982.

Susman, Warren I. *Culture as History: The Transformation of American Society in the Twentieth Century*. New York: Pantheon Books, 1973.

Takaki, Ronald T. *Iron Cages: Race and Culture in Nineteenth-Century America*. New York: Knopf, 1979.

Thelwell, Chinua. "'The Young Men Must Blacken Their Faces': The Blackface Minstrel Show in Preindustrial South Africa." *TDR/The Drama Review* 57, no. 2 (2013): 66–85.

Toll, Robert C. *Blacking Up: The Minstrel Show in Nineteenth-Century America*. New York: Oxford University Press, 1974.

Tompkins, Kyla Wazana. *Racial Indigestion: Eating Bodies in the Nineteenth Century*. New York: New York University Press, 2012.

Trachtenberg, Alan. "Lincoln's Smile: Ambiguities of the Face in Photography." *Social Research* 67, no. 1 (2000): 1–23.

———. *Lincoln's Smile and Other Enigmas*. New York: Farrar, Straus and Giroux, 2007.

———. "Reading Lessons: Stories of a Daguerreotype." *Nineteenth-Century Contexts: An Interdisciplinary Journal* 22, no. 4 (2001): 537–57.

Trumble, Angus. *A Brief History of the Smile*. New York: Basic Books, 2004.

Tucker, Jennifer. *Nature Exposed: Photography as Eyewitness in Victorian Science*. Baltimore: Johns Hopkins University Press, 2006.

Vendryes, Margaret Rose. "Race Identity/Identifying Race: Robert S. Duncanson and Nineteenth-Century American Painting." *Art Institute of Chicago Museum Studies* 27, no. 1 (2001): 82–99, 103–4.

Wagner, Karin. "Moblogging, Remediation, and the New Vernacular." *Photographies* 4, no. 2 (2011): 209–28.

Wajda, Shirley Teresa. "The Commercial Photographic Parlor, 1839–1889." *Perspectives in Vernacular Architecture* 6 (1997): 216–30.

———. "A Room with a Viewer: The Parlor Stereoscope, Comic Stereographs, and the Psychic Role of Play in Victorian America." In *Hard at Play: Leisure in America, 1840–1940*, edited by Kathryn Grover, 112–38. Amherst: University of Massachusetts Press; Rochester, N.Y.: Strong Museum, 1992.

Walker, Nancy A. *What's So Funny? Humor in American Culture*. Wilmington, Del.: Scholarly Resources, 1998.

Wallace, Maurice O., and Shawn Michelle Smith, eds. *Pictures and Progress: Early Photography and the Making of African American Identity*. Durham: Duke University Press, 2012.

Waterhouse, Richard. *From Minstrel Show to Vaudeville: The Australian Popular Stage, 1788–1914*. Kensington: University of New South Wales Press, 1990.

———. "Popular Culture." In *Americanization and Australia*, edited by Philip Bell and Roger Bell, 45–60. Sydney: University of New South Wales Press, 1998.

Waters, Hazel. *Racism on the Victorian Stage: Representation of Slavery and the Black Character*. Cambridge: Cambridge University Press, 2007.

Watkins, Mel. *On the Real Side: A History of African American Comedy from Slavery to Chris Rock*. Chicago: Lawrence Hill Books, 1999.

White, Richard. *Inventing Australia: Images and Identity, 1688–1980*. Sydney: George Allen and Unwin, 1981.

Wickberg, Daniel. *The Senses of Humor: Self and Laughter in Modern America*. Ithaca: Cornell University Press, 1998.

Williams-Myers, Albert J. *Long Hammering: Essays on the Forging of an African-American Presence in the Hudson River Valley to the Early Twentieth Century*. Trenton: Africa World Press, 1994.

Willis, Deborah. *Let Your Motto Be Resistance: African American Portraits*. Washington, D.C.: Smithsonian Books, 2007. Exhibition catalogue.

———. *Reflections in Black: A History of Black Photographers, 1840–1999*. New York:

W. W. Norton, 2000. Exhibition catalogue.

———. *VanDerZee: Photographer, 1886–1993.* New York: Harry N. Abrams, 1993. Exhibition catalogue.

Willis, Deborah, and Carla Williams. *The Black Female Body: A Photographic History.* Philadelphia: Temple University Press, 2002.

Willis-Thomas, Deborah, ed. *Picturing Us: African American Identity in Photography.* New York: New Press, 1994.

Wilson, Fred, and Lisa Corrin. *Mining the Museum: An Installation.* New York: W. W. Norton, 1994. Exhibition catalogue.

Winston, Brian. "A Whole Technology of Dyeing: A Note on Ideology and the Apparatus of the Chromatic Moving Image." *Daedalus* 114, no. 4 (1985): 105–23.

Wittmann, Matthew W. "Empire of Culture: U.S. Entertainers and the Making of the Pacific Circuit, 1850–1890." Ph.D. diss., University of Michigan, 2010.

Wood, Marcus. "The American South and English Print Satire, 1760–1865." In *Britain and the American South: From Colonialism to Rock and Roll*, edited by Joseph P. Ward, 107–40. Jackson: University Press of Mississippi, 2003.

———. *Blind Memory: Visual Representations of Slavery in England and America, 1780–1865.* New York: Routledge, 2000.

———. *Slavery, Empathy, and Pornography.* Oxford: Oxford University Press, 2002.

Woolfork, Lisa. *Embodying American Slavery in Contemporary Culture.* Urbana: University of Illinois Press, 2009.

Index

Italicized page references indicate illustrations. Endnotes are referenced with "n" followed by the endnote number.

198

202 |